March 27-April 25, 1978
Center for the Arts
Wesleyan University
Middletown, Connecticut

May 20-June 25, 1978
Springfield Museum of Fine Arts
Springfield, Massachusetts

July 11-August 20, 1978
The Baltimore Museum of Art
Baltimore, Maryland

September 8-October 15, 1978
Dartmouth College Museum and Galleries
Hopkins Center
Hanover, New Hampshire

November 3-December 15, 1978
University Art Museum
University of California
Berkeley, California

January 5-February 16, 1979
Cincinnati Art Museum
Cincinnati, Ohio

March 9-April 20, 1979
Georgia Museum of Art
The University of Georgia
Athens, Georgia

May 11-June 22, 1979
The St. Louis Art Museum
St. Louis, Missouri

July 13-September 9, 1979
Newport Harbor Art Museum
Newport Beach, California

October 3-November 18, 1979
Rhode Island School of Design
Museum of Art
Providence, Rhode Island

JASPER JOHNS:

By Richard S. Field

This exhibition and catalogue were aided by a grant from the National Endowment for the Arts, Washington, D.C. (a Federal Agency) and a generous contribution from the Travelers Insurance Companies, Hartford, Connecticut.

Wesleyan University, Middletown, Connecticut
1978

Copyright 1978 by Wesleyan University

Library of Congress Catalogue Card Number 77–093988

Printed in the United States of America
by The Meriden Gravure Company

Typography by Typographic House

Design by William Van Saun

ISBN: 0–931266–00–9

Distributed in the United States and Canada
by Wesleyan University Press,
Middletown, Connecticut 06457

Distributed in Great Britain and Europe
by Petersburg Press, Ltd., London

Photographic Credits: Gemini, G.E.L., Los Angeles
(129, 135-145, 147-163, 175-190, 194-205, 249-257);
Multiples, Inc., New York (193); Petersburg Press, Lon-
don and New York (206, 207, 209, 213-248); Eric Po-
litzer, New York (132, 133, 146, 171-174, 191, 192, 211,
260); and Universal Limited Art Editions, West Islip,
Long Island, New York (130, 131, 134, 164-170, 208,
210, 212, 258, 259).

Jasper Johns is a giant among painters and a printmaker without peer. His visual inventiveness and mastery of technique has set the standard for printmaking in the United States for seventeen years. The prodigious inventory of Johnsian surfaces seduces our interest but all too often disguises a remarkable integration of technique, image, and meaning. Johns inevitably locates the viewer's perceptions in the interfaces between languages—between the literal object and the represented objects, between illusions and the devices of which illusion consists, between seeing and thinking. So it is both enthralling and risky to attempt both a critical and an objective description of Johns' printed oeuvre. For no other artist has so deeply penetrated the languages and process of printmaking; no other artist has been so insightful or so able to utilize and control the precise degree of concreteness, of objectness, of illusion, of tactility, of opticality, and of reproductiveness of every surface of every medium in which he works.

Thus it is a privilege to be able to carry on the cataloguing of Johns' prints begun in 1970 with the exhibition held at the Philadelphia Museum of Art. My gratitude to those who have helped make this exhibition and catalogue a reality is all the more profound since this entire experience has so deeply enriched my own life.

I feel it fitting that my first and greatest appreciation should go to the National Endowment for the Arts. In large measure this exhibition and its catalogue were made possible by the Endowment's support.

And no exhibition could take place without the generosity of its lenders. To Gemini G.E.L. in Los Angeles, to Petersburg Press in London and New York, to Leo and Antoinette Castelli of New York, and, of course, to Jasper Johns go my deepest thanks for having made available so many precious works for such an extended tour. To Sidney Felsen, Stanley Grinstein, Paul Cornwall-Jones, Susan Lorence, the Castellis, and the artist, I would like to extend the appreciation of Wesleyan University and the vast number of visitors to the exhibitions.

As author, I would like to thank the many who have shared their knowledge, good will, and interest. First of all, Jasper Johns and Mark Lancaster have helped at every turn with facts, ideas, designs and hospitality. Brooke Alexander kindly consented to the reprinting of the essay on Johns' screenprints. Andrea

3

Miller-Keller of the Matrix Gallery, Wadsworth Atheneum, Hartford, Connecticut, generously permitted me to adapt parts of my essay on *Fragments—According to What* and *Four Panels After Untitled 1972*. At Gemini, Margaret Ramsey, Donald Guild, and Patricia Heesy enthusiastically answered every question and filled each request. At U.L.A.E., Tatyana Grosman fed, educated, and gave me the sustenance of which both curators and catalogues are made. Tony Towle and Bill Goldston, as so often in the past, were at hand to clarify and expedite matters whenever called upon. In New York City no one could have been more willing to bend over printers' proofs than Hiroshi Kawanishi of Simca Print Artists, nor could I have imagined more cooperative colleagues than Susan Lorence at Petersburg Press, or Karen Bangs and Bob Monk at Castelli Graphics. In Paris, I spent an enthralling afternoon with Aldo Crommelynck who led me through the technical maze of the wonderful etchings he printed in *Fizzles*. Others who have been gratifyingly willing to help were Marion Goodman of Multiples, Inc., Judith Goldman, James Burke, and John Paoletti. It would also seem appropriate for me to record the debt I feel to the truly gifted writers whose works I have mined and whose ideas I have, in so far as I am capable, absorbed: Barbara Rose, Max Kozloff, Rosalind Krauss, Michael Crichton, Leo Steinberg, and Thomas Hess. Hopefully, something of what follows will find acceptance by such insightful minds.

At Wesleyan, many friends and colleagues have helped to bring this exhibition and its documentation to fruition. Principally I would like to thank William Dillon who has obtained materials for my research over several years; also Joan Jurale, John Bengtson, Arthur Shail, and John Martin. To my assistant, Janette Boothby, who is also Registrar of Collections, goes my warmest gratitude for having typed the entire manuscript and for having watched over countless details. For the elegant, fitting, and useful catalogue design I had the pleasure to work once more with William Van Saun, Designer for Wesleyan University, and his assistant, Mary Duffy Morris. And finally I thank my wife, Elise Wechsler Snyder, M.D., for her forbearance, for her insights, and for her editorial services.

Last but hardly least it should be recorded that much of this book was researched and written while I was a John Simon Guggenheim Fellow in 1976-1977. For the Foundation's support and understanding, I express my deepest thanks.

Richard S. Field
Curator, Davison Art Center,
Wesleyan University

I. PRINTS IN SERIES/GEMINI G.E.L.

During the past seven years, 1970-1977, Jasper Johns' prints have become more sophisticated and more complex. Like the great *peintre-graveurs* of the past, he has achieved total mastery over the means of reproduction without ever falling prey to the lure of pure craftsmanship. Yet he has repeatedly probed the limits of his craft, combining and comparing the draughtsmanly and the reproductive, the abstract and the illusionistic, the linear and the tonal. What he set out to accomplish in the past few years has indeed required his virtuosity. In lithography he has learned to use each printing element[1] as a distinct part of vision or as a separate modality of style (and not merely as an ingredient of a unified image). In screen-printing he has made each mark on the screen allude to the painted brushstroke while focusing on a complex structure that is distributed in discrete layers of printing (opposed to traditional side by side, hard-edge color printing or vertical build-ups of heavy impasto). And in etching, Johns has perfected the use of open-bite—hand application of the etcher's mordant that results in the most sensitive and autographic tone control ever devised for the copperplate.

Johns' focus in printmaking (as in the paintings of 1964-1977) has been on the nature of memory, reproduction, and replication.[2] As a consequence, he has returned by an unexpected route to the 1960s' concern with media and information processing. Yet, both his subjects and his processes are cast strictly in Johnsian terms. As a result, the viewer's focus is maintained on the specific experience of what Johns has made, its mechanisms, and its internal laws. By working with images uniquely established as his own, Johns leaves the viewer free to explore the languages of reproduction and their dependence on forms of recollection.

It is by now a widely held view that languages, styles, media, etc., are not so much means of expression as they are embodiments of knowledge.[3] Art, too, has increasingly come to be viewed as knowledge rather than expression, almost as a branch of epistemology rather than psychology. Beauty is not only present in the handling and optics of the materials of art, but now resides in the precision and density of meaning. This point of view is reflected in many of the prints of our time—particularly those of Johns, Rauschenberg, Warhol, and Hamilton on the one hand, Serra, Marden,

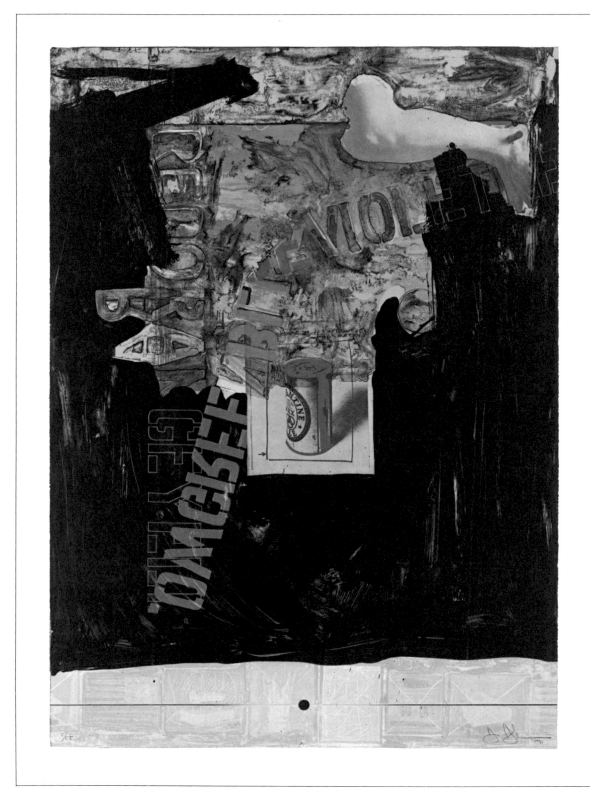

134. Decoy, 1971

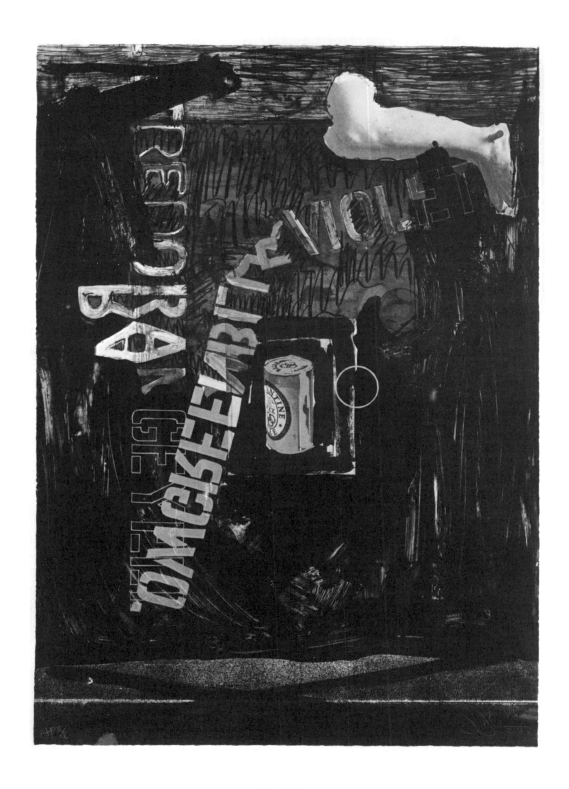

169. Decoy II, 1971-73

Ryman, LeWitt, and Katz on the other. Each endows the printing medium with a severely limited but inescapable physical presence that is incredibly merged with the "image" it transmits. Rather than register as externally experienced expressive transformations of what is represented, these prints succeed in questioning the observer's internal perceptions of the work of art itself. In a very real way they have focused on the essential nature of the print itself, because the print is, in truth, *the* analogue for the processing of visual information. Yet, for some years Johns' detractors have maintained that his prints are no more than copies of his paintings. Some of his defenders have answered that the prints pose different problems than paintings and represent a totally new graphic reinterpretation of the themes. Other students of Johns do not compare the prints with the paintings at all. They concentrate on the prints *sui generis* and their contribution to the refinement and expansion of the autographic potentials of lithography and etching. By 1977 it seems reasonably clear, however, that Johns' prints not only demonstrated consummate artistry in the realm of technique, but that they are really a running, critical commentary on the painted oeuvre. Not only do they rephrase the problems posed in the paintings, but they also formulate new questions that shed considerable light on all of Johns' work.

Johns' practice of restricting the subjects of his prints to those developed in other media (*Decoy*, F.134, was the one major exception to this rule) has had numerous consequences. First of all, the prints are subtle and ingenious media translations. It is a commonplace that much of our experience is couched in terms of media to which we have a vast fund of rich but barely perceived associations. But Johns' images are no more transformations of common experience than his objects possess func-

tions similar to those they have in ordinary circumstances. The change in media not only reduces references to experiences outside art, but, more importantly, serves to underscore that which remains constant: the process of seeing itself. Much has been written about Johnsian devices and the uncertainty of their real, represented, or implied actions.[4] Many writers have described the incredibly seductive richness of Johns' materials and textures. Others have plumbed the basic stylistic issues embedded in the flag, the map, and the field paintings or have puzzled over the even more elusive identity of the numerals (which are mental objects rather than "things out there"). The major constant in Johns' work (as Michael Crichton and all of those who have studied *Watchman* and *Souvenir* have definitively recognized) is the relation between the viewer and the work of art. What Johns demands of us is that we understand the notion of "seeing oneself seeing."[5] Being aware of our languages while we use them is perhaps the most difficult function of the mind; it involves a higher order of consciousness than ordinary and habitual use of language allows.

In recent years, Johns has preferred to work on series of prints.[6] Undoubtedly the reasons are multiple, ranging from the banal to the intrinsic. To begin with, many of the paintings executed since 1963 have been large and not easily subsumed by a single print. In addition, some of these paintings have not been received with much critical acclaim or public comprehension. Many have seemed subjectless. I think this uncomprehending reception may have spurred the artist to "explain" his works by unceasingly inventive variations. The wish to work in series has probably both led to and been fostered by a change in his working environment. Increasingly he has traveled to Gemini in Los Angeles or to Crom-

melynck's in Paris—away from his home on the East Coast. Tatyana Grosman's shop on Long Island simply is not set up to encourage multiple, major undertakings; the whole atmosphere at ULAE emphasizes the perfection of a unique image, rather than groups of very similar stylistic character. If these reasons for change harbor an unromantic view of the creative process, they hardly seem at variance with Johns' own procedures which so often involve precise measurement, labored efforts to achieve an exact relationship to a prototype or to a mental concept, and his self-imposed principle of forced change. These considerations bring us closer to the underlying reasons for Johns' exploration of series.

Johns' evolution has been a gradual one, without dramatic shifts. His focus on ever-narrower and more precise problems has required ever subtler control over his media. As he has come to feel at home with various printmaking techniques, his increasingly precise notions of stylistic specificity have extended to each printing element.[3] A close examination of the prints will demonstrate how separate printing surfaces may be equated with conceptually disparate elements of the paintings.[7] Thus, the process of making the print gradually assimilated the content of the image. It is this sophisticated grasp and control of every conceivable aspect of a craft that has enabled Johns to explore the problems of language and perception through the modalities of art. He has realized that in printmaking the multiple layers laid down by successive printing elements can embody basic analogies to our systems of seeing, learning, and retaining knowledge of the world.

In order to emphasize these analogies and the highly individualized vocabularies that compose them, Johns has frequently repeated a given procedure in several prints. Thus there have been intrinsic and developmental grounds for Johns' increasing habit of working on groups of prints.

The resultant series are held together by their linguistic unity, and this unity unexpectedly emphasizes or brings out the subtle reproductive nature of the prints. By modulating the print's transparency—the viewer's feeling of looking through—Johns urges on him an examination of the distinctly different modes or languages embodied in each series. At the same time, Johns has curtailed his fondness for playing autographic brushiness against dampening devices of a more rational or measurable nature.[8] This reduction of the presence of his own hand aims at providing more opportunity for the viewer to explore the interface between the print as printed object and the print as representation. In other words, many of the prints of the seventies openly court comparison with the paintings—but with the caveat that the viewer be very sensitive to the degree and "feel" of the reproductive qualities.

As Michael Crichton, Rosalind Krauss, Robert Morris, and Johns himself have already emphasized, much of the creative work of our time grows out of making and remaking.[9] In other words, the physical act of embodying a banal form or object focuses attention in such a way that unconscious elaborations are encouraged.[10] Printmaking with its built-in "delays" conspires to abet, not so much the appearance of accident, as the emergence of new meanings from having to work with what might be called the grammatical elements of a printed image. Thus Johns' habit of constantly reworking, refocusing, and inverting (I am thinking particularly of all the so-called black states) is really an exploration of process in language rather than idle variation-on-a-theme. Each group of prints is a class unto it-

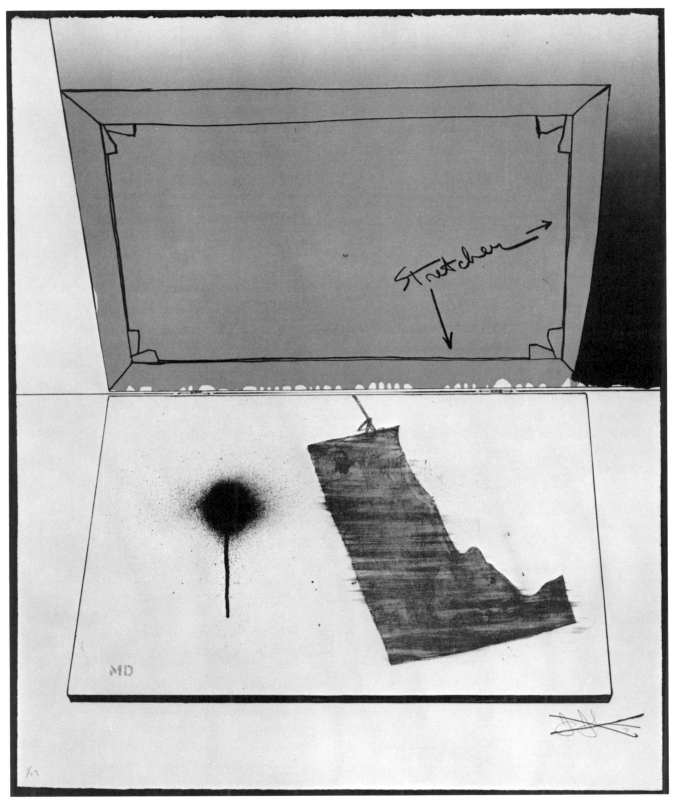

139. Hinged Canvas, 1971

138. Bent Blue (Second State), 1971

self, a subtle language game. Each print is a kind of reproduction and/or memory image that alters our perception of its prototypes. The evermore complex overlapping of illusions (like the complexity of the *Decoy* lithographs) underscores the very deceptive nature of that which we take to be reality – of that which we point at and assign meanings to in an ostensive manner. Here lies the ultimate root of Johns' preoccupation with casts, illusions, and drawing modes. He leads us to question what seem to be essential and unalterable figure-ground relationships, the very basis of our ability to separate objects or concepts from their context.[11] This is certainly the most fundamental reason why flatness, as a modernist preoccupation, could never be the ultimate stylistic goal of Johns' paintings and prints. For him, flatness only provides the benchmark against which the *multiple* conventions of picture-making must be evaluated.

It is for similar reasons that Johns has not exploited his superb graphic facility in order to catalogue abstract graphic and textural systems. Granted this is one of the most attractive aspects of his works, one that is clearly in evidence in the series of black *Numerals* of 1967, but it exists, in my opinion, far more to arouse our interest and even to mislead our attention than as a goal in itself.[12]

Ultimately, what seems important is not how the viewer feels about his own experiences, but how his means for representing the world to himself (including mass media) determine the very range of his experience and his sense of conscious existence. Because the prints are so often a mapping of the three-dimensional painting or sculpture onto a two-dimensional surface, and because each series represents its own mini-language of reproduction, they are metaphors for the ambiguity of experience.

That ambiguity arises out of an insufficiency of memory and our habit of transferring aspects of one object to another. I am claiming, therefore, that the effort demanded by the prints relates directly to the kind of efforts made to structure perceptions. The issue is not whether, but how much, perception is to be regarded as purely visual and outside, or, as Johns seems to prefer, as a complex, and "impure" network of multi-sensual learning and projection that shuttles back and forth between experiences felt as both outside *and* inside.[13] His continual references to the written word, to touch, to sound, and even to smell and taste, are not only indications of his very unorthodox sensibility, but suggestions that the experience of his works includes a kind of bodily analogue to the process of vision. Implied, in fact, is the notion that learning, the process of taking in and giving out, is bound up with all of the senses (we grasp an idea or we swallow an illusion).[14] Certainly the sculpture, *The Critic Sees*, in which the mouth replaces the eye, is not only a trenchant criticism of art writing but a conjoining of physical and mental systems. As Michael Crichton first pointed out, its block-like form clearly suggests the inseparable quality of thought and sight.[15]

To an extent unique in the history of printmaking, each series of prints has its own flavor, its own place on the continuum that separates our inner experiences from the world outside of us.[16] Each series, therefore, participates in Johns' exploration of the nature of reality and its legions of surrogates. They even ask whether there exists any difference between our perceptions of reality and the symbols we use to depict it. Since it is only through language that a fragmented world attains some unity, and since language mediates our experience of the world, it follows that all of Johns' work embodies the uncertainty that haunts

the mind of the isolated individual. This tragic sense of life can be viewed epistemologically or psychoanalytically. Each view can be justified and each has led to errors of interpretation.[17] In Johnsian terms, the overriding question about any thought, image, or description is how it relates to what we comfortably like to label "reality" – "something out there." In 1969 in a series of revealing statements to Joseph Young,[18] Johns openly stated that in the context of artistic discourse he no longer really knew what reality was, that is, what one could justifiably call an object. This is a crucial question for one who makes pictures. But most of Johns' objects are fictitious – they are deprived of their normal functions, given new roles and new contexts, or transformed by being remade or reproduced. Furthermore, most are presented in several different notational modes. Thus Johns forces us to reflect on the presentational aspects of the object rather than on its thingness. Disjunctiveness becomes Johns' tool of dissection and not just the expression of a tragic sense of life.

What I am describing, therefore, cannot be a matter of a particular style. If style seeks to present a coherent world view, the discontinuity of Johns' work must be seen as anti-style. This is not so much a denial of past styles, as it is a revision of the possibilities in his own work.[19] An oeuvre based on contradictions rarely has that air of purity Michael Fried called "presence."[20]

From the beginning, even the flags' commitment to flatness and abstraction was limited by the contradictions inherent in the layers of collage and encaustic.[21] Only in the paintings of the past five years has Johns, running counter to virtually all painting of the moment, abandoned all allusive figuration. By equating the structure of the picture with this new, simple hatching and by severely curtailing the role of illusion to the cracks of space at the junctions of adjoining fields, Johns finally has created works whose single-mindedness might be associable to a personal style. Nevertheless, this motif still avoids making a total commitment to the canvas, its flatness, and its four bounding edges, i.e., its object quality.[22] The hatching produces important pictorial events not at its own edges or at the edges of the canvas (Olitski and Stella), but where it abuts its own replication. There are no inviolate rules as in modernist painting, only the subtle events to be detected and evaluated during the experience of the work. As usual Johns' prime subject is the relation of the work of art to the viewer.

The internal events of the recent works obey organizational rules that are not immediately obvious; they virtually force the viewer to detect various degrees of mirroring, repeating, matching, and shifting. Thus, from the beginning to end, one of the constant hallmarks of Johns' art is its reflectivity. It is no surprise that a mirror was one of the prime attributes of his self-portrait, *Souvenir*. Johns' goal (like Warhol's) may be to reflect the viewer's habits and decisions, but his method is to reflect his own work. Johns is almost obsessed with the notion that anything can be done differently, that anything can be experienced differently. Johns' method, therefore, is one of clarity and specificity. For him, each work poses and disposes of a specifically defined case.[23] I believe that in the prints he has attempted to make this particularly clear through a growing inclination to distill disparate and complex events through homogeneous series. As a result, one becomes aware of the inflection of the language of each series. In addition to yielding their peculiar Johnsian meanings, therefore, the series become metaphors for the variability and uncertainty of all experience.

Since 1970, a good two-thirds of Johns' output has appeared in series form: *Fragments According to What* (six lithographs, 1971); the *Good Time Charley* series (sixteen lithographs, 1972); *Casts from Untitled* (fourteen lithographs, 1973-74); *Four Panels from Untitled, 1972* (eight lithographs, 1973-75); *Ale Cans* (four lithographs, 1975); *Fizzles* (thirty-three etchings, mostly after *Untitled, 1972;* 1975-76); and *6 Lithographs* (after '*Untitled, 1975'*) (1976). A comparison of the series of the Seventies with those of the Sixties—with the thirty images (three sets of ten) of *0-9* (F.17-46, 1960-63) and the twenty prints of the *Numerals* (F.94-113, 1968-69)—reveals an interesting shift.

The earlier works were simultaneously demonstrations and symbols of serial change. The objectlessness of the concept (number) was strongly and mysteriously contrasted with the strong graphic identity of each image (numeral).[24] By contrast, varieties of purely graphic vocabularies hardly appear in the *Fragments*. Similarly, the individualized spectrum progressions of the *Color Numerals* do not reappear. Although the Gemini *Numerals* are tinged with a unifying machine precision, the character of the entire set is subordinated to that of the individual works. It seems to me that a new attitude was announced in *1st Etchings* of 1967 (F.71-77). First of all, Johns was dealing with objects he had already made. Second, all six images were couched in the same very pure, bone-dry outline; they were minimal conceptualizations, almost ideographs. Subsequently, they were all reprocessed (*1st Etchings, 2nd State*). Johns added varying densities of aquatint and open bite that purposely did not obscure his original lines. As a result each image was refocused in a new, individualized space. The lead reliefs (F.118-122) of 1969 continued the series approach of the etchings. Images, old and new, were cast in a medium of very unusual optical qualities. It is possible that the machined surfaces of the lead reliefs—surfaces that provided an uncanny experience of simultaneous opticality and opacity—suggested the anonymous machine-smooth blends of the *Fragments*.

By the time Johns finished his first decade of printmaking (1970), there were unmistakable signs of change. His commitment to Gemini projects was strengthened as his tendency to make major single prints dwindled. The 1970 lithograph, *Souvenir* (F.127), marked a new dryness and contemplativeness. The same mode, more analytic and less autographic, would be employed to re-examine the great painting of 1964, *According to What*. Executed at Gemini where, under Ken Tyler, precision and control were never better served, the six *Fragments* were coolly received by the public. They seemed to lack that Johnsian touch and the warm and slightly *malerisch* artistry of Tatyana Grosman's workshop on Long Island. They were fragments of a difficult painting, and they were cleanly analytical to a degree that contrasted with the brushiness of their prototype (except for *Bent Blue* which did contain the prized, succulent washes of old). Their indifferent reception indicated that the artist had indeed managed to break out of the mold of public expectations. The fact that six major lithographs shared such a finely controlled idiom signaled Johns' departure.

Although the prints of 1960-70 were invariably based on paintings, few were so transparent that one had the feeling of looking beyond the surface into a space at another object. *Passage I* of 1966 (F.57) and *Souvenir* of 1970 (F.127) were clearly exceptions. Both incorporated photographic passages and heightened tonal clarity to enhance illusion. But neither were as systematically precise nor as optically pure as the gray blends which acted

like polished surfaces in the *Fragments*.[25] Nor had any of the prints of the 1960s possessed such abundant spatial implications as did the *Fragments* of 1971. The pictorial motion implied in the gray blends was picked up in many evocative passages of spatial illusion, particularly by the bent or hinged objects such as the coat hanger, stencil, letters, and stretcher. The content of these lithographs, far more than their painted prototype, concerns illusionism. Whereas the canvas is full of palpable marks, real objects, and occupies real space, the prints are emphatically flat. Whereas the painting clearly embraces a variety of acts and materials, the prints are far more synthetic and uniform. They are composed of a limited variety of printed marks that give rise to representation and illusion. In *Fragments*, Johns has set about examining and comparing these forces of illusion.[26]

The *Fragments*, therefore, are diagrams of devices, systems, actions, and words, all implying shifts of focus, change, and motion. They exist in an environment of bendable space, largely established by the precisely modulated bands of blended ink. The total effect of this precision is what I have called transparency. Although the viewer is aware of the textures and flatness of the lithographs, he nevertheless has some feeling of looking into a further space. This carefully controlled transparency strengthens the illusionistic potential of the entire image, and is really the framing language with which the artist and the spectator go about their analyses.

It is impossible to examine each of the *Fragments* in their entirety, but some details may be noted. Consider *Bent Stencil* with its progression of circles within squares. The topmost is clearly a drawn image, simple and diagrammatic. The middle consists of two darker, flat, gray areas that seem to share the flatness of the paper. The lower figure is an illusion of the stencil itself — the apparatus that purportedly (and in the painting, literally) was the template. The illusion is enhanced by a photographic halftone plate made from the painting, a layer of silver ink, and the irony of a few random dabs of paint (printed in a logical fashion from the same plate that also deposited ink in the stencil opening). The stencil overhangs the bottom edge of the third zone which, like the upper rectangle, is actually incomplete. Like so many Johnsian devices, it implies both past usage and present dysfunction. It still serves illusionistically as a measuring device, something that is bent away from the surface and could be used, at least visually, to give scale to the marks it has aided in making. In the painting, the real stencil hangs over the bottom of the canvas; in the lithograph, it overlaps an area of succulent wash (unorganized space). The implied succession of events up and down the image is strengthened by the movement of the band of blended grays at the right. At the same time the unprinted whiteness of the left-hand column reasserts the ineluctable flatness of the lithograph. Whereas the painting more understandably focuses on real objects, real functions, and real space, the prints operate far more symbolically. They are populated by tensions between implied and perceived spaces, objects, and functions — and their denials (the bent stencil is symbolic of loss of function, although it thereby gains another). This further compression and symbolization of reality in the prints should dispel once and for all the uneasy notion, still found among the sceptical, that Johns' activities as a printmaker are something less than creative.

In *Bent Blue* the spectator is moved to total acceptance of what, in any other context, would be regarded as rather meaningless: the bending of a color as it (the word) moves through pictorial space; the imprinting or

projection of itself in various aspects of completion on the machined surface of blended ink at the right; and the immersion or emergence from the painterly surface at the left. It is the total illusion engendered by the wonderfully modulated washes that distracts from the inexplicable qualities of the situation and sets up an acceptance of the implied motion of the letters.[27] Yet, in another part of the lithograph, Johns explicitly cancels a spatial event, that of reading the newspaper which was transferred from our side of the surface to read illusionistically on the other. Throughout the series, bends in and out of the space are marked by a spectrum line (the closest analogy to bending actual color).

Hinged Canvas alludes to a host of inside-outside situations, beginning with the spectrum line and the "action" of the word, "hinge." Most obvious is the ambiguous view of the back of one stretcher (again only a diagram) and the front of another. (In the painting Johns used two stretchers, hinged together so it was possible to see two versos in succession.) The blended shading seems to pass from the front around to the back of the stretcher. The same ambiguity is detected in the profile of Marcel Duchamp whose appearance is in the field (a pun on the white of the paper) but whose presence can only be attributed to the gray, template-shape. This template, in turn, turns out to represent the projected shadow of the stencil (note the shadow of the suspending string), one that is a slight distortion of the actual Duchampian device (a square of torn paper) which is not within our view. Through these allusions we are brought into contact with Marcel Duchamp's painting of 1918, *Tu m'* (collection Yale University Art Gallery). *Tu m'* posed questions about the varieties of conventional illusion which have been inventoried by Patricia Kaplan and Barbara Rose.[28] Finally, there is the air gun's splash and drip which is

unthinkable without the "bachelor shots" of Duchamp's *Large Glass* (Philadelphia Museum of Art), marks made by pigmented matches shot at the glass. For both artists this was yet another unorthodox mode of applying paint, this time from a position that denied physical contact with the painting.

Coathanger and Spoon seems far less complex. Essentially, this print compares three linear spaces (gray "shadow," bent coathanger, and twisted wire and spoon) with three tonal spaces (black, green, and gray). The gray shadow (in the painting it is also a cast shadow[29]) and the drips of paint are ephemeral or accidental marks. Like the suspended spoon, they are also elements of frozen movement. A similar concern for readings in and out of the picture space are produced by the enigmatic inverted chair and leg cast of *Leg and Chair*. Again, one might ask whether the linear drawing is not just as "real"—at least in how it affects our readings of space and objects—as the photoplate of the cast. After all, the linear chair has also "acted" to divert the dripping gray paint, and is as much a part of the concept of "being seated" as the photographed cast. And is not the cast itself—though necessarily rendered photographically—only an illusion, a symbol, or a kind of memory of something else?

Although this motif has appeared in *Watchman* and has been discussed by this writer and others[30], and although I hold firm to the notion that there are meanings that hold for the artist that are not available to the viewer, my present position must settle for a reading that makes sense in the terms of the other elements of the painting and lithograph.[31] In *Leg and Chair* it is the inside of the "cast" that the spectator sees—a negative space rather than a positive form. Like the drawn chair, we take the image at Johns' word, that is, as a leg and not as a special kind of memory impression of

16

141. Bent Stencil, 1971

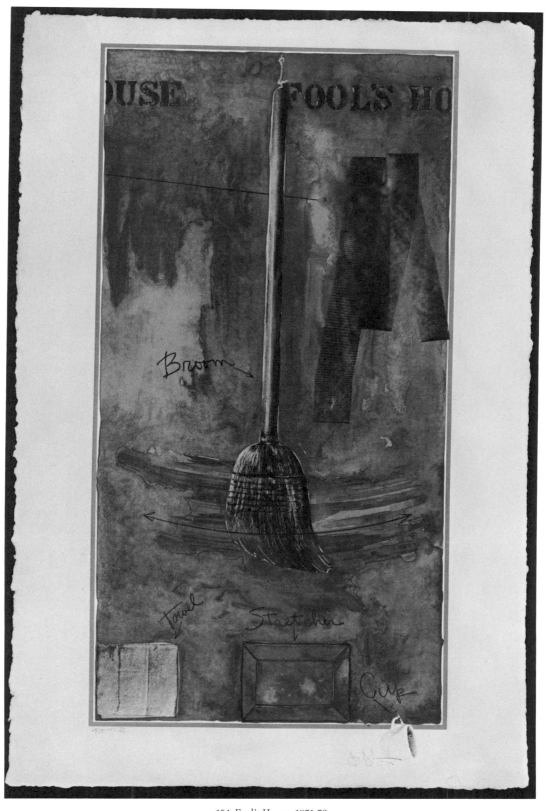

154. Fool's House, 1971-72

some past event. Seen both positively and negatively[32] it partakes of that spectrum of inside and outside actions of which *According to What* is made.

All of the events of these *Fragments* may be regarded as continuing Johns' fascination with the territory that separates fact from illusion. In these works, the artist focused on implied movement, especially those toward and away from the canvas. That many of these events occupy the space of our minds more than the depicted space of the works of art, is just Johns' point. In squeezing us into this position of uncertainty, he not only plays with paint-applying methods (literally in the painting, illusionistically in the lithographs), but he begins to question the nature of objects, of illusions of objects, diagrams of objects, of actions of objects, and even of words as objects. In the end, what he implies is that the only thing one can point to is the specific function or use that an object has in a given context. In art, the context of meaning is the work of art itself.

In 1969, two years before these works, Johns talked about printmaking

> ...in terms of discrete operations and discrete objects...this whole idea that anything can be one thing is an idea that interests me. I like the idea of taking these discrete operations and using them in such a way that doubt is cast upon them, and one is not sure what to regard as a discrete thing.[33]

Fragments reflected this attitude in several ways. First of all, they are fragments of a whole, and thus cut off and isolated even more than the events of the painting. Second, many of the depicted or implied events can be associated with specific, discrete printing elements. Third, the conviction or veracity of these functions is achieved by the most perfect execution of the limited range of printmaking techniques; the near metallic gray blends (ap-

pearing in six lithographs), the sensuous and spatially ambiguous washes (all six), the flat tones (all six), the passages of conceptual, linear drawing (all six), the spectrum line that indicates a spatial axis (three works), and the addition of discrete bits of photographic information (three works).[34]

A normal description of the depicted functions, couched in the language of past experience, might well give us what Ludwig Wittgenstein called a "mental cramp." These works are illustrations of Wittgenstein's notion of the difference between what can be said and what can be shown.[35] They distinguish what our critical language is logically suited to describe from that to which it can only allude. The various situations and functions of the depicted objects can be adequately described in words only when those words refer to the images, i.e., to these prints. Our language allows us to say that one can "bend colors," but not to mean it. Colors do not bend. But the painting and the print employ other types of language in which "bent blue" is a grammatical and meaningful phrase.[36] It may not refer to situations beyond those depicted, but we are able to decipher some of the logic which informs it through an analysis of how it was made. Johns confirmed this type of analysis when he told John Coplans:

> The painting was made up of different ways of doing things, different ways of applying paint, so that the language becomes somewhat unclear. If you do everything from one position, with consistency, then everything can be referred to that. You understand the deviation from the point to which everything refers. But if you don't have a point to which these things refer, then you get a different situation, which is unclear. That was my idea.[37]

The constant shifts in our seeing and understanding of the events of these lithographs derive not only from the painted version of *According to What*, but emerge directly from the

different types of printing elements that Johns has juxtaposed.[38] There are few works that achieve such a complex and high order of integration of image, style, and technique.

The parsing out of modes of representation that characterize the *Fragments* is discarded in the more integrated and reproductive *Good Time Charley* series of 1971-72. These lithographs lack the schematic contrast and the abstractness of the *Fragments*; they are integrated, framed, and margined images. The most salient feature is the tan border which surrounds each—a direct allusion to the wooden framing strips that Johns attached to the stretchers of the original paintings. It is not so very difficult to decide just how much one is looking through these images at the paintings; they are filled with subtle indications of having been drawn rather than reproduced. Nonetheless, Johns has formularized his approach to the set of eight lithographs to such an extent that the uniformity of language suggests a reproductive cycle. Over and beyond the illusionistic marks, their consistency breeds careless observation, and familiarity lulls the viewer into overlooking the surface texture that betrays the medium.

What are the constant elements of the *Good Time Charley* series? Each of the eight lithographs is framed by a perfectly flat, tan border that refers to (but does not reproduce) the framing strip. Each print is unified by a flat toneplate that underlies most or all of the image. Each work was printed from at least one stone that carries a consistently reticulated wash, and in some cases, broad crayon strokes. Seven of the eight lithographs are enhanced with small passages of local color, each containing important passages of crayon drawing and lettering. All are adorned with devices that imply movement or with objects that seem to protrude from the represented surface. In *Good Time Charley, Fool's House,*

Souvenir, *"M"*, and *Evion* these objects are enhanced by halftone photoplates made from the paintings which served as models for the prints. What is striking about these prints is their high order of integration. After twelve years of making lithographs, Johns had reached a point of exceptional ability to anticipate how separate elements would combine. I can think of no series of lithographs that achieves such a consistently even level of suspended reproductiveness. Their surfaces are modulated by a range of subdued color that adds depth and relief to the exact same degree that the photographic plates, bits of texture, and drawn devices impart a sense of illusion. The failure of the first version of *Good Time Charley* (F.147) to achieve the precise "distance" Johns required, probably accounts for its having been redone. The heavy marks of its fifth and sixth elements were so strong, that there was no way the viewer's attention could escape the literal surface of the print.

The prints of the *Good Time Charley* series are based on the relatively quiescent works that fall between the painterly *False Start* canvases and the diverse summations that appeared in *Diver*, *According to What*, and *Eddingsville*, i.e., works executed between 1961 and 1965. Rather than inventory classes of image-making, the *Good Time Charley* prototypes are concerned with a slightly earlier phase of Johns' thinking—a lesser degree of pictorial activity and a growing interest in objects. Many of the lithographs depict the devices that altered the surface of the paintings and reproduce the literal objects that were attached to, hanging from, or even suspended over that surface. It is the presence of the highly illusionistic cups, broom, board, coat hanger, hinged canvas, etc., and the insistence on the effects of past actions (rather than the potentials for motion found in the *Fragments*), and the fact, easily overlooked, that the entire

surface of the image is evenly printed, that raises the possibility that one is looking through the image at an actual situation.

The objects suggest personal use and associations. Most notable is *Evion* with its disquieting skull, garbage barrel cover, and bent coat hanger—all somehow linked to Johns' personal associations with a fairly seedy bar in Tokyo.[39] *Fool's House,* on the other hand, with its patently ostensive redundancy (the naming of an object by pointing to it with written words and arrows), may recall a visitor's exasperated remark that any fool would know that these objects were brooms, cups, towels, etc.[40] *Zone,* is a literal reference to the first painting in which Johns juxtaposed passages of both encaustic and oil in the same work. In the print, the cup and paint brush ironically have retreated to mere shadows, negative shapes without substance. *Good Time Charley* received its title from the inscription found on the silvered drinking cup Johns had attached to the ruler-device…implications of content that are not consonant with the painting and unknowable to the viewer. The same suspended interpretation informs "M" which may be yet another reference to Duchamp's *Tu m'* or even to Marcel,[41] and *Viola* with its inexplicable associations with Viola Farber, the dancer. *Souvenir,* on the other hand, is the leitmotif of the entire set. Its broadly brushed emptiness is both a denial and an invitation just as the artist may be regarded as looking within and making contact with the viewer.[42] Taken as a whole these prints have a kind of resistant passivity that seems to lie and wait for a never to be made interpretation.

In his review of my first catalogue, Joseph Young took me to task for being overly interpretive.[43] He argued then that Johns was a literalist, although subsequently Young has agreed that the meaning of any work must reside in more than a passive description of

process and technique. But once one enters into a dialogue with the work, is it enough to claim that there is a totally objective way to describe what one sees? The images of *Watchman* and *Souvenir* refer to the problem of verbal description of visual (artistic) events. In fact, all of Johns' work concerns description of one thing in terms of another for both artist and observer. How does one's storehouse of images and experiences filter, shape, and associate to the present experiences of seeing? Johns places an enormous burden on the observer by demanding that he be critical of his own responses and associations. But where shall we set limits on personal associations— are only those (often unknown) memories of the artist valid? For many this issue sounds the alarm for a retreat to formalistic analysis that limits description of objects to pictorial or optical events occurring in the context of the picture frame. But I would rather think that there is a range of acceptable content, that within that range there are some solutions that are better than others, and that these can be detected because they find echoes from other levels of meaning within the work of art. I also believe that Johns wants us to struggle with the situation and to cling to uncertainty as if it were content itself.[44]

Ever since *False Start II* of 1962 (F.11), Johns has sapped the color from his prints with monochromatic versions. It is tempting to regard this reduction as an anticipation of black and white reproduction, the form in which many of his prints are necessarily experienced. Certainly the *Good Time Charley* series has already been linked with the idea of reproduction. But that notion omits consideration of Johns' subtle choice of grays, just as it overlooks the resulting phenomena of reversal, condensation, compression, and emotional withdrawal. I think one has to accept that all possibilities are operative. Ironically,

21

the black and grays lower the sense of illusion; the images are more somber, feel more closely bound to the paper, and exhibit a heightening of their autographic character. There are many who prefer the monochromatic prints, and not merely because the print connoisseur has an historical bias toward black and white. Rather, these versions simply seem more honest. The structure seems to reside more on the paper than in the trickier and less verbal, less logical elements of color that float both in space and in the less accessible reaches of the mind. Perhaps the two-dimensional, black and white print is really closer to the way we conceive of the world, and more nearly analogous to the memory images by which we go about testing that world.

Casts from Untitled (F.177-190, 1973-74) very specifically allude to structure and change. Executed during the course of work on the much more elaborate project, *Four Panels from Untitled, 1972,* they represent a studied transition from the gentle illusionism of the *Good Time Charley* series to the varied illusionism of the *Four Panels.* I admit to feeling pressured to interpret Johns' body-parts imagery in a more humanist context than previously, but not to the point of regarding them as pathetic symbols of modern dissociation, isolation, and fragmentation.[45] The *Good Time Charley* images imply autobiography because Johns chose their contents and supplied their titles. Potentially, at least, their meanings are accessible to the viewer. These versions of the casts, on the other hand, are clearly single events whose significance is more formal and epistemological than psychological. I will first try to describe some fairly objective organizing principles.

First of all, these seven images (and their black counterparts) are executed in a completely identical manner, more so than even the *Good Time Charley* lithographs. Each begins with a stone-based wash that carries some kind of relatively diffuse image data. There follows a tone plate—a slightly lighter, totally flat, transparent layer of ink of the same hue. Last, comes a precisely defined drawing containing much more specific data about the same image; this is printed in white.

Second, it will be noted that these prints carry numbers from one to seven. The colors are also ordered but not quite as the seven hues of the spectrum. They are red, yellow, and blue, followed by the mixtures, orange, green, and purple, and their subtractive sum, black. They bear a logical relation to the numbered slats of the original cast panel of the painting, *Untitled 1972.* Johns found that such a fragile piece could not be transported without being torn down. Accordingly he coded the order in which the slats were to be assembled, a code that was both numerical and visual (i.e., the colors). Johns has thereby neatly downplayed the issue of choice or artistic intention. Yet the variety of determining factors illustrates the principle of overdetermination that plays such an important role in his work.

Anyone familiar with Johns' prints would recognize in the *Casts* the same kind of color progression he employed in the Gemini lithographic *Numerals* of 1967-69 (F.104-113). In 1970 I wrote that the addition of color to the black and white *Numerals* (F.94-103) imparted an unexpected and uncanny spatial dimension, one that further complicated the idea of "pointing to" a number.[46] In *Casts from Untitled* Johns is again concerned with the spatial quality of color, but now specifically in conjunction with a very neatly dissected aspect of plastic experience. As the technical description has implied, the lithographs evoke a specialized and limited kind of replication, one that is produced by the interaction of a stylized line and the amorphous color washes be-

neath. Together, and only together, they give rise to a more powerful illusion than either would alone. Yet each may be sensed separately like the numerals in the many versions of *O through 9*. The counterpoint between color and line may be regarded as metaphor for both the hallowed antinomies of art history and for the interaction of sense and idea. Although hardly a novel concept, Johns has found a purely graphic equivalent for his ideas about the beholder's share of seeing. The spectator's intentions like those of the artist's, are sandwiched between aspects of what is actually present, that is, between the layers of wash and line. Even less accessible to critical description, however, is the effect of a specific color on the perception of a particular body-part. Laying aside emotional associations, the least one can observe is a modulation of plastic existence by the aggressive/recessive characteristic of each hue. The black versions make this aspect obvious by their effective cancellation of the entire modality of seeing.

If what we perceive reflects a dialogue between what we know and what is given, then Johns has also counted on our prior knowledge of the casts, knowledge gained through our experiences of Johns' other works. The constituent chain of perceptual events recalls the objects of *Untitled, 1972*. These are real three-dimensional casts, but like their lithographic counterparts, they also are fragmentary replications taken from real life.[47] In summation, these lithographs are the end of a long chain of analytical replication. They continue Johns' experiments with transparency and reproduction so neatly posed by the *Good Time Charley* prints. Yet one might question how intensely our attention is sustained by all fourteen of these prints; it is only by looking at them in a very special way that they may be appreciated. Realizing that many observers balk at the prospect of integrating such a cool

analysis with their visual experiences, I can only maintain that, in the end, Johnsian seeing offers one of those rare opportunities to consider art itself as a probe of man's nature. That one sees with language is a notion apprehended only by the imagination; it can't really be asserted, it can only be pointed to.

When Johns exhibited *Untitled, 1972* at the Whitney Annual in the spring of 1973, critical commentary was reduced to one voice, that of Thomas Hess.[48] So refractive were these panels that Hess could do little more than describe their media and their motifs, the point at which I, too, shall begin. The two left-hand panels are painted in oils, the two right in wax encaustic. Mounted on the fourth panel are seven boards, numbered, labeled R and L, and color coded. Each board bears a wax (not plaster or rubber) cast of a body part. Panel A (the prints, *Four Panels from Untitled, 1972*, are called A/D, B/D, C/D, and D/D) was executed in the now familiar hatchings; Hess called them stripes and they reminded him of discs or parquetry. Panels B and C carried images of the "flagstones" familiar from several works of the later 1960s, like *Harlem Light, 1967*. The casts of panel D, though not repeating any earlier work, were described as "bits and pieces of four or five friends." Hess sensed a principle of confrontation and narration in this polyptych form, which had been employed by several artists in the Whitney exhibition. In Johns' case, the panels were threaded with autobiographical details:

> And into this metaphorical scaffolding, Johns has slotted autobiographical elements—analyses of his studio practices, glimpses of Harlem and of Long Island that have haunted him, bits and pieces of four or five friends. He seems concerned with preserving memories and re-evoking lost experience.[49]

Hess was uncannily astute in delving for literary content. He actually opened the way for an

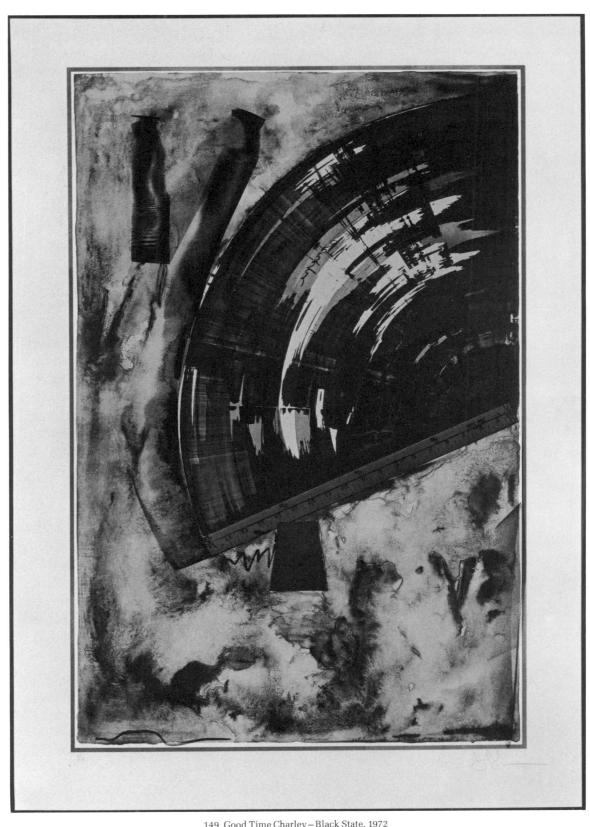

149. Good Time Charley – Black State, 1972

24

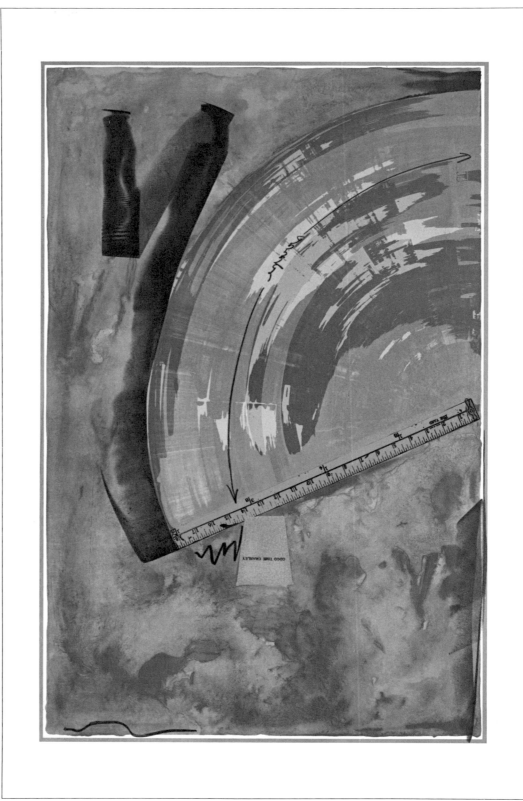

148. Good Time Charley, 1971-72

analysis of the more formal and conceptual events. Earlier, I maintain that many of Johns' images are fragments lifted out of his own life. Here again are the casts that inevitably fuse memories to painting; here again are the flagstones from a wall glimpsed in Harlem; and, though less well-known, here are the hatchings that were an epiphany of a summer's drive on Long Island, a memory snatched from the decorative painting of an on-coming car.[50] But in each case one has to inquire about the meaning of such memories, speculation not readily undertaken by the art historian. These meanings certainly derive from contextual associations and deeper memories, but another aspect must be bound up in their tactile and motional, rather than emotional, aspects. For Johns, thoughts, ideas, and memories are frequently associated with feelings about spatial relationships or concrete objects; they have a physicality that most of us do not consciously experience. In my 1970 remarks about the maps and numbers, I tried to suggest that these types of images are not simply concepts made visible, but concepts based in tactility, or even in primitive experience in the psychoanalytic sense of the word.

Yet another level of memory resides in *Untitled*, 1972, one that is a function of the retrospective nature of the four panels. Each one looks to a different part of Johns' artistic life. Most obvious are the references of the flagstones to the period of openness and experimentation from 1963 until 1972. When the panels are viewed in their normal order, they are enclosed in parenthetical allusions to the past and future.[51] The casts recall the earliest targets of 1955, while the hatchings not only look back to the flags but ahead to a future stylistic departure. The memories of events and styles provide a set with which these panels must be approached. Their almost intractable separateness can only be resolved through

powerful mental efforts by the viewer. To cling to the artistic surface is to come away empty-handed.

It may be argued that the difficulties presented by the painting pressured Johns into making *Untitled*, 1972 all over again. In 1973 he began the set of four lithographs at Gemini. What he has changed – added and subtracted – helps to clarify his central preoccupations. The visual disjunctiveness of *Four Panels from Untitled, 1972* would seem to have militated against the unified approach found in previous series of prints. Yet, each partakes of a very similar process of fabrication that can be broken down into five basic components. First, Johns provided each with an underlying structure that is quite hidden from the viewer: A/D, brush strokes of primary colors (elements 1-4); B/D and C/D, a complex structure of bold drawing in tusche printed in whites (elements 1-5); and D/D, brushed and ruled areas of white, pink, and beige that create a relatively geometric matrix for the casts (elements 1-4).

The second and third steps focus on basic image-making components that complete the essential fabric of color: A/D, dense brush strokes in secondary colors (orange, green, and purple), and a layer of white for the surrounds; then lighter additions of crayoned secondaries, and another level of white (elements 6-13); B/D, black and red stones, a further printing of the white drawing, and transparent black and reds (elements 6-10); C/D, an opaque red and black, a transparent red and black, and then a layer of white that covers more of the color than had the corresponding white printing of the previous panel (elements 6-10); D/D, a spatter pink layer with much drawing and relief, then the crucial illusionistic elements – the photoplate of the casts and the brown drawing plate for the grain of the wooden boards (elements 5-7).

The fourth stage of work adds accents of local color, many of which refer to adjacent panels. But it is Johns' fifth step, the addition of embossing to each lithograph, that so radically separates these from earlier prints and departs entirely from the painting. Each embossment is a blind, inkless image of the previous panel. That is, the hatchings of panel A/D are embossed into the paper of panel B/D, etc. Although very few observers can consciously imprint their visual memories so as to effect a transfer of an experience from one field to another, this kind of thinking was implicit in much of Johns' past work.[52] Most notable is the green, black, and orange "complementary" *Flags* where the colors of the upper flags seem to transfer themselves to a lower, neutral receptor-flag which then appears red, white, and blue. The meaning of that painting or print, however, should not be restricted to a particular use, but should be taken as a more general proposal that one structure can be seen in terms of another. In a more sophisticated manner, the same concern informs both versions of *Untitled*, 1972. In addition to the embossings, the two flagstone panels (B/D and C/D) are clearly related since the pattern of B/D is shifted to the right in C/D . Even the transparent gray in the lower center of C/D can be detected just appearing at the lower left of B/D.

Can the other panels be regarded in a similar manner, one that does not search for meaning outside of visual events? The hatched panel (A/D) is, of course, reminiscent of the flags of the past; but here an almost stolid application of paint results surprisingly in lively tensions between color areas, reversing the mechanism of older works in which the fluency of the brush served only the most mundane of patterns. Not only do the hatchings read as a pattern of color zones, but they also embody a different order of space than that of the flags or the flagstones. The nature of this new space is tentative. It is generated by the loose color patterns of the hatchings which impart a weaving motion to the picture surface. Perhaps it is for this reason that Johns and his other critics have always insisted that the paintings be described as containing crosshatching, although, for a print connoisseur, this would hardly be an appropriate terminology. Nevertheless, the spatial events are dampened by the pedestrian character of the hatchings. Together, color and weave do generate pictorial activity that bears a surprising resemblance to those of the flagstones and the casts.

By comparison, the image of panel B/D is flatter and considerably less painterly. In the second flagstone panel (C/D) almost all pictorial activity has been dampened to the point of partial transparency. The careful observer of the lithographs will notice that even the white printings of B/D are modulated into broader and more transparent swatches than in C/D. This simultaneous diminution of spatial and pictorial activity is echoed in the sequence of embossings. Whereas the embossings of the first three panels impressed the design of the foregoing panel *into* the paper, it is only in the fourth panel (D/D) that the embossing is in relief. I feel that it is no accident that it occurs on the most active image, that bearing the highest degree of illusion. If the casts rudely controvert the expectation of plastic abatement experienced as the eye travels from left to right, from A to C, they also represent a beginning. For panel A/D may be read as a logical continuation of D/D since the pattern of hatchings reflects the scale, fragmentation, and relief presented by the casts.[53] This notion of sequential circularity is hardly new to Johns who expressed it most concretely in the lithographic sets of numbers, 0-9 of 1960-63 (F.17-46).

In the painting, the high relief of the casts and

slats is actual, while in the lithograph it is illusionistic, set up by the photoscreen and a most artful use of the brush. Everything is informed with spatial ideas—the wooden boards pass over and under each other; they are also marked with orienting letters 'R' and 'L', with sequencing numerals, and with the "rotating" color scheme already described. Still, the body casts themselves cannot be reconstituted, like a picture puzzle, into a meaningful whole. Nor should they be viewed as parts of any one person. They must be seen as visual events, as patterns disposed on the field of the painting or lithograph much like the flagstones or the color hatchings. In the print, the compression of illusion and the imposition of the embossed design from panel C/D almost force this reading. But this pictorial reading is insufficient, for casts are three-dimensional events of a high order of complexity. They not only replicate the outer surface of the body, but they also imply a hollow inner space and its opposite, the mass of the body known from experience. Again one uncovers the same Johnsian obsession with outside and inside. As in *Bent Blue,* from *Fragments-According to What,* the roles of objects are logical and acceptable only in the context of the painting itself. Nevertheless, something of their meaning also derives from habits of mind brought to the work by the observer. The experience of panel D/D is determined, therefore, by a kind of mnemonic pyramid. First, by its own order, then through the micro-languages established by all other panels working in concert, third, by a limited group of associations derived from past experience of Johns' oeuvre, and finally, from the visual and tactile experiences of our own lives. Against these meanings the associations of both artist and observer must be evaluated. To seek interpretations that are not subsumed by the visual events themselves is to desire literature, not painting.

The problems of inside and outside, of "taking impressions," of transferring imagery, of hidden structure, of the literal transfer of the blind image of one panel to another by means of embossing, of appeal to the sense of touch and motion—all these are linked together in *Four Panels from Untitled, 1972* which, after all, is itself a memory of the painting that has already been described as a repository of Johns' past. The lithographs leave behind the remnants of transparency that occurred in earlier series in order to achieve an unprecedented integration of means.[54] Meaning is stealthily enfolded within the various layers of the process as well as in the horizontal flow from one panel to the next. Sequences from abstraction to reality, from flatness to illusion of depth and projection, from handwriting to photograph, set up comparative situations. The questions posed by the casts interrogate the entire work; how much experience can be retained? What does one regard as being outside and objective? What aspects of perception are determined by memory? What mediates our inner and outer worlds? Insofar as this is the meaning of consciousness (of ego function) Johns' painting becomes an intense ethical microcosm. In some senses it is a matter of accuracy.[55] It is a matter of what we can say about our perceptions, of what has been given and what has been denied by the artist, of what we may impute to his intentionality, and finally, of what degree of elaboration the work allows to the observer. I believe that the best criticism of Johns' work has been able to trace many common concerns not only on a horizontal, chronological track, but also on a vertical, in-depth analysis that peels away the levels of meaning. These concerns often appear dissimilar but may be shown to be reflections of the same informing intelligence.

In his obsessional repetitions, Johns is generous; but, in the realm of personal associations

he provides little more than hints of how much is being withheld. It is up to the observer to determine meanings. It is this viewer's conviction that what can be talked about resides in the kind of overdetermined analysis we have directed at the *Four Panels from Untitled, 1972.* What can be sensed about the psychologically primitive aspect of Johns' perceptions and associations cannot be elaborated. What can be decided about his mechanisms, devices, and habits, on the other hand, may very well be subjected to interpretation. But this process risks a tautological system of criticism—for the mechanisms detected and developed from one level of analysis are then used to probe and explore another aspect. Yet this risk of self-fulfilling criticism is implicit in Johns' work. Like the very panels under discussion, the sequence of intellectual events is circular and self-reinforcing, almost a symbolic narcissism. There are many of us who are captivated by the dissection of these Johnsian palimpsests of meaning, especially when the progressive enrichening is experienced as the result of relatively honest, objective, but imaginative description. The most difficult problem is really one of sufficiency. How far must the observer accommodate Johns' denials? At what point do the disassociated and attenuated levels of meaning become impossible to integrate with the simple, pleasurable visual experiences? Are Johns' demands on the viewer a testing of the limits of the critical mentality, or are they in fact an eruption of hostility towards the observer?

In 1975 Johns decided to recast *Four Panels* in grays and black (F.198-201). Both space and illusion are modulated downward while drawing assumes a more dominant role. What had appeared white in A/D, B/D, and C/D is now deep gray; what was at best a shadowy understructure that functioned more as texture than as perceived gesture, suddenly assumes a bold, autographic character. What had been a soft, smooth, light gray paper has been supplanted by a medium gray paper of considerable granular texture. What had been thrown into relief by the superimposed embossing has now been noticeably muted by the unmodulated printing of a tone plate of flat, gray ink over the central area of each panel. Each decision achieved a further compression and abstraction. In the entire range of Johns' prints, no transformation (not even the virtual collapse of aggressive structure in the gray, screenprinted *Flags II, 1973,* F.174) is so radical, so successful in recalling lost structures while suppressing others. The absence of both color and embossing may be interpreted as a signal for the shift of attention away from depth. No longer is each panel so isolated, so dependent upon memory images. By printing fragments of adjacent panels (some transferred, some redrawn) on the side margins of each print, and by allowing these fragments to bleed off the highly irregular edges, the horizontal sequencing is emphasized.

Johns has also altered the terms of the horizontal readings. Whereas the color versions of panels A/D and D/D possessed considerable spatial complexity, the gray and black panels are almost anti-illusionistic. They no longer participate in the progressive dampening of space that one experienced while traversing the four color panels. The hatchings of panel A/D are not only deprived of the sharp differentiation provided by color, but also the sense of hidden work underneath (i.e., the hatchings in primary colors) has totally disappeared. Instead, the grays and black create a very restricted chiaroscuro whose three-dimensionality is scarcely more than that of a pattern of ripples on a watery surface. The halftone casts of D/D are similarly denied their relief function and are allied with the grain of

the gray inks and the fibrous paper. As if this optical flattening were insufficient, the addition of stenciled lettering further limits the space inhabited by the boards and casts.[56] Nonetheless, the four panels in grays and black are not repressive denials of picture-making activity; what has been repressed has managed to release the bold sense of shape and line that was only latent in the color versions. The slightly aseptic quality of the color panels is reversed by the coarse drawing, by the granular textures, and the emphatic progression of shapes across the four black and gray lithographs.

The grays also serve to heighten another structural feature, the seam that appears in B/D and divides the flagstones into two kinds of textural areas. This, like the hatchings, will also appear in later works. Its function, however, is twofold. From the vantage of process, it represents a literal transfer from part of C/D. From the vantage of the observer it is ambiguous. He no longer is certain whether he is observing the movement of his own attention from panel to panel, left to right, or whether he is detecting a movement of the framing margins from right to left. The ambiguity heightens the new emphasis on horizontality, an emphasis developed in many of the subsequent hatched paintings and prints.

The same need to emphasize the activity of his hand also informed Johns' four *Ale Can* lithographs of 1975 (F. 202-205), executed at the same time as *Four Panels from Untitled, 1972* (Black and Grays). In these, Johns wielded his brush with unusual freedom, evoking four different materializations of the famous *Painted Bronze* of 1960. Like the *Four Panels,* these modest *Ale Cans* do not isolate a single visual language, but utilize several to modulate the sense of relief, materiality, and detail. In a very tangible fashion, they have the same kind of cyclical progression as do the panels. But they

should also be compared with *Casts* of 1973-74. The *Casts,* too, possess a cyclical structure and study a problem deductively derived from the major work then under way. Each set probably serves to dispel some of the tensions accumulated while working with the more disciplined and controlled languages of the larger pieces—the release being similar to that provided by the free-wheeling gesturalism of the two-color, screenprinted *Target* of 1974 which was executed during the making of the complex and not-so-spontaneous color *Target* (F.191 and 192).

Because Johns has worked in terms of the controlled orchestrations demanded by serials or series, many of his Gemini prints lack the softness and seeming individuality associated with prints produced on the East Coast at Tatyana Grosman's. The Gemini prints are ambitious conceptually, but are sometimes tinged with a slight dryness. Perhaps this is caused by the precise control of ink deposit demanded by a series of prints, or perhaps it is an adjustment made by the artist in accordance with his preconscious image of the final work. On the other hand, the inexorable working out of a highly intellectual solution in *6 Lithographs (after 'Untitled 1975'),* 1976, actually tends to draw one's attention away from the sensuous qualities of the prints—from the watery, almost cellular remains that float among the more regularized hatching. In other words, I would caution those who would make quality judgments about the character of a publisher's production before they consider the numerous variables and intentions involved in a particular project.

The three years separating *Four Panels from Untitled 1972* and *6 Lithographs (after 'Untitled 1975'),* produced many elaborations of the new hatching motif, including three versions of *Corpse and Mirror, Scent,* and the many

etchings for Beckett's *Fizzles*. Unlike the monolithic panel A/D, these prints dealt more and more with the junctures between sections of hatching. Most of these seams reflected the structures of the paintings that had served as their models. For example, the vertical division of the painting, *Corpse and Mirror II*, was translated in the screenprint (F.211) by printing the right and left halves separately. Additional varnish and white screens were printed on the right half to emulate the differences between the oil and encaustic surfaces of the painting. The horizontal seams were fashioned by a combination of outright ruled lines and refracted or discontinuous hatchings. In *Scent* and *Untitled I* (F.208 & 213) the seams became more complex. Aside from the basic vertical divisions (established in *Scent* by the abuttings of three different printing media), there are far more subtle vertical demarcations, first observed in the paintings by Tom Hess.[57] These implied seams result from traces of systematic breaks in the patterns, colors, and brush strokes, and function like a reversible Necker cube, for they are perceived only by an effort of focus, and are then, almost instantly, lost. It is possible, then, to point to different orders of plan or division, each of which has its own optical modality.

What has not been discussed is the intense, if constricted, spatial life of these seams. Only along the junctures are the refracted and mirrored hatchings able to suggest a distinct recession. The space in these areas seems to bend or to be enfolded into the picture surface itself, although it is immediately countered by the relative flatness of the overall design pattern and the literal flatness of every single brush stroke. If the handling of the early flags denied space to an otherwise brushy activity (there was the literal space of the submerged layers of collage), the hatched images forced spatial readings on an otherwise totally flat

and virtually deadpan brush stroke. In some very arcane sense, Johns momentarily evokes the barely articulated forms of much painting and sculpture of the early 1970s, from the abstract illusionism of a Ron Davis to the laconic and attenuated figuration of an Alex Katz. Thus the spatial innuendos emerge despite the literal activities which were all dedicated to preserving the flatness of the support.

6 Lithographs (after 'Untitled, 1975') may well be regarded as a picture of a mental system, as Barbara Rose has suggested.[58] It is also an explicit display of how to make a work of art. In its steps, the series recapitulates the passage from panel A/D to #6. Although derived from the painting, *Untitled 1975*, the first lithograph, #1, is an undifferentiated hatched surface that very much recalls A/D in structure and proportions (except that primary colors are substituted for the secondaries of A/D). At first, the process from #1 to #6 seems overlabored, but it is both systematic and a demonstration of logical necessity. Briefly, the development may be divided into three steps. #1 is the undifferentiated hatching from which Johns has extracted three squares developed in lithographs #2 and #3. The second step, represented by lithos #4 and #5, compares the three squares just developed. In other words, #2 and #3 develop rules for horizontal development. At the top, the vertical juncture is a mirror image, in the middle the strokes are refracted (bent) as they cross the boundaries; and in the lower squares, the brushstrokes continue across the boundary with only the interruption imposed by the gray line. Lithographs #4 and #5 make explicit the rules for vertical development. #4 compares the bottom and center right squares revealing a discontinuity at the seam; although the direction of the brush strokes are maintained, the physical break is heightened by a change in color. #5 compares the top and

center right squares, showing strokes that barely abut, changing both direction and color.

The third stage assembled the entire image; the left two-thirds was taken over unchanged from #1, while the right-hand squares were printed from plates derived from cutting apart the corresponding parts of #4 and #5 (see the documentation in the catalogue). The seams created by the repeated printing of the physically separated plates are slightly more pronounced than those of the prior four prints, a separation that is emphasized by the additions of white and varying layers of varnish to the right-hand squares. The completed lithograph, #6, embodies subtle spatial/optical distinctions arising out of publically demonstrated rules. The right-hand squares have "grown" out of the right edge of #1 (the upper right square mirrors an entire section of #1), though they are each distinguished by varying degrees of continuity. All three are varnished but lack the underlying orange, green, and violet of the left-hand squares. They break another minor rule in that the extreme top and bottom edges do not mirror each other as they do in the left-hand two thirds. There, an equal number of color brush strokes are made to touch the top and bottom edges.

Barbara Rose has astutely pointed to J.J. Gibson's book, *The Senses Considered as Percep-* *tual Systems*, as a veritable source book for Johns' ideas.[59] Memory is now regarded as a comparative tool with which one detects constant elements in a field of more or less random units. This idea of memory informs the hatched paintings, where it is mapped onto actual abstract systems. But it is also possible to regard the manner in which these units are made to line up and regenerate as an analogue for biological memory, like that encoded in genetic and immunological systems. This all suggests what we already know about Johns, that he views all of art-making as a process of comparison, rather than of invention, as a comparison of fragments of experience, rather than the creation of expressive, emotional events. Memory itself, that arbiter of experience, is held accountable to formal accuracy and is seen as a tool of cognition; only by implication is it considered the repository for past feelings.

In Johns' hands the print has taken on new potentials for exploring mental functions. Each series continued the themes of the painted oeuvre while superimposing new ideas. It is unique to Johns, however, that each succeeding group of prints has provided its own micro-language for this task of continuous revision. No other artist has been so consistently able to modulate the very structure of his media so that every series unmistakably manifests the same keen mind in the act of probing the problems of art and life.

1. The term "printing element" is used throughout this essay and catalogue to indicate a physical surface from which a discrete part of an image was printed.

2. Barbara Rose in "Decoys and Doubles" (B-54), p. 72, uses these terms. I prefer to restrict the idea of replication to something crafted; Johns' sculptures of the late 1950s, for instance, are more replications than reproductions. In the same sense, his mirror or double paintings consist of two parts, one a replication rather than a reproduction of the other.

3. This is the basic contention of Crichton's final essay, "The Function of the Observer" (B-9), in which the links between perception and knowledge are strongly established.

4. Much of what I wrote in 1970 (B-11), relates to the uncertainties experienced by the viewer of Johns' works. This is especially true of prints because how things look can be a very poor indication of how they were made. Crichton, *op. cit.*, p.76, goes so far as to call in Heisenberg's Uncertainty Principle.

5. In his "Sketchbook Notes," Johns wrote: "The spy must remember and must remember himself and his remembering." (See B-11.)

6. The ideas surrounding the words "series" and "serial" are complex. John Coplans (*Serial Imagery*, The Pasadena Art Museum, 1968, p.11) has set forth the ideal conditions for serial imagery in art: "Seriality is identified by a particular inter-relationship, rigorously consistent, of structure and syntax: Serial structures are produced by a single indivisible process that links the internal structure of a work to that of other works within a differentiated whole." Seriality involves the concept of a constant macro-structure within which multiple variations are allowed. Clearly, Johns, with his continuingly metamorphosed and reflexive imagery is *not* a serialist, although the U.L.A.E. and Gemini lithographs of numbers do come very close to fulfilling Coplans' conditions. What Johns' series share with seriality, however, should not be missed. Both offer opportunities for mutual elucidation; both establish contexts for viewing the next element or work; both span time and refer directly back to the spectator's experiences and memories. For some other comments, see B-32; B-54; Mel Bochner, "Serial Art, Systems, Solipsism," in *Minimal Art, A Critical Anthology*, ed. Gregory Battcock, New York, 1968, pp.92-102; and Joseph E. Young, "Serial Prints," *Print Collector's Newsletter*, vol.6, no.4 (September-October 1975), pp.89-93.

7. See, for example, the discussion of Johns' *Ruler* of 1966 (F.56) in B-11.

8. In terms of Pop Art, this duality was often expressed as the opposition between hand and machine.

9. The idea that art is "making"—processing and thinking, as opposed to simply feeling and expressing—has been adduced from Leonardo to Duchamp. Perhaps the best recent statements are in Robert Morris' "Some Notes on the Phenomenology of Making: The Search for the Motivated," *Artforum*, vol.8, no.8 (April 1970), pp.62-66. See also Rosalind Krauss, "Sense and Sensibility," *Artforum*, vol.12, no.3 (November 1973), pp.43-53.

10. Crichton (B-9), especially pp.42 & 47, emphasizes that "creation is only a process," that what counts is the acting out of an idea in relation to some medium that offers resistance and allows chance and unconscious factors to come into play. Johns, of course, has often spoken of doing something, and then doing it again.

11. The figure-ground dichotomy is an image of cognition much as that embodied in the notion of a "figure of speech." See R.L. Gregory, *The Intelligent Eye*, New York, 1971, pp.11-31.

12. See my comments on Johns' seductiveness in B-13.

13. "Most of my thoughts involve impurities...I think it is a form of play, or a form of exercise, and it's in part mental and in part visual (and God knows what that is) but that's one of the things we like about the visual arts. The terms in which we're accustomed to thinking are adulterated or abused. Or, a term that we're not used to using or which we have not used in our experience becomes very clear. Or, what is explicit suddenly isn't. We like the novelty of giving up what we know, and we like the novelty of coming to know something we did not know. Otherwise, we would just hold on to what we have, and that's not very interesting."—Johns quoted in Joseph E. Young, "Jasper Johns: An Appraisal," *Art International*, vol.13, no.7 (September 1969), p.51.

Johns' association with ideas of discontinuity has been most recently set into a philosophical context by Rolf-Dieter Herrmann (B-20).

14. Johns' references to all the senses and their parallel functions have received very little attention; see B-13 and B-34. Remarks on the significance of silverware have been even scarcer (but see Rose, B-53, part II, p.65). The very conceptual etching, *Untitled (Ruler and Fork)* of 1969 (F.123) seems to compare two modes of perception and cognition: one that relies on measuring and thinking (ruler), and another that is more reflexive and habitual, perhaps more traditionally linked to "direct" sensory stimulation (fork). The fork is directly linked to "taking-in" in a very physical way—much as we say one swallows an illusion, i.e., without critical thinking or measuring. "'Looking' is and is not 'eating' and 'being eaten',"wrote Johns in his Sketchbook Notes.

15. Crichton (B-9), p.48.

16. Robert Rauschenberg's prints span a far wider group of interests than do Johns'. They range from the intimate and totally non-image bearing *Bones* and *Unions* of 1975 to the completely imagistic *Currents* of 1970. Like Johns, Rauschenberg tends to work in series, especially at Gemini.

17. The cryptic nature of *According to What* has, in our opinion, been rather exaggerated by Patricia Kaplan (B-34). In a peculiar misinterpretation, she maintains that the coat hanger is suspended from the spoon. She also includes a very liberal dose of the language of hiding, spying, and despairing, and speaks of the "ominous" presence of the "watchman" at the upper left. Even Crichton, who cautions the reader about the present writer's elaborate interpretations of the painting and print, *Watchman* (see B-11), falls into the trap of equating the so-

33

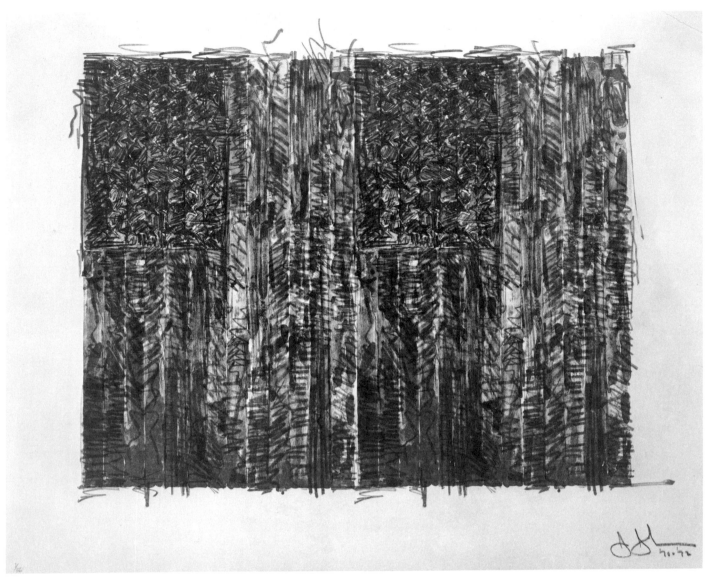

164. Two Flags (Gray), 1970-72

called seated cast with the critic. The problem with Johns is that he capitalizes at every opportunity on our thirst for certainty, for simplicity. He tells us so often that things are impure and complex, but we cannot hear him, any more than did Barbara Rose when (in B-29) she writes that the theme of fragmentation is "a highly charged metaphor for various forms of cultural, social and psychological alienation...." For a critique of Kozloff's use of emotional descriptions see Masheck (B-42).

However much Crichton popularizes 20th century scientific thought in order to bring it to bear on Johns' work, he does make a very convincing effort to probe the artist's mind. His discussion of critical statements on pp.88ff. is very illuminating. It is instructive to compare Crichton's cautious and multiple interpretations of *Diver*, *Land's End* and *Periscope* with the more emotion-laden suggestions of Roberta Bernstein (B-4). Very often the choices we feel compelled to make are better left as co-existent and even mutually exclusive readings that must be experienced and considered by turns.

18. See statements in Young (as cited in note 13), as well as the remarks Johns made to David Sylvester (in B-26).

19. Johns' many forms of denial have been most poignantly explored by Max Kozloff in his brilliant monograph to which I am continually indebted: *Jasper Johns*, New York, 1969. Denial as a philosophical stance is discussed by Herrmann (B-20). Denial as a critical method directed towards contemporary as well as his own art is penetratingly examined by Barbara Rose (B-54).

20. Fried, who borrows the term from Greenberg, really assigns it to the realm of Minimal Art; it describes the special relationship the viewer and a minimal structure are thought to share. See Michael Fried, "Art and Objecthood," reprinted in *Minimal Art, A Critical Anthology, op.cit.*, pp.116-147.

21. See my remarks in B-12.

22. Rose remarked how often Johns studiously avoids committing himself to a prevalent style; his works anticipate and then offer alternatives to the various modalities of contemporary art (see B-54). Johns would never permit himself to adopt wholly the style of color field painting or abstract illusionism.

23. This idea of specificity and precision was first developed by Andrew Forge in "The Emperor's Flag," *The New Statesman*, vol.68, no.1761 (December 11, 1964), pp.938-939.

24. Johns' paintings and prints bestow an object quality on the numerals that confounds their purely conceptual nature. Rose's suggestion (B-53, part I) that the *Numerals* are really equivalents of figures is a bit bizarre (despite the aptness of the pun). Nonetheless, the idea does indicate a way in which one might approach these unexpected particularizations. For a parallel treatment of the relationship between color words and pigments, see Peter Higginson's article (B-24).

25. The printing of blended colors was for several decades an asset of the commercial world, particularly the screenprinting industry. In essence, a palette or fountain is loaded with two or more colors of ink. These are then rolled out by mechanical or hand-powered means so that the blend from one hue to the next is smooth and continuous. At this stage the ink can be used to print a design. The artists who popularized this procedure during the 1960s, Rosenquist and Ruscha, had long experience in the commercial world of image-making. The really smooth, gray blends in the lithographs, *Fragments—According to What*, were anticipated in the painting, *Untitled*, 1964-65 (Crichton plate 125), a work that is devoted to ideas about blends and spatial continuity.

26. One thinks of Richard Hamilton's earnest media comparisons, especially the prints executed between 1967 and 1970. In 1969, Hamilton sent Johns an impression of *The Critic Laughs* (see Richard S. Field, *The Prints of Richard Hamilton*, Middletown, Connecticut, 1973, no.22).

27. In his interview with John Coplans (B-8), Johns spoke about the shadows cast by various objects attached to the painting: "The shadows change according to what happens around the painting....Everything changes according to something, and I tried to make a situation that allows things to change."

28. See B-34 and B-54.

29. Both casts and shadows may be considered types of imprints or memory traces.

30. See discussion in volume I of this catalogue (B-11); in Kozloff, *op.cit.*, p.45, footnote 46; and Crichton, B-11, pp.51-52.

31. Barbara Rose has offered a restricted view of this problem: "Their meanings, if decipherable, lie entirely within the world created on canvas or paper. Within this world, not the identity of the objects, but the nature of their relationships counts." (B-53, part II, p.66.) In the very same article (part II, p.66), however, she abandons this literal point of view and surprisingly claims that "...the pathetic fallacies which abound in the later works perversely mimic types of erotic and emotional encounters...." It is very difficult, indeed, for any writer to adhere to a single critical approach to Johns' work.

32. See R.L. Gregory, *op.cit.*, pp.69 and 128-132, for additional comments on the ambiguity of the outside and inside of casts.

33. Young, *Jasper Johns: An Appraisal, op.cit.*, p.52.

34. In his interview with Coplans (B-8), Johns discusses why he used photographs of the painting while working on the prints. In her essay on the recent *6 Lithographs (after 'Untitled' 1975)*, Rose misconstrues Johns' words to mean that he actually transferred "to the lithographic plate the image of the letter (sic!) BLUE through the mass reproductive medium of photography..." Unfortunately Rose makes constant errors about processes, even when being one of the most imaginative critics in understanding Johns' relationship to them. In the same article she refers to *Study for Skin* "made by transferring charcoal from his own face and hands on to a sheet of paper." In fact, Johns transferred oil from his face to the paper and then rubbed on the charcoal powder. And later, in describing the new lithographs, Rose again misunderstands the exact nature of the process of image-making (see footnote 58, below).

35. On the first page of *The Blue Book*, Ludwig Wittgenstein begins his investigations of the functions of language as follows: "The questions 'What is length?', 'What is meaning?', 'What is the number one?', etc., produce in us a mental cramp. We feel that we can't point to anything in reply to them and yet ought to point to something. (We are

up against one of the great sources of philosophical bewilderment: a substantive makes us look for a thing that corresponds to it.)"....from Ludwig Wittgenstein, *The Blue and Brown Books*, New York, 1965, p.1. Ideas about the general limits of language (or modes of discourse) were developed earlier, in the *Tractatus Logico-Philosophicus* (1921); see David Pears, *Ludwig Wittgenstein*, New York, 1970, pp.29-82. A few critics have grappled with the influence of Wittgenstein's thought on Johns, including Rosalind Krauss ("Jasper Johns", *The Lugano Review*, vol.1, no.2 (1965), pp.84-113; and Peter Higginson (B-24).

36. See Kozloff, op.cit., p.40, who attributes the "false truth value" in many Johnsian works to a tautological functioning rather than to a shift in language games.

37. Coplans (B-8), p.30-31.

38. Spectrum lines do not appear in the painting, *According to What*. They emerge from the many experiments which, during the 1960s, associated a changing sequence of colors with several kinds of spatial events. *Passage II* (1966) literally bends the names of the spectrum colors back into the space of the picture, whereas the panels of *Untitled* (1964-65) suggest that an entire painting may be thought to operate in such a manner. In the exhibition of Johns' prints in Philadelphia in 1970, I managed to hang the Gemini color *Numerals* in a circle so that the progression of colors and numbers would be perceived without beginning or end.

39. Conversation with the artist, May 18, 1977. On the skull as symbol, see Bernstein (B-3), p.144; Field (B-33); and Crichton (B-9), p.69, note 78.

40. Higginson (B-24), p.53-54, objects to the notion of redundancy and claims that the issues raised by Johns' words and arrows are those that appear in Wittgenstein's *Philosophical Investigations* about the nature of pointing and saying. How can one be sure at what aspect one is pointing?

41. The fact that there is a double 'M' here might signify a pun on Duchamp's *Tu m'* (=Two M). Johns' lack of comment—the emptiness of 'M'—parallels John Cage's homage to Duchamp, *Not Wanting To Say Anything About Marcel* (1969). Cage's prints consist of word

and image fragments chosen and arranged with great expenditure of energy according to a complex application of *I Ching* methods of chance.

42. *Souvenir* is a piece about memory (the self-portrait plate is a genuine souvenir) and about looking within. It offers the observer an image of the artist, but at the same time the work of the artist is strangely withheld or occluded. See Field (B-11). A painting related to the *Good Time Charley* series, is *In Memory of My Feelings—Frank O'Hara*, 1961; once again, memory is hardly made visible but it seems to be encoded onto the various textural, spatial, and tactile events of the work itself.

43. See Young (B-61).

44. See note 4. Uncertainty operates with regard to content as well as form. The painting and print *NO* have given rise to several discussions about the nature of multiple meanings and mutually excluding denials (B-11, 20, and Kozloff, *op. cit.*, p.20; etc.). In the painting *NO*, for example, how are we to read the imprint of Duchamp's *Female Fig Leaf*? In the painting, *Souvenir I,* how are we to interpret the hidden 'NO' Johns painted behind the plate?

45. Barbara Rose in B-29, n.p. Johns' continuous use of body-parts is inventoried in Bernstein (B-4) and deftly analyzed in Goldman (B-14), who writes: "Each fragmented piece of the body suggests painful separations between the mind and body, the eye and hand, perception and creation." These ideas are rather in accord with those set forth in footnote 14, above. They tend to establish the focus of Johns' content within the circle of interaction between artist, work, and viewer.

46. B-9. It is now possible to observe that the spatial dimensions of color have been of increasing concern to the artist; see footnotes 25 & 38, above.

47. Since the unveiling of *Untitled*, 1972, virtually every writer has tried to deal with the problems associated with Johns' casts. The cast is a replication, a memory, a transfer, a fragment, a surrogate presence, a physical object that has illusionistic properties (like Richard Hamilton's *Five Tyres Remoulded), and* a pictorial event in the context of a work of art. They are metaphors for the cru-

cial questions of outside and inside, of fact and illusion, of reality and symbol.

48. Hess, B-21.

49. *Loc. cit.*

50. Crichton, B-9, pp.54 & 59.

51. Johns specified that the Gemini lithographs should be kept in proper rotational order: ABCD, BCDA, CDBA, or DABC. These possbilitites are "explored" in the etchings of *Fizzles*.

52. See Kozloff (B-37), pp.22-24 for a reconsideration of matters I discussed in 1970 (B-11). It is clear that the idea of transfer occupied Johns during the late 1950s, as the statement for the Museum of Modern Art (1959) proves (the text appears below in my discussion of *Scent*).

53. In a recent interview with Roberta Olson (B-46, p.25), Johns revealed a good deal about his intentions: "It seemed that the cross-hatchings could be equated with the flagstones. I know that the last section is psychologically loaded, but I wanted to see what would happen if the same artistic attitude was taken toward all of the sections...I think that I did take the same (formal) attitude toward them all. The size of the body fragments are related to the size of the flagstones as well as echoing their placement on the canvas."

An unexpected correspondence between the hatchings and some of M.C. Escher's periodic images suggest itself. Both share a reciprocity of figure-ground/positive-negative relationships that establish a woven, fabric-like space.

54. Complexity in printmaking is a tricky issue. One should avoid being overly impressed by high numbers of printing elements, but should take note of their discrete purposes and degree of integration. The majority of the elements used to print *Decoy* (F.134), for example, are purely additive bits that convey much the same information. Another kind of technical tour-de-force, informs the marvelously complicated screenprints fabricated by Christopher Prater for Eduardo Paolozzi during the mid-1960s. But excellence in registration of a complex image had become the standard by 1970; only works like Richard Estes' *Urban Landscapes* (50-100 screens) seem to achieve that special wedding between means and vision

that transcends mere bravura perform-ance. In his best works, Johns neither sets up a key plate to which he adds, nor simply piles similar elements on top of each other until he is satisfied (even the screenprints are not achieved in this manner—see my essay in B-33). Perhaps the simple illustration on the cover of this catalogue gives an indication of the kind of the languages that are fused in Johns' best prints.

55. See Andrew Forge, *op. cit.* What we can say about a particular work by Johns be-comes an ethical issue because it in-volves self-evaluation. On the opposite side of the picture Johns maintains a parallel sense of responsibility: "One of the crucial problems is the business of 'meaning it.' If you are a painter, mean-ing the paintings you make; if you are

an observer, meaning what you see. It is very difficult for us to mean what we say or do. We would like to, but society makes this very hard for us to succeed in doing." (Johns to Joseph E. Young, "Jasper Johns: An Appraisal," *op. cit.*, p.54.)

56. In this state, Panel D/D approached the *Maps* of the early 1960s. They, too, su-perimposed labels on shapes.

57. See Hess, B-22.

58. Barbara Rose (B-29) incorrectly states that the plates of #1 were cut apart. Only #6 was printed from fragmented and reassembled plates (and only the three right-hand squares at that). For de-tails see the catalogue entries.

59. *Ibid.,* n.p. Gibson claims that all the

senses are organized to detect constants among sensory data. Like Johns, he is anxious to explore the parallels and in-teractions among the sensory modali-ties of perception. Furthermore, Gibson's view of memory may provide some insight into Johnsian memory. Gibson seems less interested in associa-tions between words and sense data than in a precision of attention and rec-ognition. Memory thus becomes a kind of resonance between external and in-ternal orders. My idea that Johns' mem-ories are really not so much associational (verbal) as they are bound to literal facts of perception like mo-tion, texture, weight and shape really is saying that for Johns memory is exter-nalized, that memory is embodied in *things*.

218. Words, 1975-76

II. SINGLE PRINTS/U.L.A.E

Johns' strong commitment to working in sets or series has inevitably been reflected in the reduced number of prints he has executed at Universal Limited Art Editions, in West Islip, Long Island. Three-quarters of Johns' 1960-70 output came from Mrs. Grosman's shop, but in the next seven years only one-ninth of the prints were Long Island-made.[1] Nonetheless, these fifteen lithographs are strongly individualized, and most maintain the tradition of autographic sensuosity associated with Johns' work of the 1960s. A few, however, show something of the intellectualization pursued at Gemini—prints such as *Scott Fagan Record, Decoy, Cups 4 Picasso,* and even *Scent.* During this period Johns was increasingly occupied with the sensuous tactility of other media, the screenprint and the aquatint, each of which was investigated in other workshops. As a consequence, the U.L.A.E. prints of 1970-1977 became individual experiments covering an unusually wide range of interests.

Diversity was the hallmark of Johns' endeavors. Until 1975, work in each medium was relatively isolated, each workshop presenting its own types of skills and working conditions. In *Decoy* there were striking contrasts between reproduced and hand-applied illusionistic passages, while in *Fragments* the wide range between the two was explored, utilizing a far more synthetic and analytic manner. In 1972 and 1973, Universal's *Two Flags (Gray)* probed the optical subtleties of offset lithography while the screenprinted *Flags I,* produced at Simca Print Artists, turned out to be the most painterly version ever. All this diversity changed after the completion of the painting, *Untitled,* 1972. Johns brought his printmaking into the present by immediately setting out to analyze the imagery of *Untitled* 1972. By 1975-76 he was finally able to integrate all the works executed in Paris, Long Island, New York, and Los Angeles.

If Johns' work at U.L.A.E. in the early 1970s seems disjointed, there were, nonetheless, two strategies that established continuity. First of all, it is characteristic of a number of Universal editions that they play a synoptic role. Some seem to be the ultimate statement on a given theme—in purely qualitative terms, the best or the most ambitious print. *Decoy, Scent, Corpse and Mirror,* and *Savarin* all reach positions of singular preeminence among the prints of the 1970s. But there is another, more germane preoccupation with continuity, one that threads its way from 1960 down to the present. Ever since Johns commenced his *0-9* lithographs in 1960 (published in 1963), the idea that some older work should be visible in the new has virtually obsessed him. Nowhere has he acted out this need (or theme) as he has at Tatyana Grosman's. In other prints there are bits of an immediate past buried away, such as the complementary layers in the screenprinted *Flags* and *Target,* or in the many states of most of the etched plates for *Fizzles.* Far more complex are the threads that link certain Universal prints over spans of several years.

Flags II of 1967-70 (F.130) is a most salient embodiment of past and future. It resurrected the stones and plates used in the complementary *Flags* of 1967 (see catalogue entry). Of all the flag prints none possesses the feeling of depth found in this version. The interaction of the levels of drawing is uncanny, reminding one of the still unfathomable *White Flag* painting of 1955. One is never sure of how to reconcile perceived depth of drawing (or pigment) with the received flatness of the image and paper (or canvas). In *Flags II* layers of drawing resonate through the intervening gray-white washes in an apparent play between comple-

mentary images. The black, green, and orange flag is neither completely hidden nor totally transformed: the new, red drawing only partially encroaches on the original green stripes; the added, black shading manages even less and ends by reasserting the black underlying stripes (the gray washes are only a hesitant transition to white); and the applied, blue hatching fails to mask the original, orange ground of the starry field. Thus, by adding to the depth of the print, Johns has altered its functioning as well as the role of the observer. Because the upper flag is in a state of change, the bottom, gray flag is no longer a repository for a transferred, complementary image. Because the bottom flag is overlaid with a new, but loose black structure, its hallucinatory aspect has all but vanished. By permitting the black drawing to overflow the structural boundaries of both flags, Johns coalesces image (line) and field (color). As a result of these changes, the strength of the image no longer arises from an idea but from the sensitively manipulated equilibrium between the becoming and the dematerialization of a vision.

So totally different from *Flags II* is *Scott Fagan Record,* 1970 (F.131), that it forces a revision of what one expects from Johns' U.L.A.E. prints. Its cool, ideational feel anticipated the thinking and technique developed in 1971's *Fragments—According to What.* Johns owned Fagan's "South Atlantic Blues;" in the print it became another of those objects that embody personal associations through the sense of touch. Still it is a strangely cool image whose visual character relates to its other sensual modalities: the grooves are pictures of sound, and the sound implies motion and time. It would not be Johns' first depiction of sound, nor the first time that implied motion had been symbolized by the color spectrum, nor the first instance in which a "found" texture would be compared to the handmade wash drawing (the label).[2] What is so East Coast about *Scott Fagan Record* is its implied intimacy, that is, its continued exploration of objects of known size, touch, use, and structure (flatness). In 1960 the observer could "use" the illusion of a coat hanger to "measure" the indefinite, engulfing space of an abstractly drawn picture. In 1970, the imprint of a similar kind of object, a phonograph record, is made to question its *own* role, since it printed its own image. Our knowledge of the object no longer serves to control pictorial space, but to imply pictorial movement, i.e., the rotation of the record. What becomes increasingly important in Johns' thinking in the 1970s is not how to limit created space, but how to create limited space.

Few prints have been greeted with as much attention as *Decoy* of 1971 (F.134). Not only was it a landmark in the artistic use of offset lithography,[3] but it was also Johns' most complicated print in terms of both printing and imagery. I cannot help being suspicious of such immediate interest, just as I am constantly wary of the thinly disguised disparagement suggested by the title. Although Roberta Bernstein has looked deeply into the sources and structures of this lithograph, no one has seriously asked who is being decoyed, and by what? Ironically, the most interesting answer may develop from Bernstein's idea that the frieze of canceled etchings suggests the predella panels of a Trecento or Quattrocento altarpiece. Normally these narrate incidents from the life of a saint whose patronage coincided with the family, monastery, or order that commissioned the altarpiece. What might be the connection, then, between the central image of *Decoy,* the ale can, and the predella? Could one say that the lithograph is "about" the life of the decoy, that is, of objects in art? How might the predella be read as a

173. Flags I, 1973

174. Flags II, 1973

"life?" Although Johns has emphasized the horizontal continuity of the frieze, the life cycle really exists in depth—in mental and historical space—much the way the space of the main panel quite literally reads and bends into depth. Each object represented in the predella is an everyday thing: flag, flashlight, paintbrushes in Savarin can, numbers, ale cans, and light bulb. But each was remade by Johns in a particularly nuanced modality of replication.[4] These were then photographed and reproduced beside the highly abstracted, conceptualized *1st Etchings*.[5] In their second states, Johns reworked both the etchings and the little halftones. The latter lost some of their illusionistic potential to the quick and often capricious, hand-drawn lines (conversely, the space and surface of the etchings were made increasingly tangible by the addition of aquatint). After the printing of *1st Etchings, 2nd State,* these little plates underwent yet another alteration: they were canceled, but not without deliberation (Mrs. Grosman was loath to dispose of them in any case). For example, the flag was scored with the standard 'X' and additionally inscribed with a large star over the starry field. But the life of these plates was not yet at an end. They were to appear in *Decoy.* Accordingly, they were inked, printed on paper and transferred to an aluminum plate. This processing led to two further fundamental changes. Not only did the many reversals of transfer and offset printing alter the final direction of the printed images, but it also inverted their values. Since the transfers were made by surface inking rather than intaglio inking, that which had printed black now received no ink, and that which had been wiped clean now received ink.[6] The dematerialization of Johns' objects was completed by printing in gray rather than black—what were once real objects of habitual use have become mere ghostly reminders of past existences. They are images of their own history. Metaphorically, they narrate a history of the transformations of objects in art. Iconographically, they relate to the central image of the ale can, the object-source for *the* icon of the 1960s. But here resides *Decoy's* irony—this ale can is a straight reproduction in totally transparent, illusionistic space![7] The ale can clearly stands as the only non-art aspect of *Decoy.* Its full volume, convincing depth, and its detailed surface reality decoys the viewer into the picture space and distracts him from the myriad of other transformations that are really the subjects of art and not of reality. In the end, reality becomes far more artificial (reproductive) than art (replication).

Much of *Decoy's* complex metamorphoses, references, and spatial weavings have been discussed by other writers and need no repetition here.[8] The very density of *Decoy* manifests itself in both meaning and opticality. It is a work that plays the richest of washes and brushwork against reproductive elements in a fashion almost reminiscent of Rauschenberg. The seductive skin competes with illusion and threatens to blot it out as if *trompe l'oeil* illusionism were the enemy of modernist painting! Although I can see nothing "ominous" about the large area of black, it does suggest covering or hiding. It continually asks, as did the *Watchman* images of 1964 and 1967, whether or not some implied presence set up the decoy in order to watch the struggles of the spectator.[9] In the final evaluation, one must question the tricks played and the burdens placed upon the observer. Is not the entire work a kind of decoy? Must every work by Johns be a masterpiece? After all *Untitled* (F.145) is inscribed "shit."

There are times when one feels the success of *Decoy* lies in its ability to deceive and to divert our sensibilities from a realization of its patent

191. Target (Black and Gray), 1974

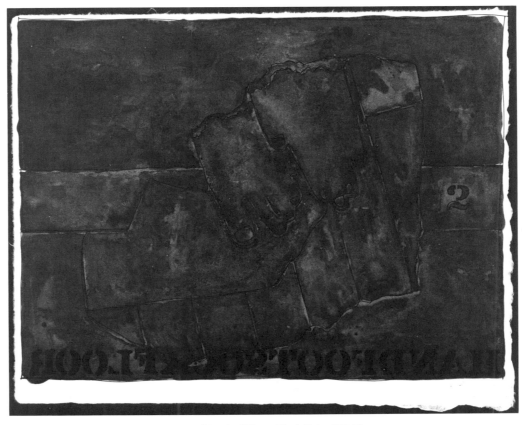

180. HandFootSockFloor—Black State, 1973-74

failures. *Decoy* is clumsy and overworked, messy and intellectually suspect, outsized and, at the same time, too detailed. It lacks the kind of sensuous and conceptual unity that one has so admired in the tough-minded and intensely integrated work of Jasper Johns. The title itself ought to be taken literally; the whole work is only a decoy—it is neither high art nor a very interesting slice of reality.

For what reasons did Johns return to *Decoy* two years later? *Decoy II* (F.169) represents a wholesale canceling of the earlier illusions. The ale can is now mostly fashioned by hand

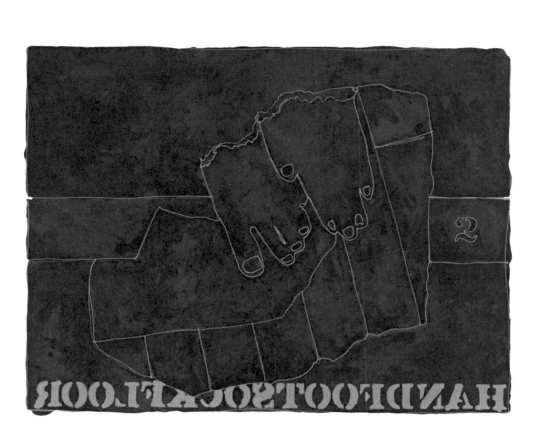

179. HandFootSockFloor, 1973-74

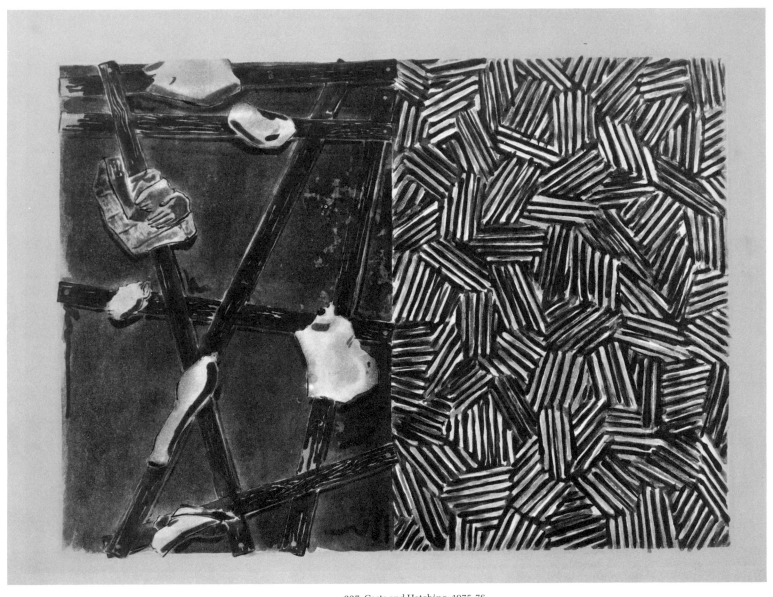

227. Casts and Hatching, 1975-76

and sits in a space completely flattened by surrounding gray brushstrokes. The predella has been obliterated by bands of spectrum color, black spatter, some smaller, irrational intrusions, and a broad 'X'. Dark gray crayon strokes mask off the central washes, depriving them of their optical depth while reasserting the flatness of the image (as do the circle motifs that overlap portions of the black wash). The additional seven, overprinted elements (see catalogue) manage to retrieve *Decoy* from the jaws of disaster by instituting a clear return to painting and painterly interests.[10] In this negation I find an act of brave self-criticism, and

am far less inclined to detect and praise so-called "far-reaching philosophical implications" in the first lithograph as did Rolf-Dieter Herrmann.[11] *Decoy* (1971) may indeed accumulate a vast number of traces of the past, but it just will not do to justify their presence by considering them as illustrations of a theory about artificial constructs and dialectical contradictions. Ultimately, a work of art must be integrated. In *Untitled,* 1972, Johns managed to create imbricating visual and cognitive experiences that went far to make up for the failures of *Decoy*.

Between *Decoy* and *Decoy II* Johns fashioned a number of fine lithographs at Mrs. Grosman's. The continued experiments with the flag provided material for new painterly investigations that also have multiple links with the past. *Two Flags (Gray),* 1970-72 (F.164) reutilized the three drawing plates Johns had executed in 1970 for *Flags II* (F.130). Printed in graphite ink over two wash stones, they created what is probably the most beautiful of all flag prints—transparent, rich, and constantly bewitching because of the implied tensions between the two slightly different side-by-side images. I have twice before dealt with these flags,[12] but nowhere has it been written that these works attain the zenith of lithographic beauty. The interaction of line and wash conjoins two kinds of structure in a visual feast: the rapid and compressed reversals of line imply an unraveling of structure that is pulled up tight once more by the underlying washes. Some of the same subtle reciprocation between apparent surface and depth structures finds a reprise in *Casts After Untitled* executed at Gemini in the following year, as well as a later echo in the *Light Bulb* of 1976.

Two Flags (Black) pulls the new wash stones of the previous gray image to the surface,

prints them in a deep black, changes the orientation of the flags, and imposes a new drawing in white line.[13] The relatively simple images invite comparison with the first *Black Flag* of 1960 (F.5), which suddenly looks monolithic and flat. The new lithograph of 1972 is activated by a lively chiaroscuro that embraces and organizes the entire picture surface. What had been flat and succulently transparent in *Two Flags (Gray)* is now able to suggest light and even a slight bend in the picture plane. A diagonal space seeps into the flag as Johns makes a subtle departure from what had hitherto been an insistent flatness. Could this new pictorialism signify, too, a seepage of feeling and drama into this paradigmatic image of indifference?

Cups 4 Picasso is another of those unanticipated moves of the 1970s. Alfred Frankenstein has already linked Johns and American *trompe l'oeil* realism from which the prepositional pun derives, and Philip Leider first pointed out that Johns' penchant for and suspicion of "fooling the eye" is a deeply-rooted American attitude.[14] The ambiguous image, on the other hand, repeats one of the most famous concoctions of the Danish psychologist, Edgar Rubin.[15] Johns employs Rubin's figure-ground scheme to pay an ironic homage to a specific kind of European draughtsmanship, that which manifests the most perfect control over the ambiguous spatial aspects of line. But he manages this tribute by means of four blends that scrupulously avoid a commitment of his own hand! One could very well inquire whether the future historian could even attribute this work to Johns were it not signed.[16] Both squares, of course, may be read as cup or profile. When observed together, however, it is impossible (for me at least) to read them differently. If one perceives the gray cup as figure in the left square, then the color cup on the right is experienced as the

positive figure. If one sees the color profiles on the left, then the gray profiles come forward on the right. What is fascinating is what occurs when one proceeds in the reverse direction. The entire perception is changed. For instance, if the color cup on the right is experienced as formed by the masking effect of the gray profiles, then the gray cup on the left is seen as a figure masked by the color profiles. Although Rubin's initial construction served to cast out uncertain perceptual presumptions, Johns' commentary quadruples the options, demonstrating that both figures on both sides can be experienced either as in front of or behind the ground. As in *Decoy*, the languages of daily experience find themselves an inadequate casebook for understanding art.

After the two Picasso prints, Johns fashioned a lithograph whose lack of discriminatory clues almost succeeded in denying all reading: *Painting With a Ball*, 1972-73 (F.170). The ball is suspended in a central space whose three-dimensionality is only implied by the lozenge-shape wedge into the middle of the dimly marked, gray field. Remarkably, the image seems equally at home in 1973 as a commentary on the monolithic flatness of a Brice Marden or the abstract illusionism of a Frank Stella as did the prototype in 1958 as an object-like alternative to the indefinite and engulfing space of Jackson Pollock or Willem de Kooning. With its absurdly simple maneuver and almost unbrushed surface, it manages to be critical of the serious aesthetic of the late 1960's high art, just as the first flags may have been a miraculously simple criticism of the intensely political statements implicit in the individualism of the art of the 1950s. Surprisingly, both the *Cups* and *Painting With a Ball* continue Johns' critique of modernist flatness, but they also illustrate how easy it is for Johns to modify his weapons so as to home in on any target.[17]

It is probable that Johns will never abandon the iconography of his early years. Side-by-side with his unceasing search for new motifs and new problems, the old themes keep coming up for re-appraisal. In 1976 *0 through 9* was reconsidered at Gemini and *Light Bulb* (F.212) was the subject for a marvelously Johnsian lithograph at U.L.A.E. The prototype was the first *Light Bulb* of 1958, the most sculptural and the most anthropomorphic as the bulb seems struggling to emerge from the material of its base.[18] Johns has carefully recaptured this same softness in the lithograph by intentionally restricting the drawing plate (see our inside front cover) to one or two rhythms of diagonal shading. As a result, the base is amazingly un-block-like, and the bulb fails to complete itself. Only the assertive but soft washes square off the base and round out the volume of the bulb. Those who recall the drawing stone for the 1964 *Ale Cans* (F.47) remember how strong and complete were the key stones of the 1960s. Now, in the 1970s, Johns is capable and desirous of an organic unity that gives rise to a stronger illusionism and a new interest in chiaroscuro already detected in *Two Flags (Black)* of 1972. Although terribly conscious of the surface textures of wash and crayon, Johns succeeds in summoning up a magical spatial ambience for this latest apparition of his light bulb.

Scent, 1975-76 (F.208), was the first print devoted to the new hatching motif since panel A/D of 1973-74 (F.194). Johns used three media—lithography, linoleum, and woodcut—to parallel the different surfaces and structures of the oil and encaustic painting of 1973-74. Each third of the print was conceived and printed differently, setting up a slight optical bend in the surface of the print. Each third was subtly differentiated by its textures: the slight watery quality of the lithographic strokes; the harsh, sharp, flat colors of linoleum; and the

grainy textures of the strips of wood veneer. Less perceptible, but equally distinctive were the final whites that were dropped around the color strokes. The lithographic white is just a shade more yellow and opaque, and more strongly changes the colors it overlaps. Parallel variations occur in the 1973 screenprint, *Corpse and Mirror*, where the creamy whites create a palpable matrix in which the colors float.[19] The subtlety of image/paper relationships is mediated by these whites which, in certain passages separate, in others unite, the colored strokes with the literal plane of the paper. In *Scent*, however, these and other variations are to be regarded more as elements of manifest than of deep structure. They are feints, real differences used to further mask the structural-spatial seams.

Otherwise the print is particularly precise and unpainterly, fiercely ungiving insofar as signs of the artist's emotional involvement are concerned. But this precision hides the infrastructure first detected in both painting and print by Tom Hess during their exhibition at Leo Castelli's in February of 1976.[20] It has been reported that Johns was actually dismayed when his efforts to make a truly "difficult" painting were so quickly neutralized.[21] His role as spy had been easily exposed.[22] Hess decoded the abc/cde/efa bands that had infiltrated the seemingly random areas of hatching.[23] Although the act of detection (of "following the scent") must concern the viewer, the real problem is one of retention. The shifting bands of pattern cannot be discerned without a special kind of focus that simultaneously obliterates our experience of the whole. I have already asked with regard to the *Four Panels from Untitled 1972* whether the spectator is not being unbearably "spread-eagled" by the impossibility of attending to two such disparate phenomena at once.[24]

To use Johns' metaphor one must try so hard to detect the scent that it is virtually impossible to follow it. If certain features of early paintings like *Target with Four Faces* and *Tango* demanded up-close inspection while other aspects distanced the viewer, the disparity is not quite so disjunctive as that of *Scent*. But even if *Scent* stretches memory to its limit, it is a painting (or a print) that is still consonant with the ideas expressed in Johns' first public statement which appeared in the catalogue of the *Sixteen Americans* exhibition at the Museum of Modern Art in 1959:

> Sometimes I see it and then paint it. Other times I paint it and then see it. Both are impure situations, and I prefer neither.
>
> At every point in nature there is something to see. My work contains similar possibilities for the changing focus of the eye.
>
> Three academic ideas which have been of interest to me are what a teacher of mine (speaking of Cézanne and Cubism) called "the rotating point of view"...; Marcel Duchamp's suggestion "to reach the Impossibility of sufficient visual memory to transfer from one like object to another the memory imprint"; and Leonardo's idea ("Therefore, O painter, do not surround your bodies with lines...") that the boundary of a work is neither a part of the enclosed body nor a part of the surrounding atmosphere.
>
> Generally I am opposed to painting which is concerned with conceptions of simplicity. Everything looks very busy to me.

As did the four panels of *Untitled*, 1972, the structure of *Scent* implies rotation. Although disguised by its all-over, busy character, *Scent*'s structure is neither drawn from nor depends upon a conventional figure-ground dichotomy. The structure is so subtle that the observer must change focus to find it, unlike his approach to a painting by Frank Stella where structure follows from the very shape of the support and painted elements. Taxed as memory may be, it is impossible to really see the similarities between columns of hatching while experiencing the entire work. *Scent*

truly maintains the impure situation, that old Johnsian dichotomy between seeing and knowing (vision and thought).

Untitled I, 1976 (F.213) is an aquatint with etching printed like *Scent* in three colors and a final white which fits around and partially overlaps the color hatchings. Smaller than *Scent, Untitled*'s structure is that of a diptych while its concealed structure is that of a triptych. Although obviously a work in two halves, the two hidden seams divide the work into thirds, with a rhythm of aba. Since the left seam corresponds quite precisely with the right-hand edge, the flat image embodies suggestions of spatial overlapping and circularity. The same play with hidden seams also occurs in *Untitled II* (F.214); as already noted, flagstones gave rise to the idea of seams in the first place.[25] It is my guess that with the images of 1976 Johns has sated his fascination with the game of detection, and has opted for other concerns that grew out of the hatching motif. Some of these have already been discussed apropos of the Gemini 6 *Lithographs,* but the most interesting were realized only in the three versions of *Corpse and Mirror.*

The first rendering of the painting, *Corpse and Mirror,* 1974, into print came with Petersburg Press' lift ground aquatint of 1975-76 (F.209). It captures the starkness and the sparseness of the painting and similarly inflects the meetings of contiguous groups of hatching to produce acute rather than oblique angles.[26] A strong vertical axis marks where the two halves meet, and a far less emphatic horizontal axis traverses the center of the entire image. More pronounced are the other horizontal seams which are established by the synchronized changes of direction of all hatching along a single edge.[27] Hess pointed out that this kind of seam very probably derives from the Surrealist game called the Exquisite

Corpse, in which a drawing is commenced, folded, added to by the next player, again folded, and so on.[28] Are not Johns' seams with their implied spatial recession the folds of the game?[29] The "mirror" opposite the "corpse" marvelously demonstrates the continuity within Johns' work—as it escalates the theme of the double flag.[30] But this duplication may also be referred to as a reflection, thereby raising the problem of both depth and surface. Should the pink tone and the 'X' at the upper right be regarded only as an error and its cancellation, as has been previously implied?[31] Or, are they not marks that establish the reflecting surface itself, like a smudge on a mirror that betrays its surface? The 'X', like the blue 'X' in *Bent Blue* (F.138), serves as much to cancel the illusion as it does to reestablish the surface plane. I do not think we are simply dealing with an image and its double as did *Two Flags (Gray)* of 1972, as much as with a subtle spatial image and its doubly subtle spatial reflection.[32]

Far more sensuous is the lithographic version of *Corpse and Mirror* of 1976 (F.210), in which the artist reaffirms the transparent and lambent brushwork of the earlier lithographs. Whereas all of the hatched prints so far discussed were printed in three colors and white, Tatyana Grosman's *Corpse and Mirror* achieves the density of white, black, and gray that rivals the best of the paintings and drawings. Whereas the other works *finish* by printing a white (negative) plate around the previous color brushstrokes, this version *begins* with several printings of negative, white shapes. But black paper is used, with the consequence that a network of black strokes emerges. These possess particularly ambiguous edges, formed by overlapping layers of transparent white and experienced as both figure and ground. Subsequent layers of grays and whites heighten transparency and

depth, transforming the lithograph into something far less palpable than the original, encaustic image.

Each half of *Corpse and Mirror* is articulated by subtle differences of texture, density, and color. Again, the greater opacity (whiteness) of the right half, the crossed out panel, and the mark of the bottom of some stray can appear as deliberate devices to distinguish surface from image.[33] The horizontal seams also vary: those of the left half are established by a build up of overlapping, while those of the right half include a linear demarcations. Consequently, they are of a different order of flatness, far better suited to a mirror and its image. Each of the six sections is itself individualized by subtle tonal and color differences on the same order as the subtle spatial foldings along the seams. As far as I can detect, this lithograph plays no games with structure, but exacts a maximum of attention to exceptionally refined sensuous and spatial nuances.

An entirely different transparency and color pervades *Savarin* completed in the summer of 1977 (F.259) and used for the poster of the great Johns retrospective at the Whitney Museum of American Art. It is a studio piece, the famous Savarin can (*Painted Bronze* of 1960) seen dead on, perched on a wood-grained table, against pastel hatchings which might well be a detail from an unknown version of *Corpse and Mirror*. Retrospection is the name of Johns' game and the obvious meaning of this lithograph. Few images could so neatly symbolize past and present. But since when has Johns been so straight forward or single purposed? Of course, *Savarin* incorporates inverted as well as obvious references! The

hatchings also recall the older flags, and the Savarin can with its frozen brushes may well relate to the newer, laconic brush work of the hatched paintings. This double reciprocity between figure and ground meanings has a dual function. It mirrors Johns' constant preoccupation with modernist meanings, and it also seems to close the circle on a quarter-century of art history as reflected in Johns' career. Indeed, one does wonder how much Johns is haunted by the idea of ceasing to paint. Here, in *Savarin,* Johns' brushes, coated with the colors of his own work, loom up in a scale far in excess of the original *Painted Bronze* of 1960, and appear as a monumental surrogate for the painter. Whether the artist has put up his brushes for the day or whether they have been permanently stilled as implied by the 1960 sculpture is the ever-present question.[34] It is a mystery about creativity that is as profound as the non-existent painting of the background. No print from Johns' hand has ever attained the sensuous beauty of these transparent washes and delicately undulating colors. It is a miraculous synthesizing of the color and space of *6 Lithographs (after 'Untitled 1975')* and the gray and whites of the lithographic version of *Corpse and Mirror.* It signifies what the Whitney retrospective of 1977 made us understand: before and after all interpretation Johns remains first and last the most incredibly delicious and sensuous painter.[35] The very recent canvases and *Savarin* itself seem to break free of the former dependence on a fascinating but sometimes oppressive hermeneutics. In its stead stands a revitalized concern with pure painting that is free of any restraint, of any received notions about objects, flatness, space, or replication. It is both end and beginning.

1. Of the 128 prints considered in volume one (1960-1970), 95 were executed at Universal Limited Art Editions; of the 132 prints published since 1970 (through October 15, 1977), only 15 were printed at U.L.A.E.

2. In the same year, 1971, Johns executed *Voice 2*, a three-paneled painting whose disjunctive readings and displaced flatness engender circular readings: see Crichton's comments (B-9, pp.58-9). On the use of the color spectrum to imply motion, see the first part of this essay, note 38, as well as the textual comments on *Casts from Untitled*. Johns' use of RED, YELLOW, BLUE as words, as tripartite divisions of paintings, or as pure color has not yet been sufficiently studied. They have provided a scaffolding for much of his work, and have played a symbolic role much as the scribbles and hatchings served as symbols of artistic presence and activity. In addition to their verbal, architectural, and sensuous roles, the colors have gradually taken on spatial functions. Obviously, Johns has learned many lessons from the colorists, from Hans Hoffmann through Jules Olitski, whose colorforms inhabit a shape or space that does not subvert the given flatness of the modernist painting.

3. See B-25 and B-45.

4. Some of the early sculptures were casts of found objects that were then painted; others were combinations of the objects and sculpmetal; and many, like the *Ale Cans*, were fabricated by hand, cast in bronze, and then painted. The same kind of play with modalities of illusionism informs many of the prints—for example the different modes of lettering in *Passage I* of 1966 (F.57).

5. The little photoplates were prepared so that the normal half-tone dots were etched *into* the plates. which were printed intaglio rather than in relief (letterpress).

6. In more detail, the process was as follows: the little photoplates, bearing a) the photo images, b) Johns' etched revisions, and c) Johns' cancellation marks, were inked not in their depths (intaglio), but on their surfaces—as if they were relief plates like normal halftone blocks. They were printed on paper. The image was reversed by the printing process, and the tones were reversed by surface inking. The images on paper were then placed in contact with the offset plate and run through the press, effecting a transfer but once again reversing them. Since the printing of the offset plate involved two further reversals, the image emerged as it had appeared on the original copperplate, i.e., the reverse of the reproduction that had been printed alongside of the etching. So now the image had been reversed in value, reversed in direction, and because it was inked in gray, had been endowed with a rather ghostly air.

7. But the spectator also witnesses the conversion of the saint, as Johns begins to paint over the image of the ale can (with printing element 8).

8. Crichton (B-9, p.59), Herrmann (B-20), Bernstein and Littmann (B-25), and Rose (B-54).

9. I feel less inclined today to identify the leg and chair with any single idea about the watchman (critic?) or the spy (artist?). Rather, I prefer to think that Johns allows several possibilities for an exchange of roles: his paintings, prints, and sculpture all make us terribly aware of both artist's and spectator's roles in that complex interaction which we might simply call looking at a work of art. When we most like Johns we are most willing to suspend our desire for certainty.

The reader is strongly reminded, however, that the cast (photoplate of) in *Decoy* must first be regarded as a pictorial event, like the casts in *Four Panels from Untitled, 1972* (F.194-197).

10. The spatter and color blends and notches over the photographic predella may be an allusion to the work of Jules Olitski, a suggestion made to me by Judith Goldman.

11. Herrmann, B-20, p.32: "Johns himself knows that his complex of juxtapositions amounts to a 'fiction,' to use Wittgenstein's term—that is an illusion, an artificial construct of his own imagination. And he knows that he can bring this artificial construct into question in a dialectical process....the point is to stress that the creation of a work of art—and the experience of one—always implies a *negation*."

12. B-12 & B-45.

13. The image of the flag was drawn wrongway-around on the stone. When the stones for *Two Flags (Gray)* were printed on the *offset press* the image would have appeared backwards if given the normal horizontal orientation. But just at this time Johns was drawing vertical flags. He knew that a 90° counterclockwise rotation of the reversed horizontal flag would establish the correct orientation of a vertical flag. When the same stones were then printed on the *regular lithographic press* as was *Two Flags (Black)*, the image came out in a correct horizontal orientation. Thus Johns was able to solve very different pictorial problems with some of the same printing elements.

14. Frankenstein, B-15, and Philip Leider, "In the American Grain," *Frontier* (Los Angeles), vol.16, no.12 (October 1965), pp.23-24.

15. Edgar Rubin, *Synoplevede Figurer*, Copenhagen, 1915, as cited in R.L. Gregory, *The Intelligent Eye*, London, 1971, pp.15-18.

16. *Cup 2 Picasso* (F.168) adds a crayon line to the flat tusche silhouette with the result that the stylized cup seems more embedded in the plane, the Picasso profile identified with the line.

17. Probably the single most insightful article on Johns' mind and objectives is Rose's "Decoys and Doubles: Jasper Johns and the Modernist Mind" (B-54), to which I have often referred. Throughout, Rose shows how Johns offers a critical counter-position to prevalent styles. One passage in particular is worth quoting extensively: "In Johns' attitude toward both serial imagery and colorfield sensation, we find the element of negation primary. Indeed, it is this element of negation—an intractable commitment to going against the grain instead of with the traffic—that identifies Johns as a radical conservative intent on preserving, with exceptional clarity in the midst of aesthetic and moral confusion, the dialectical ethos

of modernism. Johns' modernism is implicit in his fidelity to the central modernist themes: reflexiveness, autonomy, and self-sufficiency of the work of art, aesthetic distancing and unresolved complexity leading to a condition of permanent doubt." Although it is *not* clear that Johns' work participates in the linear development of a so-called dialectical modernism, Rose's picture of Johns as an auto-dialectician is utterly convincing.

18. Kozloff, *op. cit.*, p.32, speaks of the painterly aspects of Johns' sculpture, comparing Johns with the symbolist sculptor, Medardo Rosso.

19. Both *Scent* and *Corpse and Mirror* (screenprint) must be seen in unusually bright light for the various white pigments to be fully visible. Johns' recent use of white, in *Untitled II (Flagstones)*, F.214, to take yet another example, imposes on the viewer a shifting point of view: not only do the whites simply become visible as he moves, but they also change in color and structure.

20. Hess, B-22.

21. Olson, B-46.

22. Johns' watchman/spy vocabulary has been examined in a new political context by Moira Roth (B-55A). She has related Johns' dispassionate interrogations of objects and the languages of their representation to a pervasive "neutrality of feeling and withdrawal of commitment." This "aesthetic of indifference" was generated in reaction to the political climate in the United States during the witch-hunting, McCarthy years. We are admonished not to forget that in 1954 a painting of the American flag that purported such indifference could not be taken as a purely formalist, apolitical statement. I would like to add, too, that the spy vocabulary, the notion of guilt, of crossing borders, of escaping detection, of hiding, of harboring secrets is all part of the events of the late thirties in which Johns grew up. It was the events of these years that the popular media were so busy re-examining during the 1950s, not only as an echo of anti-communist sentiments at home, but also as a nostalgia for the exciting, morally invigorating days in which America had played *only* a spectator's role!

23. Hess described the infra-structure of *Scent* as taking the form of five overlapping squares whose divisions are marked in two ways. Sometimes their borders coincide with the four vertical edges of the three panels. But other internal marks can be detected. These seams were made by painting up to a given line from both directions; there results a series of subtle but planned disjunctures in an otherwise continuous image. Personally, I cannot think of overlapping squares so much as a surface with a series of periodic repeats and ultimate circularity.

Masheck (B-43) observed other means employed by Johns to avoid a decorative surface pattern, namely, the "infinite shallowness" caused by the irregularities implicit in the groups of hatching (he fails to note the structural seams or their spatial implications).

Perrone (B-47) claimed that underlying all of the new paintings is the structure of the Cubist grid. It points up rather than disguises the imperfect aspects of Johns' quasi-mechanical patterns of hatching, achieving a tension that spans the entire surface of the work. What is missed—by Perrone and even Krauss (B-39)—are the references to the still-Fauve-like Picasso canvases, such as the *Woman in Yellow* in the Pulitzer Collection or the *Dancer* in the Chrysler collection (both works of 1907). When Perrone goes on to compare the structure of the hatchings with that of the flag paintings, he is provocatively insightful. When he attributes a hand-like structure to them, however, he is, in my opinion, weakening his critical gains. Not only do these groupings contain anywhere from three to ten hatchings, but they are not at all the kind of expressive transfers that Johns has experimented with in the past. They are patently un-modulated, surface-adhering brushstrokes (in this sense they *invert* the morphology of the flags, as I try to make clear in my essay). But Perrone is correct in noting their relationship to the earlier flagstone images, especially to the raised grouting or pointing. Johns' images always manage to link up with each other in most unexpected manners.

I would like to draw one further parallel to Johns' hatched imagery. In their repetitive and implied overlapping struc-tures, they may be likened to Robert Morris' recent wall drawings and lithographs (e.g., *Light-Codex-Artifacts I (Aquarius)*, 1974, illustrated in B-55, pp.92-93). Here the relationship to body rhythms and illusionistic space is far more emphatic (as it is in the drawings and prints of Richard Serra). Morris, like Johns, cannot subscribe to a purely formalistic, topological art; both artists have always maintained references to the human body. Although I cannot here explore the matter of influence, it is clear that Johns, however, is less involved with motions of the body than is Morris. But both are concerned with new means of drawing, means that are personalized, but not overly expressive, spatial but not particularly illusionistic, systematic but not geometric or serial, and abstract but not planar.

24. I owe the quoted expression to Max Kozloff, "Johns and Duchamp," *Art International*, vol. 8, no.2 (March 1964), p.45: "And yet, many of his works provide little crises of attention because they are so divisive thematically, and low-keyed emotionally, because they are so illusive and so abstract, and finally, so mental and so sensuous. One's responsiveness is spread-eagled by the very delicacy with which these factors are kept in solution, vibrating like a visual tuning fork in memory and experience." As a description of *Untitled*, 1972, this statement would be a considerable understatement.

25. In panels B/D and C/D of *Four Panels from Untitled, 1972*. The seam in B/D raised the question not only of recognition, but of movement, overlapping, and memory.

26. Although Johns has not especially explored these aspects, the acute angles subtended by contiguous hatching in *Corpse and Mirror* of 1974, differentiate the entire painting from other works and indicates a more compacted surface.

27. The horizontal axis in the aquatint version of *Corpse and Mirror* (F.209) does not appear in the painted version; conversely, the raised seams of the painting do not find a physical analog in the print. Also missing, alas, is the hot iron that Johns impressed into the encaustic, driving both color and design from the surface.

28. Hess, B-22, p.66.

29. Concern with minimal indices of spatial recession or even volume abound in the works of Dan Flavin, Fred Sandback, and many others. See Matthew Baigell, "American Painting: On Space and Time in the Early 1960s," *Art Journal*, vol.28, no.4 (Summer 1969), pp.368-374, 387, & 401.

30. I have discussed this concept in B-12, p.74.

31. Perrone, B-47, p.50. Goldman (B-14), on the other hand, offers a more extended notion as to the roles of Johns' "cancellations."

32. In the present version of the essay on Johns' screenprints I have dropped one clause, that about the "corpse" evoked by the bilateral symmetry disposed along the vertical junction of *Corpse and Mirror* (F.211). Although the symmetry does evoke a kind of humanoid shape and also imparts the inorganic aspect of death, I would rather derive the expressed notion of corpse from the Surrealist game. Furthermore, the Whitney exhibition has unveiled a recent ink, paintstik, and pastel drawing —clearly to be equated with the left-half of the painting—entitled *Corpse* (Crichton 157).

33. The subtle play among levels of concreteness recalls Monet's *Water Lilies*. The viewer must acknowledge the literal, painted surface, the depicted surface of the water and its lily pads, and the complex of reflections of landscape and sky. Once he is able to focus his attention properly, the viewer has no problem in making these distinctions.

34. On the significance of the *Painted Bronze*, see Max Kozloff, *Jasper Johns*, New York, 1969, p.32 and the same author's article, "Johns and Duchamp," *op.cit.*, p.45. The idea of artistic impotence parallels the imprisonment expressed in *Skin with O'Hara Poem*, 1963-65 (F.48).

35. It is a most remarkable coincidence that the Cézanne exhibition at New York's Museum of Modern Art coincided with Johns' retrospective at the Whitney Museum of American Art.

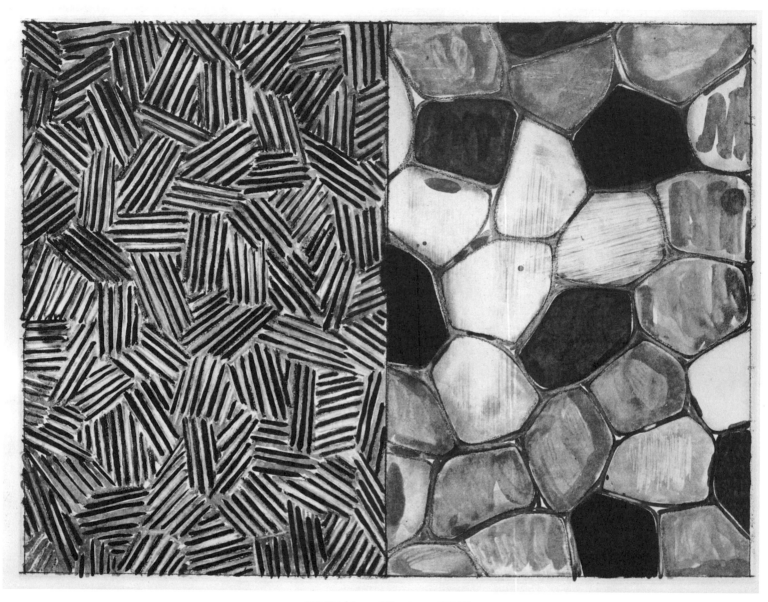

234. Hatching and Flagstones, 1975-76

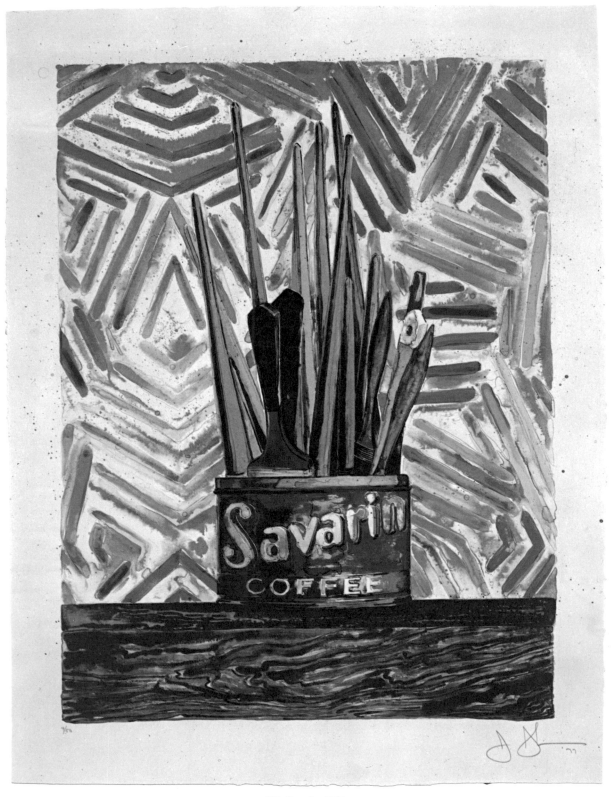

259. Savarin, 1977

III. THE SCREENPRINTS/SIMCA PRINT ARTISTS[1]

Just seven years ago Jasper Johns regarded screenprinting with suspicion. How could so bold a medium serve an artist whose print-making style was founded on the subtlest oppositions between transparency and opacity? Obviously the screenprint of the 1960s had no place for Johns' fluent brushwork, although prints of extraordinary quality were being produced. All manner of combinations of hard-edge (knife-cut stencils) and media-collage (photographically processed screens) abounded. Johns was not unaware of the medium. He deeply admired the work of Richard Hamilton, and Andy Warhol himself first showed Johns that a screen could be used to squeegee paint onto a canvas.[2] It was, however, the coarse illusions and the novel manner of paint application that interested Johns at that time; the question of making a print on paper did not arise. After all, his prints were neither comments on public media nor information degradation; their allusive complexity was never discarded in favor of formalist single-mindedness.

The screenprint of the 1960s depended on the medium's potential for anonymity and its ability to absorb images from other media. It was *the* means by which artists of the post-Abstract Expressionist generation—beginning with Vasarely and Albers on the one hand, Warhol and Rauschenberg on the other—created works that reduced the importance of the artist's hand and reintroduced a vast new range of figurative subjects. And screenprinting was commercial, in feel, in its conventions, and in its ease and relative cheapness. It was hardly Jasper's medium.

Target with Four Faces of 1968 (F.92) was Johns' one bold venture into the medium during the 1960s. Executed to raise money for Merce Cunningham's dance company, the image suitably contained a likeness of Johns' long-time friend and collaborator. In its blatant contrast of plane and line, hardly tempered by the muted brown textures and modeling, this work succeeds in projecting its message. Yet, it acted then, and even now, in an abrasive fashion, blunting our expectations; it was as if Johns were consciously caricaturing the medium. How wide is the gulf between this screenprint and Johns' lithographs of the same period! Nonetheless, it might be regarded as a gentle protest against commercialism as well as an admonition to return to a more intimate contact with the medium.

By the end of the 1960s, it seemed that screenprinting had run its course; the Philadelphia Museum of Art mounted an extensive survey, *Silkscreen: History of a Medium*, covering the period from 1920 until 1970.[3] Few serious works in the exhibition indicated an interesting future for the medium. A number of artists had adapted screenprinting to a relatively straight processing of drawings; they included Segal, Thiebaud, Bontecou, Christo, and by 1971, Jasper Johns. A few others, such as Loring, Morley, Levine, Nauman, Stark, and Winner (Estes was to follow a year later), were experimenting with the various New-realist vocabularies. These artists, however, still concentrated on the reproductive look and utilized photographs and photographic methods in their work. What the exhibition failed to emphasize were the 1969 experiments, not to be repeated, of Walter Darby Bannard and Jules Olitski. In their portfolios they sought to turn screenprinting away from the hard-edge or photographic look and toward a more painterly involvement; in retrospect, their work seems to relate to the group that includes Johns' *Painting with Two Balls* of 1971.

At about the same time, during the spring of

1971, in an interview with the present writer, Warhol stated that he probably had exhausted the machined look of his work (epitomized by the *Flower* portfolio and the *Cow* wallpapers). True to his word, traces of his hand showed up in the *Mao Tse-tung* series of 1972. Another sign of the reaction against the machined look was given by a new avant-garde interest in etching, both figurative and abstract. These works, clearly incorporating the artist's hand, albeit in a precise and controlled fashion, were dedicated to an exploration of the essence of copperplate printing. Even lithography, always a rallying point for the expressively drawn image, advanced its prestige through the work of such diverse artists as Katz, Rauschenberg, and Pearlstein. In a noteworthy series of large lithographs Richard Serra fused the gestural language of Abstract Expressionism with boldly articulated spatial structures based on his own sculpture.

It is in this context of reaction against the 1960s that Johns' growing involvement with screenprinting must be viewed. The two versions of *Painting with Two Balls* (1971, F.132, 133), as the earlier *Target with Four Faces*, resulted from a request for a poster, for the European exhibition of his prints. In a decisive move away from the stark simplicity of *Target with Four Faces*, Johns decided to translate tone, wash, and crayon into the new medium. Separations were drawn on mylar and photographed through a "mezzotint" screen (a random dot substituted for the halftone grid of ordinary reproductions). This yielded a positive transparency, which in turn was used to make the final printing screens which integrated the information to be reproduced with the regular mesh of polyester fabric. The result was an image that could not be said to reproduce a drawing (there was no "original drawing"—only the separations) whose character was shaped by the tusche washes, the mylar

support, the mezzotint screen, and the polyester fabric that carried the final printing matrix. These prints have rich, integrated surfaces that do not act like reproductions. One sees the image, not a transparent reproduction of something else. There exists nothing quite comparable to them in the realm of screenprinting. Unique as they were, these prints still did not reflect that exploitation of medium that one has to come to expect from Johns. Fittingly, his next screenprint embodied a further reduction of mechanical process, but did so ironically by making careful distinctions between several kinds of "screens."

Screen Piece (F.146) was executed in 1972 not long after Johns had met the Japanese publishers and printers of Simca Print Artists. In Japan, they had worked with Tadanori Yokoo whose prints were much admired by Johns. Most importantly, these craftsmen possessed the sensibilities and capabilities that heretofore were associated only with lithographic and intaglio workshops. They offered Johns the opportunity to enter into a far more intimate relationship with the entire process of creating the printing matrix. Furthermore, by 1972 Johns had gained confidence in his new work which was slowly moving away from the language of illusions and devices that had informed his painting of the 1960s (these were, however, still the subjects of his lithographs). The new and purer approach to painting was broached in *Harlem Light* 1967, the *Screen Pieces* of 1967 and 1968, *Wall Piece* of 1968, *Voice 2* of 1971, and culminated in *Untitled*, 1972, one of whose panels introduced the hatched style that has occupied Johns ever since. Perhaps it is too ambitious to detect the influence of these changes in *Screen Piece* whose major motif is a halftone illusion of a hanging spoon and fork (a motif derived from the painting, *Voice*, 1964-67, and then used in several paintings and drawings of the *Screen*

Piece series). The silverware hangs in sharp relief against an indefinite gray background. At the left are three distinct areas of red, yellow, and blue; at the right their complementaries, green, violet, and orange are printed in a continuous blend. The last five printing elements alter the givens; they are all screen patterns, that is, halftone dot systems reflecting specific choices made by the artist. The dot patterns, available commercially, were selected for size and density, and then photographed onto open screenprinting fabric. Through these Johns made his marks, sometimes using a bit of blockout for a negative line, but mostly drawing through the dot screens onto the final printing screens. In other words, the last five printing elements were themselves fabricated by screenprinting a variety of halftone dots onto their surfaces. In this manner, Johns integrated his own hand into the very dot patterns that usually served reproduction, as in the hanging spoon and fork. Ironically, he managed this without using the dot patterns to *reproduce* something already known. For this reason *Screen Piece* is a transitional object, utilizing but then ultimately rejecting reproductive methodology.

Within Johns' printed oeuvre, *Screen Piece* is closely related to the concerns of the lithographs of 1971, *Fragments—According to What,* which are also studies in comparative illusion making. Yet, where *Fragments* are precise and well-machined inventories of forms of pictorial motion, *Screen Piece* is a work of relative quiescence, even of some emptiness, endowed with subtle beauty. It may well be one of the least understood of Johns' works, although the hanging silverware is a fairly well-understood metaphor for the notion of consuming illusions—our habit of taking one thing for another, of uncritical acceptance of symbols as if they were reality.

By 1973 Johns was committed to the Simca craftsmen, Takeshi Shimada, Kenjiro Nonaka, and Hiroshi Kawanishi. Together they produced the modest gray *Target* of 1973 (F.171), an experiment in transparent brushwork. Five of the six screens were executed in the old-fashioned tusche-and-glue method that allows the artist to draw directly on the fabric. Each of these screens was printed with the same transparent gray ink. The resulting complex of overlappings imparted new spatial and pictorial dimensions to what would otherwise be taken as a flat image.

Only in the case of *Untitled (Skull)* of 1973 (F.172) did Johns turn to another workshop, to Adolph Rischner's Styria Studio in New York. Perhaps it is no accident that the print harks back to the more mechanical finish of the 1960s. In the best impressions the skull emerges like a ghost from the slowly unfurling space. The motion is underscored by the spectrum line beneath. But what kind of apparition this is cannot be known since it threatens the negation of the artist (the cross under the signature) as well as its own disappearance. This it does since the entire blend—the particularly tangible space of the image—is gathered up by the drip that emerges from its lower edge. In typical Johnsian fashion, doubt is cast on any reading of the whole.

In the *Flags* of 1973 Johns returned to Simca and to a firm commitment to the painterly screenprint. In his use of tusche and glue stencils, he reverted to one of the most basic methods of screenprinting. Historically speaking, this could be regarded as a revitalization of the neglected little silkscreen prints of the 1940s and 1950s. These were called serigraphs, in order to separate them from commercial endeavors (the term was first coined by Carl Zigrosser for the first important exhibition of screenprints by American artists that

took place at the Weyhe Gallery in 1940). Although I hardly wish to claim that Johns was inspired by the works of Ben Shahn, Adolph Dehn, Elizabeth Olds, Hyman Warsager, Harry Sternberg, Ezio Martinelli, Sylvia Wald, or Seong Moy, it is true that our artist has often mined the provincial styles of the American past. The only major artist of the 1940s to try screenprinting was Jackson Pollock who in 1952 allowed a few prints to be made after his black paintings. Pollock failed because he neither touched the screen (they were executed photographically), nor made any attempt to translate the layers of pigment or the scale of his paintings into the new medium. Johns, too, in the 1970s, did not seek to emulate the loaded screens of the earlier American artists who all too often produced miniature paintings. Rather his screenprints allude to the build-up of the surface of a painting, while using quite thin inks. Furthermore, since *Flags I* of 1973, each printing element distributes marks over much or all of the surface, so that the image looks quite uniformly constructed. As usual, Jasper Johns arrives at a very precise and measured use of his materials.

Flags I (F.173) was executed in five basic stages. Elements 1-6 printed each flag in green, gray, and orange flats; 7-12 imposed a layer of brushed marks, in darker green, gray, and orange; 13-18 went over each star, field, or stripe with its complementary—red, white, and blue covering about 75% of the prior image; 19-24 added lighter brushmarks of red, white, and blue; elements 25-27 printed a medium red but a lighter blue and a brighter white to the left flag; 28 covered the right with a varnish gloss; and lastly, screens 29-31 completed the right flag. The thought, effort, and concentration entailed in the production of this large print resulted in a surprisingly simple image. No individual stripe or star, for example, is composed of more than five layers of pigment, but the effect is suggestive of a great deal of painterly activity, indeed of a hidden past that is only dimly perceived.

While a photograph of the painting of 1973 was used as a guide for overall structure, it also served Johns' efforts to maintain the same kinds of subtle morphological differences between the adjacent flags. Similarly, Johns also devised ways to suggest in the print some of the physical differences found within the painting. For example, the contrast between the varnished colors of the right flag and the more saturated colors and the slightly denser drawing of the left-hand flag suggest the original contrast between oil and encaustic paints. Most of these comparisons, those within the screenprint as well as those that refer to the prototype, suddenly vanish in the grays of *Flags II* (F.174). With only a few minor alterations to enhance the transparency of certain passages, the very same screens were employed for *Flags II* as for *Flags I*. What was an aggressive and physically tangible image retreats into impalpable shadows. Incredibly, by means of negation alone, Johns demonstrated the structural—as opposed to the sensual—significance of color. It is striking that such a simple, basically mechanical change can exact so significant a transmutation. Ironically, the comparison between adjacent flags (which *do* differ in detail) has now paled. In other words, what was a fundamental subject of *Flags I* has itself been altered by the creation of *Flags II*. Subtle and self-critical, these discriminations are typical of the demands made of us by Johns' objects. Whether such choices are sufficiently worthy of our attention is ultimately an individual decision. But surely there is something profound in the way that these images reveal to the dedicated observer a subtle dialogue between those modes of perception which favor measure and those which

rely on intuitive feeling.

In the *Target* of 1974 (F.192) Johns continued to explore the relationship between loose brush-work and compositional structure. Far more complex than the *Target with Four Faces* of 1968, *Target,* 1974, repeats a painting of the same year now in the Seibu Museum, Tokyo. Both versions were inspired by the targets of the 1950s which were executed in layers of newsprint, encaustic, and pigment. Striving to match this painterly surface, Johns discarded the unmodulated flatness of the complementary colors printed underneath the red, white, and blue *Flags I* of 1973. In *Target,* 1974, broad strokes of green, orange, and violet were distributed throughout the image as well as concentrated in the upper three rectangles. Once again, however, the execution was orderly and rational: each of the two triads was printed four times; only the last three screens were permitted to add irregular accents. This systematic execution did not exclude a spontaneity of brushstroke which continuously covers and uncovers itself, threatens to exceed established boundaries, or succumbs to the pull of gravity in the numerous vertical drips. Ironically, the drips suggest activity and time on the one hand, and rest and resolution on the other. To achieve such ordered spontaneity required enormous effort from the artist; many screens were drawn, proofed, and subsequently discarded. During this activity, Johns ran off a two-screen *Target* in gray and black as a release from the problems of the color version. In this bold, two-color *Target* there is a greater complicity between the form of the image and the brushstrokes that articulate it— so much so that the chiaroscuro and spiral-like implosion threaten the flatness of the image.

Based on the 1955 painting, *Target with Plaster Casts,* in the collection of Mr. and Mrs. Leo Castelli, all of the targets of 1974 reconsider the relationship between the shape of the support and the shape of the image. The early painting reveals Johns' unwillingness to allow his target to become identical with its support. As Barbara Rose has pointed out, the wooden cubbyholes and protruding casts break the flatness of the canvas by opposing an outward projection to the inward pull of the target motif.[4] In the color screenprint of 1974, the rectangles of complementary colors occupy the very same positions. As pure color they assert the same countermovement as did the casts. A similar equivalent is found in the almost Klinean blacks of the three rectangles of the black and gray *Target* (F.191). Their powerful presence strengthens the rectilinear brushstrokes at the bottom of the image and ultimately the flat plane of the print. The more Johns changes the more we are able to perceive the concerns that remain the same.

In retrospect, it is clear that the breadth of touch that Johns brought to screenprinting was quite innovational. Yet, compared with his own work in other media, the screenprints have not always had an entirely comfortable reception. Occasionally it is the viewer's expectations, based on the transparency and delicacy of the lithographs, that are faulty. Nonetheless, it appears that the artist has continuously striven to achieve an ever higher synthesis between his imagery and the qualities of the medium. In 1976 Johns undertook to translate his recent hatched paintings into screenprints. It was a perfect match, for the medium was utterly suited to the task—the very infrastructure of these images being virtually inseparable from the deposits of pigment themselves. As in the mature works of Cézanne, spatial and relief elements were locked into each gesture the artist made.

The simple strokes painted on each of the color screens used for *Corpse and Mirror* of 1976 (F.211) differ from the dynamic marks of

the *Flags* and *Targets* of previous years. Much of the new laconism derives from the painting which the print rather closely follows. Not only does the print carefully repeat many of the brushstrokes, but it recapitulates the divisions of the painting by paralleling the higher densities of white of the right half and the greater saturation and depth of color of the left. Like the dual image in *Flags I*, the implied orderliness of *Corpse and Mirror* taxes the memory as one looks searchingly from one part of the image to its "reflection." But unlike the *Flags*, the flatness of the surface is continually challenged. While the color strokes seem to describe a continuous surface and function as a continuous web, it is a web with seams. It is along these internal junctures, some obvious, others detected only after searching, that the space of the picture is bent by the irresistible proclivity to read converging lines in a perspectival manner. The act of mirroring is in fact the prime cause of these spatial discontinuities. Thus, in an image that at first seems populated by relatively benign brushstrokes, there emerges, upon sober reflection, disturbing and unexpected tensions.

The organization of *Corpse and Mirror* is rather simple. The three rectangles on the left are disposed along an axis separating them from three similar rectangles on the right. Along this vertical axis the right side seems to mirror the left, although one must ask how consistently it does so. Along the interior horizontal seams there is a different order of mirroring: the strokes are bent, but continue asymmetrically across the boundaries. While the breaks on the right half of the print have been relatively smoothed over by the surrounding white pigment, those of the left half were emphasized by the purposefully separate printings of each section. The greater disjunctiveness of these boundaries alludes to the painting, *Corpse and Mirror II* 1974-1975,

whose left half is actually constructed of three separate stretchers. Because the screenprint is able to lay down strokes of pigment that have more substance and opacity, the duplicity of these junctures and the interweaving of planes implied by the hatchings is brilliantly underscored. The screenprint also imparts a greater veracity than could a lithograph to the subtle struggle of the hatchings against the containing layers of white pigment in which they are embalmed.

As this was being written Johns had just finished *Untitled*, 1977 (F.260), a small screenprint which served both as the cover of Brooke Alexander's catalogue and as a technical model for the very large but still incomplete print, *The Dutch Wives*. Despite the many printings required by *Corpse and Mirror*, the density of coverage depended very largely on whether lighting conditions permitted one to see the layers of white. The new prints sought to close the background more tightly. *Untitled*, 1977, began with a "collage" base, printed from two screens—one a flat, buff, paper color, and the other a photoscreen of the original newsprint collage. Over these are the three primaries and then, in somewhat paler hues, the three complementaries. The last color to go down is the all-embracing white. This work has a fascinating density and transparency; the "collage" elements force the viewer to be aware of the different spatial and transmitting qualities of each color. Even more remarkable is the reversal achieved in the catalogue cover. For this edition, the six color screens were printed in reverse sequence and each with the complement of its original color. Unexpectedly, the result is a subtler, flatter, and more evenly transparent print.

In all of the new screenprints, Johns has solicited and won new achievements from the medium. He has established total control over

surface tension, depth, and translucency and marked the path to a new and fertile painterliness. These screeprints thread their way between painting and lithography, embodying a tangible essence that is often tested against the strongly reproductive aspects of the images. Like the paintings, they dip back into Johns' own artistic roots which spread to embrace both the soil of the New York School and the solid earth of a provincial scepticism.

NOTES TO III. Screenprints/Simca Print Artists

1. This section is only a slightly revised version of that published by Brooke Alexander, Inc., New York, in November 1977.

2. The silkscreen stencil was not that of a Coca-Cola bottle as Johns told me several years ago, but the label, "Glass Handle with Care"—possibly the one that appears in the painting *Arrive/Depart*, oil on canvas, 1963-64.

3. The Philadelphia exhibition was organized by the present writer; though a full catalogue was planned, only a small, but detailed, check list was published. We will be pleased to send a xerox copy if addressed at Wesleyan University. At the same time, an article appeared in *Art News*: Richard S. Field, "Silkscreen, the Media Medium," *Art News*, vol.70, no.9 (January 1972), pp.40-43, 74-75.

4. See Barbara Rose (B-29, n.p.) and Leo Steinberg, "Jasper Johns: the First Seven Years of His Art," in *Other Criteria*, New York, 1972, pp.46 & 54.

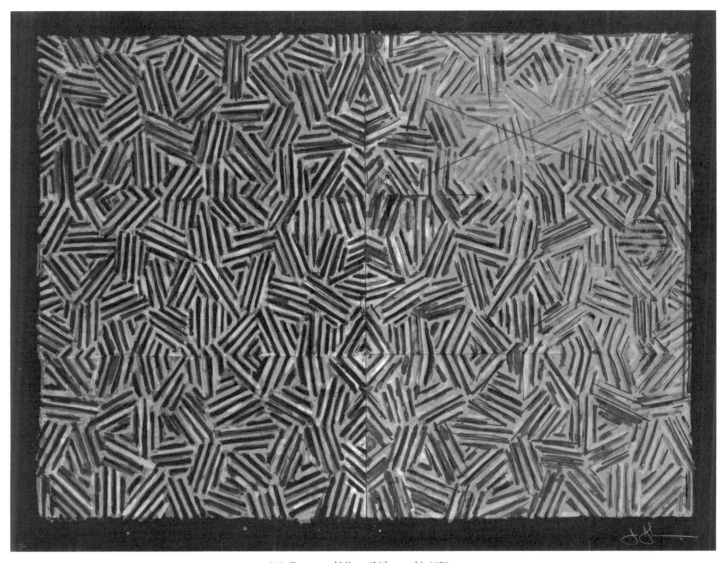

210. Corpse and Mirror (Lithograph), 1976

The present catalogue continues that published in 1970 by the Philadelphia Museum of Art. In some ways it is a more accurate catalogue, although some details have been omitted and some problems have become more difficult to handle. Chief among the latter is that of chronology. Since so many of the prints were created in series or in states, work was often discontinuous. Thus a precise chronology would have been burdensome and not really meaningful; in general, the order of the prints follows that of their publication. The one major exception is the two sets of *Four Panels after Untitled 1972* which were grouped together to facilitate understanding of how the color versions metamorphosed into the black and gray prints. An effort has been made to avoid ambiguity among the titles, often by expanding them beyond those. assigned by the various publishers; all have been approved by the artist. And most important, special care has been taken to adequately detail all of the printing elements. These have been listed in order of printing, not necessarily and in fact, rarely reflecting their order of creation.

No matter how carefully one might proceed, it is an impossibility to recapitulate process by means of words. The reader will find considerable data here, and it is hoped that what is described is indeed accurate. But in no sense do I claim that Johns' prints have been completely described. Each print has been discussed with artist, printer, or publisher—in many cases separation proofs have been consulted. Although there were occasions when complete technical explanations were not retrievable, whatever errors remain must be credited to the faulty understanding of the writer.

A few minor points should be mentioned. As usual height precedes width; measurements are given in inches (and in millimeters). In the case of etchings the dimensions are those of the platemark and of the paper; in all other cases, they are only those of the sheet carrying the image. Descriptions such as "red to yellow to blue" indicate "blended rolling" where two or more colors are blended on a palette and applied with a single roller to a stone or plate. Our terminology is rather standard, except that I have preferred the English word "screenprint" to our timebound and outmoded "silkscreen" or "serigraph." It has seemed superfluous to continue to give the location of the artist's signature and the publisher's blind stamp borne by virtually every work. And lastly, we have tried to limit our appended remarks to those concerning

sources, technical matters, and bibliographical references.

In this place, I wish to thank once again all those generous persons who have taken considerable pains to share their knowledge of these complex images. Although their respect for Johns' precision, comprehension, invention, and concentration is virtually unbounded, it is their devotion and sensitivity to their own crafts that has made this body of work the most distinguished contribution to printmaking of our times.

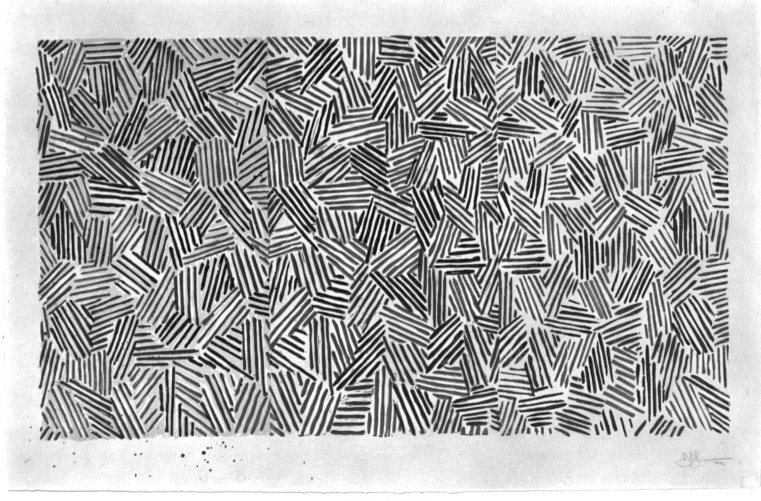

208. Scent, 1975-76

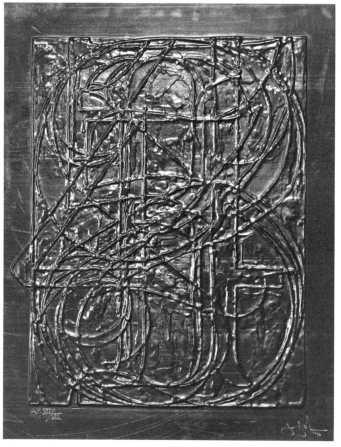

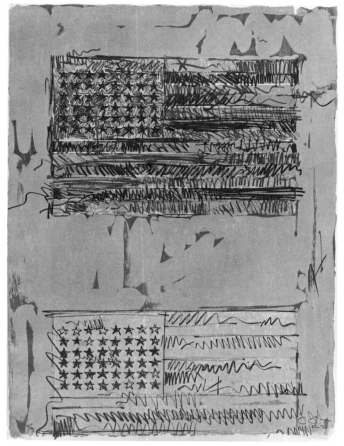

129

130

129. 0 through 9 1970

Lead relief

30 x 23½ (762 x 597)

Edition 60 plus 9 artist's proofs

Published by Gemini G.E.L.; printed by Kenneth
Tyler, Jeff Sanders, and George Page

After so many painted, collaged, drawn, lithographed (F.4
and 62), and etched (F.76, 83, and 90) renditions of this ar-
chetype image, a relief version was inevitable. Created im-
mediately after the five lead reliefs of 1969 (F.118-122), it
follows their technique of reforming a thin lead sheet in a
hydraulic press. The artist had only to supply the maquette,
in this case a rather fluid, sculpmetal version of the basic
drawing–probably the lithograph of 1960 (F.4).

130. Flags II 1967-70

Lithograph from five stones, five plates, and two
rubber stamps

 (1) green–stone
 (2) black–stone
 (3) orange–stone
 (4) warm gray–stone
 (5) cool gray–stone
 (6) light gray
 (7) white
 (8) blue
 (9) red
 (10) black

34 x 25 (864 x 635) handmade India paper

Edition 9 plus 3 artist's proofs

Published by U.L.A.E.; printed by Bill Goldston

The five stones and first plate had already been printed in
1967-68 as an over-run of *Flags* (F.70). For the new version
of 1970, these were overprinted with the additional four
plates (7-10). Three of these (7-9) were used again in *Two
Flags (Gray)* of 1972 (F.164).

67

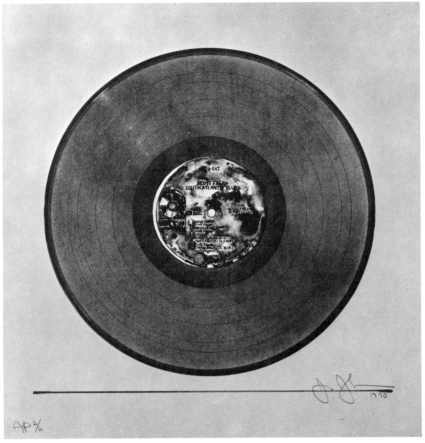

131. Scott Fagan Record 1970

Lithograph from two stones and one phonograph
record
 (1) blended roll
 (2) black (label)
 (3) black (record)

12¼ x 12¾ (311 x 324) Angoumois à la main paper
die-cut by the artist
Edition 20 plus 6 artist's proofs
Published by U.L.A.E.; printed by Bill Goldston
(stones) and Zigmunds Priede (record)

Johns' own record was used as a relief printing surface,
quite literally an object 'recording' itself. Visual analogies
to sound have occurred now and then in Johns' work, espe-
cially in the *Voice* paintings of 1964-67 and 1971, and in the
lithograph of 1966-67 (F.59). The spectrum line that makes
its first appearance here, not only has its analogue in the
so-called voice or sound spectrum, but also suggests a fur-
ther movement in space—that of a rotating disc seen edge-
on. The entire image was preceded by a drawing of 1969
(ink on mylar, 12¼ x 12¼ in., coll. the artist).

132. Painting with Two Balls 1971

Screenprint from seven photoscreens
- (1) light transparent red (flat)
- (2) red (wash)
- (3) light transparent yellow (flat)
- (4) yellow (wash)
- (5) light transparent blue (flat)
- (6) blue (wash)
- (7) black (drawing)

39¼ x 27½ (997 x 699) German etching paper
Edition 59 plus 10 artist's proofs
Printed by Alexander Heinrici at Aetna Screen Products, New York
Published by the artist
Poster edition "Die Graphik / Jasper Johns" for Bern, Berlin, Milan, Hannover, Munich, Ludwigshafen, and Monchengladbach.
Total editions: ca. 2320
Printed by Albin Uldry, Bern, Switzerland, from positives prepared by Aetna Screen Products, New York
Published by the Kunsthalle, Bern

For this and the following version Johns supplied separations drawn in graphite wash on mylar. These were photographed through a half-tone screen whose "dots" produced a random pattern rather than the conventional grid-like structure. In the trade this is known as a "mezzotint screen." The process was scarcely able to reproduce the subtleties of Johns' washes; instead, a very different grainy texture emerged. In any case, it cannot be maintained that the artist intended to reproduce a drawing, for no single drawing could even be said to exist.

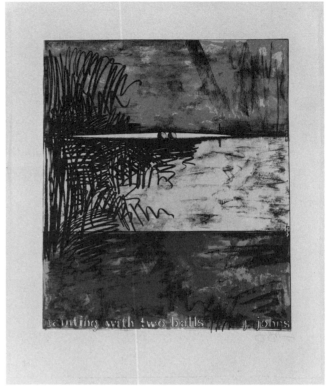

132

133. Painting with Two Balls (Grays) 1971

Screenprint from three photoscreens
- (1) gray (flat tone)
- (2) dark gray ("mezzotint" or random dot of graphite washes on mylar original)
- (3) black (line from graphite on mylar original)

34⅞ x 28¼ (886 x 718) J.B. Green paper
Edition 66 plus 9 artist's proofs
Printed by Alexander Heinrici at Aetna Screen Products, New York
Published by the artist

The three screens were made directly from separations drawn by the artist, the third screen being identical with the last element of the color version. Both echo the lithographs of the same subject made in 1962 (F.8&9).

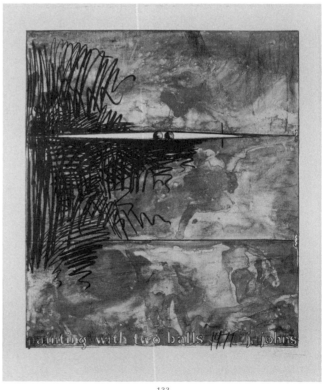

133

134. Decoy 1971

Lithograph from one stone, hand printed; and eighteen plates, printed on a hand-fed, offset proofing press
 (1) light gray (frieze of transfers from the reworked and cancelled halftone plates from *1st Etchings, 2nd State,* 1967-69, F.85-90)
 (2) black—stone (wash)
 (3) light green-gray (photo-litho plate derived from the same photographic negative of the painting, *Passage II,* 1966, that had been used for the lithograph *Passage I,* 1966, F.57)
 (4) brown-black (retouched photo-litho plate of a Ballantine Ale can)
 (5) violet (ET and VIOLET)
 (6) pink (central ale can image)
 (7) green (N and ale can)
 (8) yellow (YELL and ale can)
 (9) mustard yellow (flat around color words)
 (10) blue (BL)
 (11) red (RED and E)
 (12) orange (ORANGE)
 (13) red to orange to yellow to green to blue (line)
 (14) blue (UE)
 (15) turquoise green (perimeter of color-word area)
 (16) turquoise green (lower half of image)
 (17) white (GE YELL/OWGREEN and LETRE)
 (18) orange (ale can)
 (19) gold (ale can)

41 x 29 (1041 x 736) Rives BFK paper
Edition 55 plus 4 artist's proofs
Published by U.L.A.E.; printed by Bill Goldston and James V. Smith

The making of this work has been described in detail by Roberta Bernstein and Robert Littman (B-25). The idea of transferring the etched plates to stone was suggested by an article describing Rodolphe Bresdin's transfers of his own plates in the 1870s. *Decoy* remains one of the few prints that has given rise to a painting, *Decoy,* 1972 (oil on canvas, 72 x 50 in., coll. Mr. and Mrs. Victor M. Ganz).

135. Target 1971

Lithograph from one stone in gray; collaged elements consisting of red, yellow, and blue watercolor pads, and a red brush glued to a second piece of paper; plus rubber stamp for "Target 1970 / _____ and _____ "

12½ x 10 (318 x 254) German Copperplate paper
Edition 50 plus 6 artist's proofs, signed by hand
Additional offset edition of 22,500 for exhibition cata-

logue (plastic box), *Technics and Creativity: Gemini G.E.L.,* New York, The Museum of Modern Art, 1971. Published by Gemini G.E.L. and the Museum of Modern Art; printed by Kenneth Tyler (limited edition) and Graphic Press, Los Angeles (offset edition)

Derived from *Target,* 1960 (pencil on board with brush and watercolor discs, 6¾ x 4⅝ in., coll. Ileana Sonnabend, Paris).

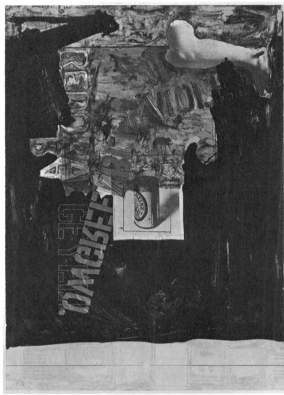

134

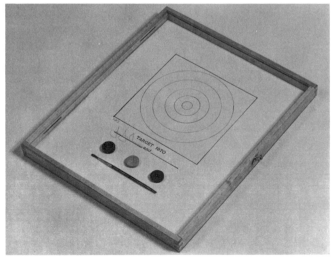

135

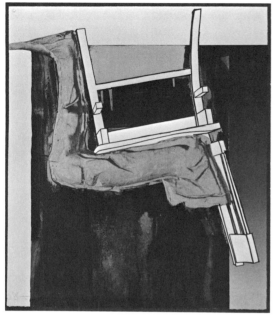

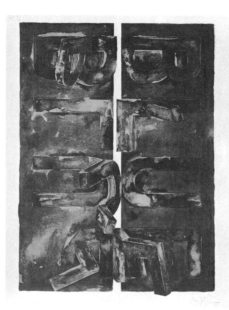

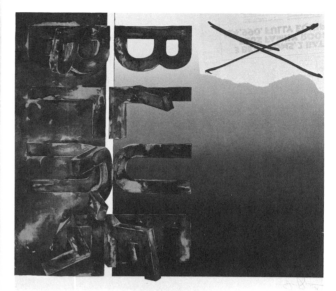

136

137

138

136.-142. Fragments – According to What 1971

136. Leg and Chair

Lithograph from one stone and six plates
 (1) black to white (blend)
 (2) black – stone (wash)
 (3) transparent gray (tone top center)
 (4) transparent warm gray (photoplate of leg)
 (5) transparent gray
 (6) white printed twice
 (7) black (chair drawing)

35 x 30 (889 x 762) Arches paper
Edition 68 plus 12 artist's proofs
Published by Gemini G.E.L.; printed by Jim Webb and
Timothy Huchthausen

The six *Fragments* (the seventh is only a "state") derive
from the painting *According to What,* 1964 (oil on canvas
with objects, 88 x 192 in., coll. Edwin Janss, Los Angeles).
The prints have served as the focus for an interview by John
Coplans (B-8) and articles by Walter Hopps, Patricia Kap-
lan and R.S. Field (B-27, 34, and 31).

137. Bent Blue (First State)

Lithograph from one stone and one plate
 (1) black – stone (wash)
 (2) transparent black (flat background)

31⅛ x 21¼ (791 x 540) handmade Crisbrook paper
Edition 10 plus 6 further impressions printed in blue
Published by Gemini G.E.L.; printed by Kenneth Tyler
and Charles Ritt

These elements, slightly altered, were used for *Bent Blue
(Second State).*

138. Bent Blue (Second State)

Lithograph from one stone, three plates, and a transfer
 (1) blue-black to white (blend) plus transfer
 (2) black – stone (wash)
 (3) transparent gray (tone)
 (4) blue (X)

25½ x 28¾ (648 x 730) Arches paper
Edition 66 plus 10 artist's proofs
Published by Gemini G.E.L.; printed by Charles Ritt,
Ron Olds, and Stuart Henderson

The torn-out newspaper cartoons were laid onto the inked
plate (1). The actual transfer of the image from the news-
print occurred during the printing of the plate and was ef-
fected by the dampness of the Arches paper.

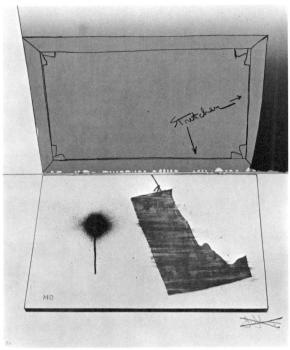

<p style="text-align:center">139</p>

139. Hinged Canvas

Lithograph from one stone and seven plates
 (1) gray (inside top stretcher)
 (2) black and white (blend at right)
 (3) black – stone (Duchamp profile and M.D.; wash
 along stretcher of bottom canvas; upper
 stretcher; word "stretcher"; gray behind words
 "hinge")
 (4) cream (bottom canvas)
 (5) black (line – lower canvas and hinges; words
 "hinge"; spatter and drip; touches to upper
 stretcher)
 (6) transparent gray (frame of lower stretcher)
 (7) blue to yellow to red (hinge line)
 (8) blue (X under signature)

36 x 30 (914 x 762) Arches paper
Edition 69 plus 12 artist's proofs
Published by Gemini G.E.L.; printed by Stuart Henderson, Ron McPherson, Jim Webb, and Lloyd Baggs

For the Duchamp profile, Johns made indirect use of Marcel Duchamp's own *Self-Portrait in Profile* of 1958. It was suspended from a string so as to cast a shadow; this new profile was traced onto stencil board, cut out, and then employed for the painting of 1964 as well as the lithograph of 1971.

140. Bent "U"

Lithograph from one stone and two plates
 (1) black – stone (wash and drawing)
 (2) dark green to white (blend)
 (3) transparent gray (central strip of flat tone)
 (4) blue to yellow to red

25 x 20 (635 x 508) Arches paper
Edition 69 plus 12 artist's proofs
Published by Gemini G.E.L.; printed by Ron Adams and Ron Olds

141. Bent Stencil

Lithograph from one stone and eight plates
 (1) black to cream (blend)
 (2) gray (center background)
 (3) dark gray violet (center stencil)
 (4) light gray violet (background lower stencil)
 (5) black – stone (wash; solid lower stencil; line
 drawing of stencils)
 (6) cream white printed twice (area that prints in
 the middle of and overlaps the third stencil –
 the latter appearing light blue-gray)*
 (7) silver (lower stencil)
 (8) transparent black (photoplate of lower stencil)*
 (9) transparent black (flat across lower stencil)

27½ x 20 (699 x 508) Arches paper
Edition 79 plus 12 artist's proofs
Published by Gemini G.E.L.; printed by Ron Olds and Lloyd Baggs

*In the Gemini documentation these two elements are reversed.

142. Coathanger and Spoon

Lithograph from two stones and five plates
 (1) gray (line drawing, drips and spatter)
 (2) light green – stone (wash)
 (3) black – stone (wash)
 (4) light transparent green (flat tone)
 (5) transparent black (line drawing)
 (6) red to yellow to blue
 (7) green black to white (bottom blend)

34 x 25¼ (864 x 641) Arches paper
Edition 76 plus 12 artist's proofs
Published by Gemini G.E.L.; printed by Charles Ritt and Ron Adams

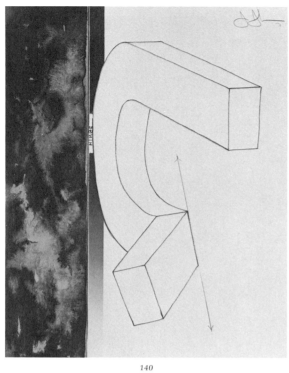

140

141

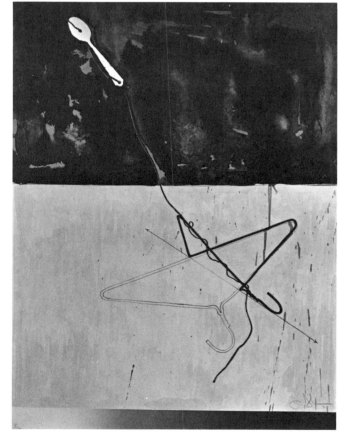

142

143. Bent Blue 1971

Lithograph from one plate in black
26 x 20 (660 x 508) Rives paper
Edition 240 plus 15 artist's proofs
Printed by Zigmunds Priede, Minneapolis
Published by the Swiss Society for Fine Arts

143

144. Untitled (Coca-Cola and Grid) 1971

Lithograph from two stones and six plates
 (1) light gray—stone (washes at right)
 (2) white (rectangle under Coca-Cola)
 (3) red (Coca-Cola)
 (4) red—stone (found grid stone)
 (5) yellow (spatter and drip)
 (6) green and gray (H and photo-plate of brush)
 (7) black (line drawing and hand)
 (8) varnish (over Coca-Cola)

39 x 29½ (991 x 749) Arches paper
Edition 66 plus 12 artist's proofs
Published by Gemini G.E.L.; printed by Timothy Huchthausen and Ron Olds

Derives from *Untitled*, 1963 (charcoal, gouache, watercolor, stencil, and collaged Coca-Cola decal, 40½ x 30 in., coll, Karl Ströher, Darmstadt). The lithograph very faithfully repeats the earlier work, with the difference that the "found object" is now the grid—printed from a stone discovered in the Gemini workshop.

144

145. Untitled (Shit) 1971

Lithograph from one stone and three plates
 (1) yellow to red—stone (background)
 (2) green to blue to purple (handmarks and ruler)
 (3) red to yellow to blue (line)
 (4) gray (upper line)

18½ x 24¼ (470 x 616) handmade Waterleaf paper
Edition 20 plus 7 artist's proofs
Published by Gemini G.E.L.; printed by George Page, Ron Olds, and Ron Adams

145

146. Screen Piece 1972

Screenprint from thirteen screens
 (1) gray (flat tone)
 (2) silver (under spoon and fork)
 (3) dark gray (halftone of spoon and fork, letters,
 and overall tone)
 (4) black (photoscreen made by printing preced-
 ing screen onto new screen)
 (5) red (left rectangle)
 (6) yellow (left rectangle)
 (7) blue (left rectangle)
 (8) green to purple to orange (right edge)
 (9) black (screened marks at right edge)
 (10) black (screened marks and spatter at left)
 (11) gray (screened light marks in gray field at left
 and stripe down right)
 (12) black (drawn marks upper right)
 (13) white (screened marks at right)

41⁵/₁₆ x 29½ (1050 x 750) Rives BFK paper
Edition 67 plus 15 artist's proofs
Printed by Takeshi Shimada, Kenjiro Nonaka, and
Hiroshi Kawanishi, New York City
Published by the artist and Simca Print Artists, Tokyo

The halftone photoscreen (3) was made from an older
screen that had been used for some of the *Screen Piece*
paintings and drawings of 1967-71. Other "screened
marks" or dots resulted from a similar double printing pro-
cedure. Having selected the dot patterns he wished to use,
Johns had them transformed into screens. Through these
screens ink was squeegeed onto the final printing screens—
i.e., those used for the present work. The resulting marks
partake of the mechanical nature of the dots and the irregu-
lar tonalities generated by the intermediate handprinting.

146

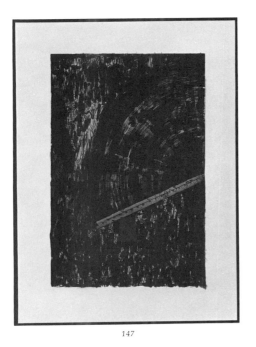

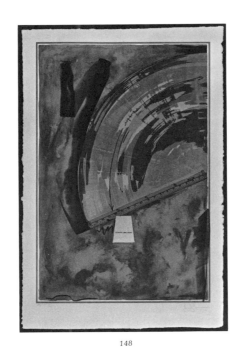

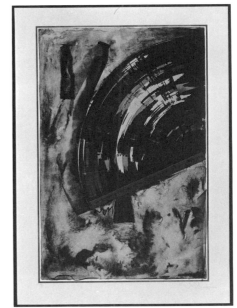

147 148 149

147. Good Time Charley (First Version) 1970-72

Lithograph from three stones and three plates
 (1) transparent gray (flat tone)
 (2) transparent gray (ruler tone)
 (3) transparent gray—stone (light wash in scrape, crayon work over entire background)
 (4) transparent gray (cup)
 (5) black—stone (large tusche brushstrokes)
 (6) black (letters, ruler markings, assorted broad crayon marks)

45¾ x 33 (1162 x 838) Arjomari paper (white)
Edition 8 plus 1 artist's proof
Published by Gemini G.E.L.; printed by Kenneth Tyler and Jim Webb

A first idea for a series of new images. By 1972 Johns had decided to "reproduce" the eight paintings in a more systematic and regularized fashion. They all include a flat tan border that is a surrogate for the strip-framing in which the artist set each canvas. The present work, therefore, should be considered outside the sphere of the other sixteen.

148. Good Time Charley 1971-72

Lithograph from three stones and three plates
 (1) light gray (flat tone)
 (2) medium gray—stone (scrape and wash)
 (3) tan flat (border and ruler)*
 (4) opaque white—stone (scrape)*

76

 (5) silver and gold (cup and wingnut)
 (6) dark gray—stone (ruler, lines, letters, broad stroke at left)

44 x 29 (1118 x 737) Angoumois à la main paper (white)
Edition 69 plus 9 artist's proofs
Published by Gemini G.E.L.; printed by Jim Webb, Ron Adams, and Ron Olds

Derived from *Good Time Charley,* 1961 (encaustic on canvas with objects, 38 x 24 in., coll. the artist). The image of the ruler was photographically transferred from the painting.
*Listed in reverse order in Gemini documentation.

149. Good Time Charley—Black State 1972

Lithograph from three stones and two plates
 (1) transparent gray (flat tone; same plate as (1) of first state)
 (2) black—stone (scrape and wash; same stone as (2) of first state)
 (3) transparent black—stone (scrape; same stone as (4) of first state)
 (4) transparent warm gray (border and ruler)
 (5) black—stone (ruler, lines, letters, broad stroke at left; same stone as (6) of first state)

44 x 30¾ (1118 x 781) Arjomari paper (white)
Edition 14 plus 1 artist's proof
Published by Gemini G.E.L.; printed by Jim Webb, Ron Adams, and Ron McPherson

150. Zone 1971-72

Lithograph from one stone and eight plates
- (1) light gray (flat tone)
- (2) opaque white (flat for cup, brush, and middle border)
- (3) tan (border)
- (4) opaque gray—stone (washes over lower half, plus overall line and broad strokes)
- (5) light gray (flat tone under upper zone)
- (6) light violet (flat of center rectangle and letters ZONE and JJ)
- (7) opaque blue and opaque white (horizontal line at very top; horizontal strokes below brush)
- (8) dark gray (broad tusche strokes upper zone)
- (9) light gray (broad crayon strokes lower zone, z-passage below brush, "Cup," and vertical rectangle drawing in center)

44 x 29 (1118 x 737) Angoumois à la main paper (white)
Edition 65 plus 9 artist's proofs
Published by Gemini G.E.L.; printed by George Page, Richard Ewen, Jim Webb, and Chuck DeLong

Derived from *Zone*, 1962 (two canvas panels—one in oil, one encaustic—with objects, 60 x 30 in., coll. Kunsthaus, Zurich).

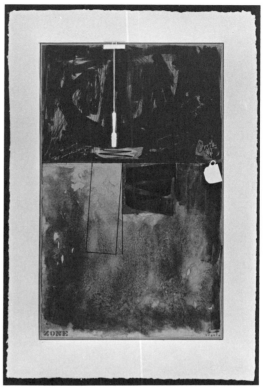

150

151. Zone—Black State 1972

Lithograph from one stone and five plates
- (1) transparent gray (flat tone; same plate as (1) of first state)
- (2) transparent gray (flat tone, cooler, for cup, brush, and middle border; same plate as (2) of first state)
- (3) black—stone (washes over lower half, plus overall line and broad strokes; same plate as (4) of first state)
- (4) transparent gray (rectangle in center and letters ZONE and JJ; same plate as (6) of first state)
- (5) black (broad crayon strokes overall, "Cup," vertical rectangle center; replaces plate (9) of first state)
- (6) black (horizontal line at very top; horizontal strokes below brush; same plate as (7) of first state)

44 x 29 (1118 x 737) Arjomari paper
Edition 16
Published by Gemini G.E.L.; printed by George Page, Serge Lozingot, and Richard Ewen

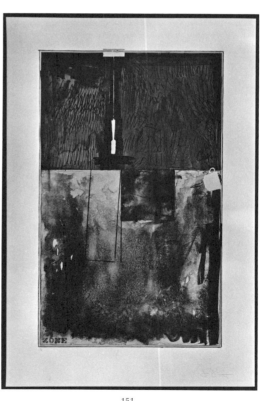

151

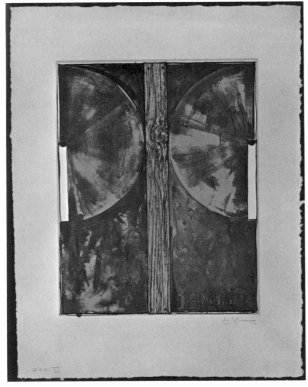

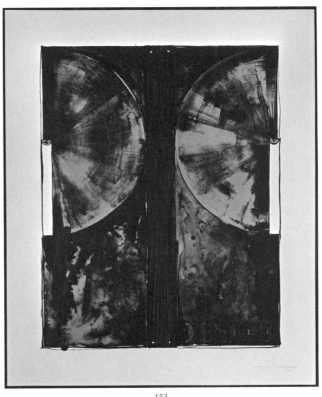

152

153

152. Device 1971-72

Lithograph from one stone and six plates
 (1) white (devices and border)
 (2) tan (border and board)
 (3) silver and gold (hardware)
 (4) light gray (flat tone)
 (5) gray—stone (washes and crayoned board grain)
 (6) medium gray (crayon lines; marks made with
 flat crayon upper left and left center)
 (7) dark gray (light line and crayon marks upper
 left; edges; four circles for nails)

38½ x 29½ (978 x 749) Angoumois à la main paper
(warm white)
Edition 62 plus 9 artist's proofs
Published by Gemini G.E.L.; printed by Richard
Ewen, Jim Webb, George Page, and Ron Olds

Derived from *Device*, 1962 (oil and boards on canvas, 40 x
30 in., coll. Ileana Sonnabend, Paris).

153. Device—Black State 1971-72

Lithograph from one stone and four plates
 (1) transparent gray (flat tone; same plate as (4) of
 first state)
 (2) transparent gray (board minus border; altered
 plate (2) of first state)
 (3) transparent black—stone (washes and crayoned
 board grain; same stone as (5) of first state)
 (4) black (crayon lines; marks made with flat
 crayon upper left and left center; same plate as
 (6) of first state)
 (5) black (light line and crayon marks upper left;
 edges; four circles for nails; same plate as (7) of
 first state)

32¼ x 25¾ (819 x 654) Arjomari paper (white)
Edition 14 plus 1 artist's proof
Published by Gemini G.E.L.; printed by George Page,
Ron McPherson, and Ron Adams

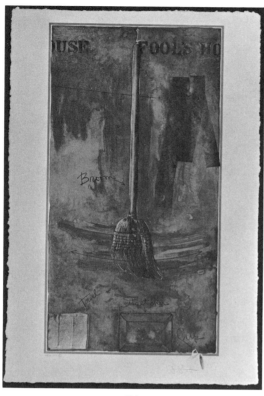

154

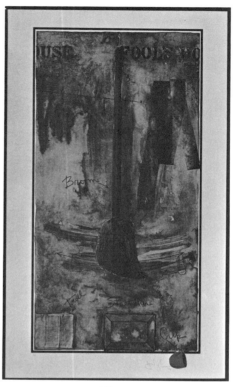

155

154. Fool's House 1971-72

Lithograph from one stone and eight plates
 (1) light gray (flat tone)
 (2) medium gray—stone (washes including sten-
 ciled letters)
 (3) orange and bluish white (flat tones under
 broom and cup)
 (4) silver (flat tone for towel, broom, and cup
 hooks)
 (5) light yellow (flat tone under brush)
 (6) warm black (halftone photoplate of broom,
 towel, and cup)
 (7) medium gray (flat tone for broom handle and
 brush)
 (8) tan (border)
 (9) dark gray (writing, letters, line, broad mark
 made with side of crayon at upper right)

44 x 29 (1118 x 737) Angoumois à la main paper
(white)
Edition 67 plus 9 artist's proofs
Published by Gemini G.E.L.; printed by Serge Lozin-
got, Dan Freeman, and Chuck DeLong

Derived from *Fool's House*, 1962 (oil on canvas with ob-
jects, 72 x 36 in., coll. Jean Christophe Castelli).

155. Fool's House—Black State 1972

Lithograph from one stone and six plates
 (1) transparent gray (flat tone; same plate as (1) of
 first state)
 (2) transparent black—stone (washes including
 stenciled letters; same stone as (2) of first state)
 (3) transparent gray (flat tone under broom and
 cup; same plate as (3) of first state)
 (4) transparent gray (flat tone under brush; same
 plate as (5) of first state)
 (5) transparent black (halftone of broom, towel,
 and cup; same plate as (6) of first state)
 (6) transparent black (border; same plate as (8) of
 first state)
 (7) black (writing, letters, line, broad mark made
 with side of crayon at upper right; same plate
 as (9) of first state)

44 x 26 (1118 x 660) Arjomari paper (white)
Edition 18
Published by Gemini G.E.L.; printed by Serge Lozin-
got and Chuck DeLong

156

157

156. Souvenir I 1971-72

Lithograph from one stone and five plates
 (1) light gray (flat tone)
 (2) white (flat tone under flashlight, plate, border, shelf, and mirror)
 (3) tan (flat for border and shelf)
 (4) gray—stone (washes)
 (5) medium gray (photoplate of artist)
 (6) dark gray (letters and heavy tusche drip)

38½ x 29½ (978 x 749) Angoumois à la main paper (pinkish)
Edition 63 plus 9 artist's proofs
Published by Gemini G.E.L.; printed by
Ron Adams and Serge Lozingot

Derived from *Souvenir I*, 1964 (encaustic on canvas with objects, 28¾ x 21 in., coll. the artist).

157. Souvenir—Black State 1972

Lithograph from one stone and five plates
 (1) transparent gray (flat tone; same plate as (1) of first state)
 (2) black—stone (washes and line border; same stone as (4) of first state)
 (3) transparent gray (flat tone under flashlight, plate, border, shelf, and mirror; same plate as (2) of first state)
 (4) transparent gray (photoplate of artist; same plate as (5) of first state)
 (5) dark gray (border and shelf; same plate as (3) of first state)*
 (6) black (letters and heavy tusche drip; same plate as (6) of first state)

34 x 26½ (864 x 673) Arjomari paper (white)
Edition 16 plus 1 artist's proof
Published by Gemini G.E.L.; printed by George Page, Serge Lozingot, Ron McPherson, and Chuck DeLong
*Gemini documentation records black ink.

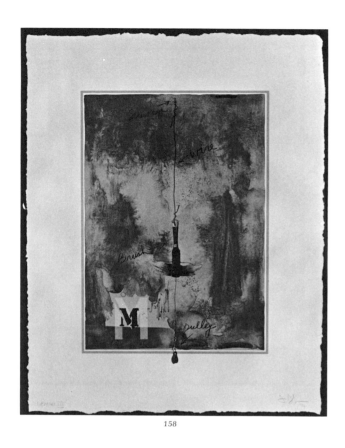

158

159

158. "M" 1971-72

Lithograph from one stone and seven plates
 (1) light gray (flat tone)
 (2) white (flat for border, brush, pulley)
 (3) tan (border)
 (4) gray — stone (washes)
 (5) silver (pulley and paintbrush)
 (6) brownish gray (photoplate of brush and
 pulley)*
 (7) blue and white (paintbrush handle and "M")*
 (8) dark gray (writing, darker marks, "M", and
 marks around brush)

38½ x 29½ (978 x 749) Angoumois à la main paper
(warm)
Edition 67 plus 9 artist's proofs
Published by Gemini G.E.L.; printed by Ron McPherson, Dan Freeman, and Ron Olds
Derived from "M", 1962 (oil on canvas with objects, 36 x 24
in., private collection).
*Gemini documentation indicates that these elements were
printed in reverse order.

159. "M" — Black State 1972

Lithograph from one stone and five plates
 (1) transparent gray (flat tone; same plate as (1) of
 first state)
 (2) transparent black — stone (washes; same stone
 as (4) of first state)
 (3) transparent black (paintbrush handle and "M";
 same plate as (7) of first state)
 (4) transparent black (photoplate of brush and
 pulley; same plate as (6) of first state)
 (5) black (border; same plate as (3) of first state)
 (6) transparent black (writing, darker marks,
 smaller "M", and marks around brush; same
 plate as (8) of first state)

34¾ x 25½ (833 x 648) Arjomari paper (white)
Edition 16 plus 1 artist's proof
Published by Gemini G.E.L.; printed by Ron McPherson and George Page

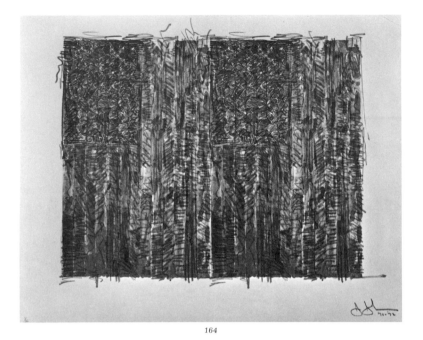

164

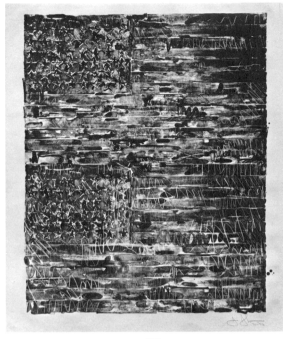

165

164. Two Flags (Gray) 1970-72

Lithograph from two stones and three plates, each
printed twice on a hand-fed, offset proofing press
 (1) gray – stone (washes; printed left and right)
 (2) gray – stone (washes; printed left and right)
 (3) gray (crayon; printed left, then altered by
 subtraction, and printed right)
 (4) gray (crayon; printed left, then altered by
 subtraction, and printed right)
 (5) gray (crayon; printed left, then altered by
 subtraction, and printed right)

27½ x 32 (698 x 813) Japan paper
Edition 36 plus 9 artist's proofs
Published by U.L.A.E.; printed by Bill Goldston and
James V. Smith

Two stones, drawn with tusche, were printed for the left flag
and again for the right. To these were added three plates
which originally had been drawn in crayon and printed
blue, black, and red for the lithograph of 1967-70, *Flags II*
(F.130). The three were printed first for the left flag, then
altered by subtraction, and printed for the right flag. The
double reversal afforded by offset printing enabled the ar-
tist to turn the image so that the flags appeared vertically
rather than horizontally (as they had in all previous prints),
and still to maintain the field of stars at the upper left. A
graphite wash drawing, *Two Flags*, 1960 (26¾ x 20½ in.,
coll. the artist) appears, despite their horizontal orientation,
to have been the immediate prototype for the present
image.

165. Two Flags (Black) 1970-72

Lithograph from two stones, each printed twice
 (1) black – stone (printed top, altered by addition,
 and printed bottom)
 (2) black – stone (printed top, altered by addition,
 and printed bottom)

31½ x 23 (800 x 584) India paper
Edition 40 plus 5 artist's proofs
Published by U.L.A.E.; printed by Bill Goldston

The two stones used for the preceding offset lithograph
were changed by scratching into their surfaces, thereby in-
troducing a new design of white lines. After pulling the
upper flag (by the normal method of hand printing that re-
verses the drawn image), the stones were re-opened, the de-
sign altered again – this time with tusche – and only then
was the bottom flag printed. Although it employs elements
from the preceding work, the image resembles *Two Flags*,
1959 (plastic paint on canvas, 79¼ x 58¼, whereabouts
unknown).

166. A Cartoon for Tanya 1972

Lithograph from one plate printed in black on a
hand-fed, offset proofing press

24¼ x 37 (616 x 940) Japan paper
Edition 10
Unpublished lithograph, printed at U.L.A.E. by James
V. Smith

166

167. Cups 4 Picasso 1972

Lithograph from four plates printed on a hand-fed,
offset proofing press
 (1) blue to red to yellow (line)
 (2) red to yellow to blue (background colors—each
 square inked separately)
 (3) black to white (cup, left—printed four times to
 build up opacity)
 (4) black to white (profiles, right—printed four
 times to build up opacity)

22 x 32 (559 x 813) Japan paper
Edition 39 plus 5 artist's proofs
Published by U.L.A.E.; printed by Bill Goldston and
James V. Smith

167

168. Cup 2 Picasso 1973

Lithograph from three plates, printed on a hand-fed,
offset proofing press
 (1) cream (cup and dots)
 (2) black (tusche and line for Picasso profiles)
 (3) red to yellow to blue (line)

19¾ x 12 (502 x 305) glass paper manufactured by
Fred Siegenthaler in Basel, Switzerland
Edition 11 plus 4 artist's proofs
Published by U.L.A.E.; printed by Bill Goldston and
James V. Smith

168

169

170

169. Decoy II 1971-73

Lithograph from one stone printed on a hand press and twenty-five plates printed on a hand-fed, offset proofing press

 (1)-(19) same stone and plates as *Decoy I,* 1971
 (20) blue to yellow to red (blended band across bottom)
 (21) black (spatter, bottom)
 (22) green gray (washes upper center)
 (23) dark gray (crayon strokes at top, upper center; x at right)
 (24) green, purple, and gold (intrusions at lower left and lower right; gold over ale can)
 (25) transparent black (broad tusche x at bottom and flat black around ale can)
 (26) white (circle)

41 x 29 (1041 x 736) Rives BFK paper
Edition 31 plus 5 artist's proofs
Published by U.L.A.E.; printed by Bill Goldston and James V. Smith

Decoy II came into being when a group of flawed impressions of *Decoy* (F.134) was uncovered (had they intentionally been put aside for further work as had the overrun of *Flags*—see F.130?). The unusually varied and bold overprintings relate to the approach Johns had taken to the second, painted version of *Decoy* (oil on canvas with grommet, 47 x 29½ in., coll. John Powers, Carbondale, California).

170. Painting with a Ball 1972-73

Lithograph from three plates, printed on a hand-fed, offset proofing press

 (1) transparent warm black (background tone)
 (2) cooler black (wash)
 (3) black (crayon)

31 x 22½ (787 x 572) J. Whatman 1962 handmade paper
Edition 42 plus 5 artist's proofs
Published by U.L.A.E.; printed by Bill Goldston and James V. Smith

Derived from *Painting with a Ball,* 1958 (encaustic on canvas, 14¾ x 9¾, coll. Edward Power, London).

171. Target 1973

Screenprint from six screens: one flat and five drawn, all printed in the same transparent gray ink

23¾ x 16⅜ (603 x 416) handmade Ohiro-Mimitsuki paper

Edition 100 plus 13 artist's proofs

Printed by Takeshi Shimada, Kenjiro Nonaka, and Hiroshi Kawanishi, New York City

Published by The Committee to Endow a Chair in Honor of Meyer Schapiro at Columbia University

One of twelve prints (by Hayter, Johns, Kelly, Liberman, Masson, Motherwell, Oldenburg, Rauschenberg, Steinberg, Stella, and Warhol) in the portfolio, *For Meyer Schapiro.*

In its monochromatic rendering, this screenprint may be related to the many single-color paintings of Johns' early years, specifically to a work like *Green Target* which derives as much of its structure from the collaged elements as from the painterly chiaroscuro.

172. Untitled (Skull) 1973

Screenprint from three screens
 (1) white to cream to warm black (blended background)
 (2) red to yellow to blue (line)
 (3) black (skull and x)

24 x 33 (610 x 838) J.B. Green English Etching paper

Edition 100 plus 25 artist's proofs

Printed by Adolph Rischner and family at Styria Studio, New York

Published by Multiples, Inc., New York

One of seven prints (by Arakawa, Fahlstrom, Johns, Oldenburg, Rauschenberg, Rosenquist, and Ruscha) in the portfolio, *Reality & Paradoxes.*

Although the skull has appeared often enough in Johns' works (e.g. in the drawings and lithograph entitled *Skin* of 1962-65, see F.48; in *Evion* of 1964, see F.160; and in the etching, *Face,* from *Fizzles* of 1975, see F.217), its significance as an autobiographical mask varies. On some occasions it has resulted from an imprint of the artist's own flesh; on others, as here, it was the direct transfer of ink from an actual skull. If meaning can be sought in the very means of printmaking—rather than in an interpretation of symbols—it may be noted that the cross or 'x' was printed from the same screen as the skull.

173. Flags I 1973

Screenprint from thirty-one screens

(1) Right—light green (handcut stencil printed under red stripes)
(2) Right—light gray (handcut stencil printed under stars and white stripes)
(3) Right—light orange (handcut stencil printed under blue field)
(4) Left—light green (handcut stencil printed under red stripes)
(5) Left—light gray (handcut stencil printed under stars and white stripes)
(6) Left—light orange (handcut stencil printed under blue field)
(7) Right—dark gray (tusche stencil printed under white stripes)
(8) Left—dark gray (tusche stencil printed under white stripes)
(9) Right—dark green (tusche stencil printed under red stripes)
(10) Left—dark green (tusche stencil printed under red stripes)
(11) Right—dark orange (tusche stencil printed under blue field)
(12) Left—dark orange (tusche stencil printed under blue field)
(13) Right—dark blue (tusche stencil printed for blue field)
(14) Left—dark blue (tusche stencil printed for blue field)
(15) Right—dark red (tusche stencil printed for red stripes)
(16) Left—dark red (tusche stencil printed for red stripes)
(17) Right—cream white (tusche stencil printed for stars and white stripes)
(18) Left—cream white (tusche stencil printed for stars and white stripes)
(19) Right—medium white (tusche stencil printed for stars and white stripes)
(20) Left—medium white (tusche stencil printed for stars and white stripes)
(21) Right—light red (tusche stencil printed for red stripes)
(22) Left—light red (tusche stencil printed for red stripes)
(23) Right—medium blue (tusche stencil printed for blue field)
(24) Left—medium blue (tusche stencil printed for blue field)
(25) Left—medium red (tusche stencil printed for red stripes)
(26) Left—light blue (tusche stencil printed for blue field)
(27) Left—bright white (tusche stencil printed for stars and white stripes)
(28) Right—varnish gloss (handcut stencil printed over entire right flag)
(29) Right—medium red (tusche stencil printed for red stripes)
(30) Right—light blue (tusche stencil printed for blue field)
(31) Right—bright white (tusche stencil printed for stars and white stripes)

27½ x 35 (698 x 889) J.B. Green paper
Edition 65 plus 7 artist's proofs
Printed by Takeshi Shimada, Kenjiro Nonaka, and Hiroshi Kawanishi, New York City
Published by the artist and Simca Print Artists, Tokyo

The print was based on the painting *Two Flags* of 1973, (encaustic and oil on canvas, 52^{7}⁄₁₆ x 69^{9}⁄₁₆ in., coll. Jacques Koerfer, Ascona). A reduced photograph of the painting was placed beneath the screens to provide a guide for the artist as well as to assure registration. In general the colors of the left-hand flag are slightly more saturated and the drawing slightly more dense; on the other hand, the colors of the right-hand flag were frequently combined with a varnish to add depth and surface lustre. These distinctions parallel those evoked by the two media of the painted prototype.

174. Flags II 1973

Screenprint from thirty screens identical to those employed for *Flags I*, minus only the varnish screen (28), all printed in the same transparent graphite ink

27½ x 35 (698 x 889) J.B. Green paper
Edition 60 plus 10 artist's proofs
Printed by Takeshi Shimada, Kenjiro Nanaka, and Hiroshi Kawanishi, New York City
Published by the artist and Simca Print Artists, Tokyo

Some of the screens were slightly altered by lacquer blockout to emphasize edges that would have otherwise been lost in the complex build-up of tones.

173

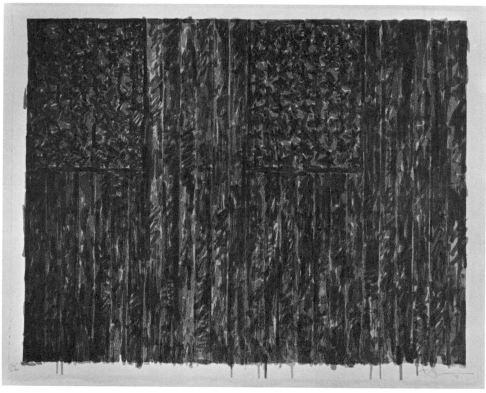

174

89

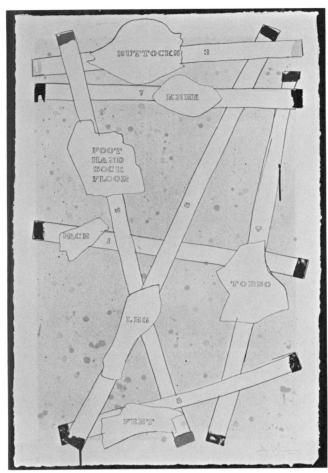

175

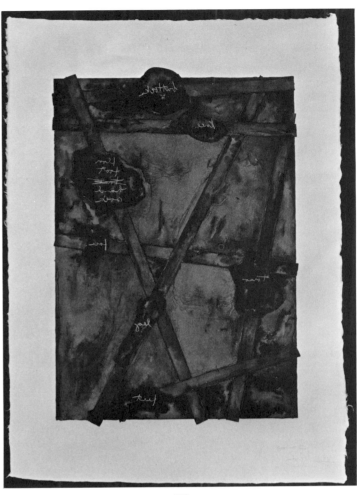

176

175. Sketch from Untitled, I 1973-74

Lithograph from six plates
 (1) golden yellow (spatter)
 (2) transparent mauve (spatter)
 (3) gray (drawing)
 (4) yellow and blue (board ends)
 (5) green, red, flesh (board ends and casts)
 (6) black, orange, violet (board ends)

43 x 29 (1092 x 737) Angoumois à la main paper
Edition 50 plus 10 artist's proofs
Published by Gemini G.E.L.; printed by Charles Ritt
and Ed Henderson

This lithograph initiated Johns' intense three-year involve-
ment with the imagery and meaning of the four-panelled
painting, *Untitled,* 1972 (encaustic, oil, and collage on
canvas with objects, 72 x 192 in., coll. Dr. Peter Ludwig,
Cologne).

176. Sketch from Untitled, II 1973-74

Lithograph from one stone and two plates
 (1) black — stone (washes)
 (2) transparent black (flat tone)
 (3) opaque white (letters)

36½ x 26 (927 x 660) Washi No Mise paper
Edition 50 plus 9 artist's proofs
Published by Gemini G.E.L.; printed by Dan Freeman
and Robbin Geiger

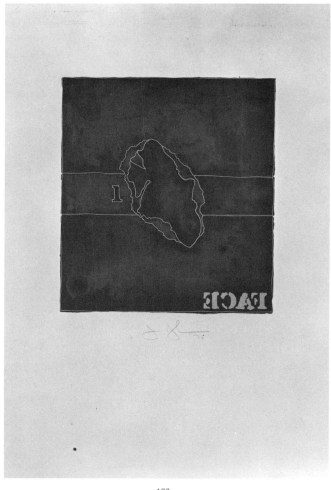

177

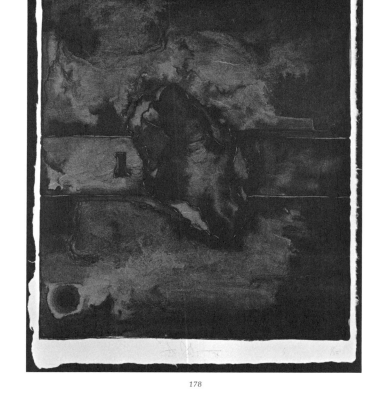

178

177-190. Casts from Untitled 1973-74

177. Face

Lithograph from one stone and two plates
 (1) red – stone (washes)
 (2) transparent red (flat tone)
 (3) white (drawing)

30¾ x 22¾ (781 x 578) Laga Narcisse handmade paper
Edition 49 plus 10 artist's proofs
Published by Gemini G.E.L.; printed by Charles Ritt and Barbara Thomason

In this and many other works of the period, the flat tone plate is printed *after* the washes. This procedure assured the transfer of the maximum amount of detail from the delicate wash stone (or plate).

178. Face – Black State

Lithograph from one stone and two plates
 (1) transparent black – stone (washes)
 (2) black (drawing)
 (3) transparent black (flat tone)

15¾ x 13¾ (400 x 349) Washi No Mise paper
Edition 15
Published by Gemini G.E.L.; printed by Charles Ritt and Barbara Thomason

The *Casts* were created and finished during the more lengthy and complex work devoted to *Four Panels after Untitled 1972* (F. 194-197). In no other series has Johns maintained such constancy of technical approach as he did with *Casts*; as such they contrast vividly with the varied and subtle procedures demanded by *Four Panels*.

179. HandFootSockFloor

Lithograph from one stone and two plates
(1) purple—stone (washes)
(2) transparent purple (flat tone)
(3) white (drawing)

30¾ x 22¾ (781 x 578) Laga Narcisse handmade paper
Edition 48 plus 10 artist's proofs
Published by Gemini G.E.L.; printed by Serge Lozingot and Edward Henderson

179

180. HandFootSockFloor—Black State

Lithograph from one stone and two plates
(1) transparent black—stone (washes)
(2) black (drawing)
(3) transparent black (flat tone)

16 x 19¾ (406 x 502) Washi No Mise paper
Edition 13
Published by Gemini G.E.L.; printed by Serge Lozingot and Edward Henderson

180

181. Buttocks

Lithograph from one stone and two plates
(1) blue—stone (washes)
(2) transparent blue (flat tone)
(3) white (drawing)

30¾ x 22¾ (781 x 578) Laga Narcisse handmade paper
Edition 49 plus 10 artist's proofs
Published by Gemini G.E.L.; printed by Jim Webb and Barbara Thomason

181

182. Buttocks—Black State

Lithograph from one stone and two plates
(1) transparent black—stone (washes)
(2) black (drawing)
(3) transparent black (tone)

16 x 16 (406 x 406) Washi No Mise paper
Edition 12
Published by Gemini G.E.L.; printed by Jim Webb, Barbara Thomason, and Richard Ewen

182

183. Torso

Lithograph from one stone and two plates
 (1) green – stone (washes)
 (2) transparent green (flat tone)
 (3) white (drawing)

30¾ x 22¾ (781 x 578) Laga Narcisse handmade
paper
Edition 50 plus 10 artist's proofs
Published by Gemini G.E.L.; printed by Dan Freeman
and Robbin Geiger

183

184. Torso – Black State

Lithograph from one stone and two plates
 (1) transparent black – stone (washes)
 (2) black (drawing)
 (3) transparent black (flat tone)

16 x 18½ (406 x 470) Washi No Mise paper
Edition 14
Published by Gemini G.E.L.; printed by Dan Freeman
and Robbin Geiger

184

185. Feet

Lithograph from one stone and two plates
 (1) yellow – stone (washes)
 (2) transparent yellow (flat tone)
 (3) white (drawing)

30¾ x 22¾ (781 x 578) Laga Narcisse handmade
paper
Edition 47 plus 10 artist's proofs
Published by Gemini G.E.L.; printed by Jim Webb and
Barbara Thomason

185

186. Feet – Black State

Lithograph from one stone and two plates
 (1) transparent black – stone (washes)
 (2) black (drawing)
 (3) transparent black (flat tone)

16 x 16½ (406 x 419) Washi No Mise paper
Edition 12
Published by Gemini G.E.L.; printed by Jim Webb and
Barbara Thomason

186

187. Leg

Lithograph from one stone and two plates
 (1) orange – stone (washes)
 (2) transparent orange (flat tone)
 (3) white (drawing)

30¾ x 22¾ (781 x 578) Laga Narcisse paper
Edition 50 plus 10 artist's proofs
Published by Gemini G.E.L.; printed by Serge
Lozingot and Edward Henderson

187

188. Leg – Black State

Lithograph from one stone and two plates
 (1) transparent black – stone (washes)
 (2) black (drawing)
 (3) transparent black (flat tone)

16 x 22 (406 x 559) Washi No Mise paper
Edition 13
Published by Gemini G.E.L.; printed by Serge
Lozingot and Edward Henderson

188

189. Knee

Lithograph from one stone and two plates
 (1) black – stone (washes)
 (2) transparent black (flat tone)
 (3) white (drawing)

30¾ x 22¾ (781 x 578) Laga Narcisse handmade
paper
Edition 47 plus 10 artist's proofs
Published by Gemini G.E.L.; printed by Serge
Lozingot

189

190. Knee – Black State

Lithograph from one stone and two plates
 (1) transparent black – stone (washes)
 (2) black (drawing)
 (3) transparent black (flat tone)

15¾ x 15 (400 x 381) Washi No Mise paper
Edition 13
Published by Gemini G.E.L.; printed by Serge
Lozingot

190

191. Target (Black and Gray) 1974

Screenprint from two hand-drawn screens
 (1) light gray
 (2) black

38 x 26⁹/₁₆ (965 x 675) ivory, varnished Japan paper
Edition 30 plus 2 artist's proofs
Printed by Takeshi Shimada, Kenjiro Nonaka, and
Hiroshi Kwanishi, New York City
Published by the artist and Simca Print Artists, Tokyo

Johns whipped off this *Target* as an antidote to the laborious
trial-and-error procedure demanded by the color *Target*
(F.192) being proofed at the same time. The boldness of the
black target may be compared to that of the now-destroyed
Black Target of 1959 (encaustic and collage on canvas, 54 x
54 in.).

192. Target 1974

Screenprint from twenty-seven, hand-drawn screens
 (1) light, light green ⎫
 (2) light, light violet ⎬ (drawn under entire image)
 (3) light, light orange ⎭
 (4) light, light blue
 (5) light, light red
 (6) light, light yellow
 (7) light blue
 (8) light red
 (9) light yellow
 (10) blue
 (11) red
 (12) yellow
 (13) light violet
 (14) light green
 (15) light orange
 (16) violet
 (17) green
 (18) orange
 (19) dark blue
 (20) dark yellow
 (21) dark red
 (22) dark orange
 (23) dark violet
 (24) dark green
 (25) dark, dark red (stroke above purple rectangle)
 (26) dark, dark orange (addition to orange
 rectangle)
 (27) dark, dark green (stroke to left of green
 rectangle)

34⁷/₈ x 27³/₈ (885 x 696) J.B. Green paper
Edition 70 plus 9 artist's proofs

Printed by Takeshi Shimada, Kenjiro Nonaka, and
Hiroshi Kawanishi, New York City
Published by the artist and Simca Print Artists, Tokyo

All screens were drawn in tusche by the artist. The immedi-
ate prototype was a painting of 1974, *Target* (encaustic and
collage on canvas, 61¼ x 53¼ in., coll. Seibu Museum of
Art, Tokyo). Basically, the image returns to that of *Target
with Plaster Casts* of 1955 (encaustic and collage on canvas
with wood and plaster casts, 51 x 44 x 3½ in., coll. Mr. and
Mrs. Leo Castelli, New York) as well as to the earlier screen-
print of 1968 (F.92).

191

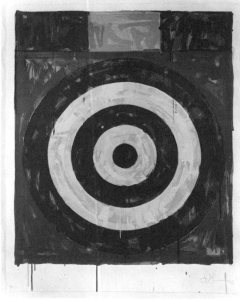

192

194.-197. Four Panels from Untitled 1972
1973-74

Each panel 40 x 28½ (1016 x 724) Laurence Barker, gray, handmade paper
Edition 45 plus 10 artist's proofs
Published by Gemini G.E.L.; printed by Serge Lozingot, Charles Ritt, and Jim Webb

194. A/D Hatching (Colors)

Lithograph from fourteen plates and embossing
 *(1) yellow } (tusche drawing for
 (2) red } obscured hatching)
 (3) blue }
 (4) violet white
 (5) yellow white
 *(6) orange
 *(7) green } (major accents of hatching)
 *(8) purple }
 (9) yellow white (same as plate 5)
 *(10) orange
 *(11) green } (crayon drawing)
 *(12) purple }
 (13) violet white (same as plate 4)
 (14) blue, green, black, red, and yellow
 (tips at edges)
 (15) embossing with pattern derived from D/D
*Indicates plate used again or transferred for A/D (Grays and Black)

195. B/D Flagstones (Colors)

Lithograph from ten plates and embossing
 *(1) white (bold underdrawing for entire image)
 (2) yellow white (mostly flats for majority of stones)
 (3) violet white (flats for six stones and contours for eight)
 (4) yellow white (same plate as 2)
 (5) violet white (same plate as 3)
 *(6) red
 *(7) black
 (8) white (same plate as 1)
 *(9) transparent red (flat tone over areas of 6)
 (10) transparent black (flat tone over areas of 7)
 (11) embossing with pattern derived from A/D
Parts of plates 1-9 were transferred from the corresponding plates of C/D.

*Indicates plate used again for B/D (Grays and Black)

193. M.D. 1974

Die-cut stencil board

22 x 18 (559 x 457) heavy, buff, stencil paper
Edition 100 plus 30 artist's proofs
Published by Multiples, Inc. and Castelli Graphics, New York
One of seven prints (by Cage, Johns, Morris, Nauman, Rauschenberg, Stella, and Warhol) in the *Merce Cunningham Portfolio.*

The die-cutting was executed commercially but supervised by Hiroshi Kawanishi. The artist is not certain whether he redrew the image or utilized the template prepared while working on *According to What* (see F.139).

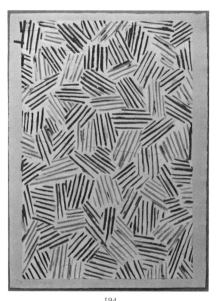

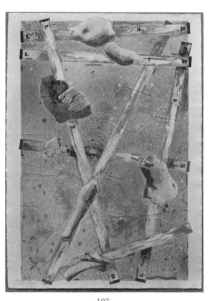

194 195 196 197

196. C/D Flagstones (Colors)

Lithograph from eleven plates and embossing
 *(1) white (bold underdrawing for entire image)
 (2) yellow white
 (3) violet white
 (4) yellow white (same plate as 2)
 (5) violet white (same plate as 3)
 *(6) red
 *(7) black
 *(8) transparent red (flats over areas of 6)
 (9) transparent black (flats over areas of 7)
 (10) white (same plate as 1)
 (11) pink, blue, red (vertical stroke center; two
 board ends right)
 (12) embossing with pattern derived from B/D
*Indicates plate used again for C/D (Grays and Black)

197. D/D Casts (Colors)

Lithograph from one stone and thirteen plates and
embossing
 (1) white (beneath casts)
 (2) transparent, cool gray-green (flat tone underly-
 ing most of image except casts and boards;
 includes a few random spots and calligraphic
 strokes)
 (3) transparent pink flesh (flat tone underlying
 areas to right and left; a few calligraphic marks)
 (4) transparent warm beige (flat tone mostly under
 upper left and lower right; a few additional
 calligraphic marks)
 *(5) warm tan-pink (spatter and drawing)
 *(6) transparent gray-green (halftone plate for casts)
 *(7) transparent brown—stone (wooden boards)
 (8) blue (board ends and a few accents)
 (9) purple (board ends and a few accents)
 (10) yellow (board ends and a few accents)
 (11) orange (board ends and a few accents)
 (12) red (board ends and a few accents)
 (13) green (board ends and a few accents)
 (14) gray and black (board ends and a few accents)
 (15) embossing with patterns derived from C/D
*Indicates plate used again for D/D (Grays and Black)

The artist has preserved 28 trial proofs of this image—not so
much as exempla of theme and variation—but as a record of
the serious and unceasing pursuit of a just solution. **97**

198.-201. Four Panels from Untitled 1972 (Grays and Black) 1973-75

Each panel 41 x 32 (1041 x 813) with irregular edges;
on John Koller HMP gray, handmade paper
Edition 20 plus 7 artist's proofs
Published by Gemini G.E.L.; printed by Dan Freeman,
Serge Lozingot, Charles Ritt, Jim Webb, Anthony
Zepeda, and Barbara Thomason

The color set was begun during the same working period as
the two *Untitled* lithographs of 1973 (F.175 & 176); at that
time the Grays and Black set was not anticipated. Although
each panel derives from its counterpart in *Untitled*, 1972
(encaustic, oil, and collage on canvas with wood and wax
casts, 72 x 192 in., coll. Dr. Peter Ludwig, Cologne), each
relates in its own specific manner: A/D (Hatching) is a free
variation; B/D and C/D (Flagstones) remain rather close to
the original image; and D/D (Casts) employs a photoplate of
the actual panel. Added to each of the prints, however, is an
embossed plate. For A/D, B/D, and C/D the image of the prior
(left-hand) panel was drawn by the artist and then commer-
cially etched. The resulting plate was placed under each
print (to avoid marring the printed surface) so that a posi-
tive image was pressed *into* the print ("debossing" in the
terminology of the Gemini documentation). For D/D, how-
ever, Johns' drawing was etched in relief so that the positive
image—in the print—was raised *above* the surface of the
print ("embossing" in the terminology of the Gemini
documentation).

We have indicated, however clumsy words render these re-
lationships, which elements of the color series were em-
ployed in printing the Grays and Black. The reader is
reminded that although actual plates were often re-used,
not infrequently were parts or whole elements transferred
to other plates.

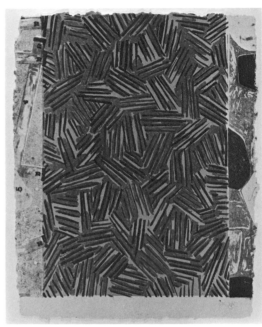

198

198. A/D Hatching (Grays and Black)

Lithograph from six plates
 (1) transparent light gray (same plate as A/D 1;
 plus drawn additions for left and right borders)
 (2) transparent light gray (same plate as A/D 6;
 plus transfers from D/D 5 and B/D 1 for left and
 right borders)
 (3) transparent medium gray (same plate as A/D 7;
 plus transfer from A/D 10)
 (4) transparent dark gray (same plate as A/D 8;
 plus transfer from A/D 11; plus transfer from
 D/D 7 and drawn additions for left and right
 borders)
 (5) black (same plate as A/D 12; plus drawn and
 stenciled additions for left and right borders)
 (6) transparent gray (flat tone over entire central
 image)

199. B/D Flagstones (Grays and Black)

Lithograph from five plates
 (1) transparent light gray (same plate as B/D 1;
 plus drawn additions for left and right borders)
 (2) transparent gray (same plate as B/D 9 with
 additions; plus transfers from A/D 5 and C/D 1
 for left and right borders)
 (3) dark gray (same plate as B/D 7; plus drawn
 additions for left and right borders)
 (4) black (same plate as B/D 6; plus drawn addi-
 tions for left and right borders)
 (5) transparent gray (flat tone over entire central
 image)

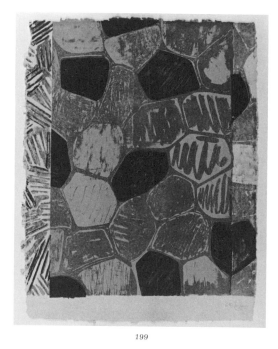

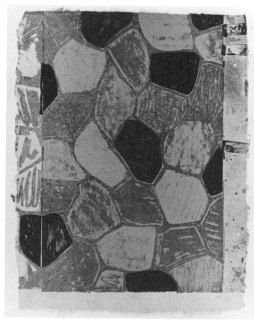

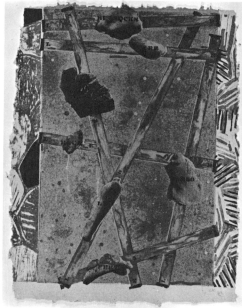

199

200

201

200. C/D Flagstones (Grays and Black)

Lithograph from five plates
 (1) transparent light gray (same plate as C/D 1)
 (2) transparent light gray (same plate as C/D 8, modified; plus transfers from B/D 1 and D/D 5 for left and right borders)
 (3) dark gray (same plate as C/D 7; plus drawn and stenciled additions for right border)
 (4) black (same plate as C/D 6; plus drawn additions for left border and transfer from D/D 5 for right border)
 (5) transparent gray flat (flat tone over entire central image)

201. D/D Casts (Grays and Black)

Lithograph from one stone and four plates
 (1) gray (spatter—same plate as D/D 5)
 (2) gray (side panels only—transfers from A/D black plate 1 and from C/D black plate 1)
 (3) dark gray—stone (boards—same plate as D/D 7; plus drawn additions for border at right)
 (4) black (casts—same plate as D/D 6 with stenciled additions; plus drawn additions for right border)
 (5) transparent gray (flat tone over entire central image)

202. Ale Cans (I) 1975

Lithograph from two plates
 (1) blue (flat tone)
 (2) blue-black (image)

22¾ x 31¼ (578 x 794) Laga Narcisse handmade paper
Edition 41 plus 11 artist's proofs
Published by Gemini G.E.L.; printed by Dan Freeman, Barbara Thomason, and Serge Lozingot

Four very loose studies quickly executed while working on *Four Panels from Untitled 1972* (Grays and Black). They continue Johns' exploration of one of the most pregnant and condensed images of the 1960's (see F.47). In these works the play with illusionism has given way to the most abstract and abbreviated references to the ale cans sculpture (*Painted Bronze* of 1960).

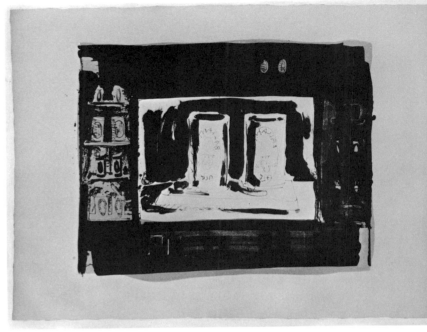

202

203. Ale Cans (II) 1975

Lithograph from six plates
 (1) yellow
 (2) tan
 (3) green
 (4) red
 (5) light gray
 (6) dark gray and light gray (upper and lower
 images respectively)

19 x 14¾ (483 x 375) John Koller HMP Waterleaf handmade paper
Edition 14 plus 7 artist's proofs
Published by Gemini G.E.L.; printed by Serge Lozingot and Dan Freeman

203

204

205

204. Ale Cans (III) 1975

Lithograph from three stones and one plate
 (1) dark gray — stone (washes and drawing)
 (2) black — stone (washes and drawing)
 (3) dark gray — stone (washes)
 (4) gray (flat tone)

20½ x 26 (521 x 660) Washi No Mise handmade paper
Edition 46 plus 11 artist's proofs
Published by Gemini G.E.L.; printed by Anthony
Zepeda and Serge Lozingot

205. Ale Cans (IV) 1975

Lithograph from one plate in black

16½ x 21 (419 x 533) Velin Blanc Narcisse handmade
paper
Edition 22 plus 7 artist's proofs
Published by Gemini G.E.L.; printed by Serge
Lozingot

The indefinite oil-water effect was obtained by the applica-
tion of a commercial "image remover." Other white marks
were made by scraping with a needle.

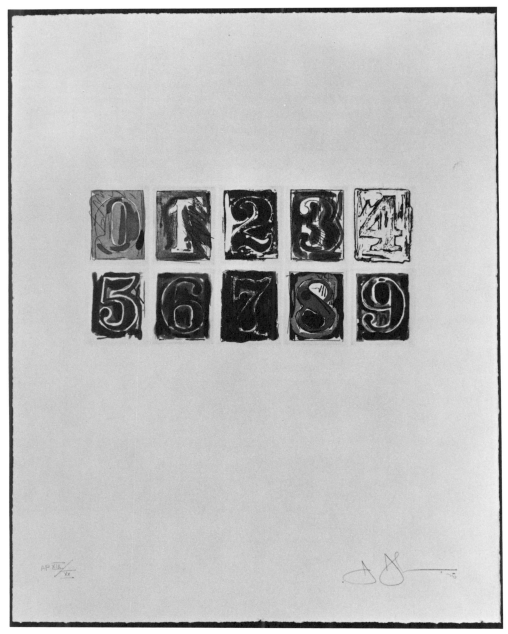

206

206. 0-9 1975

Ten etchings with drypoint, soft-ground, open-bite,
lift-ground aquatint, and varnish stop-out, printed on
one sheet

Each plate 2⅛ x 1¾ (54 x 45)
15½ x 12½ (394 x 318) Barcham Green handmade
paper watermarked with the artist's signature
Edition 100 plus 20 artist's proofs
Printed by Aldo Crommelynck, Paris
Published by Petersburg Press, London and New York

207

207. 0-9 (A Set of Ten Numerals) 1975

Ten etchings with lift-ground aquatint, soft-ground, and open-bite

Each plate 2^{7}/$_{16}$ x 2^{1}/$_{16}$ (62 x 53)

8^{1}/$_{4}$ x 5^{7}/$_{8}$ (210 x 150) Barcham Green handmade paper watermarked with the artist's signature

Edition 100 plus 20 artist's proofs

Printed by Aldo Crommelynck, Paris

Published by Petersburg Press, London and New York

Executed in Paris virtually as a rehearsal for the Beckett project, these etchings make use of the same techniques of applying and working various grounds and explore the more individualized manners of controlling the flow and bite of the acid. The latter includes "open-bite" which signifies that the acid is applied to the plate with carefully controlled brushstrokes. The acid eats directly into an aquatint grain; unlike traditional methods, there is no intervening layer of protective varnish to determine where the acid will and will not attack the plate. The result is utmost freedom of touch, a softness and a transparency heretofore reserved for lithography (or to Picasso who also worked with Crommelynck from 1947 until his death in 1973).

Lift-ground or sugar-lift aquatint accounts for most of the more precisely defined and/or heavier tonal passages. First a suitable size grain of rosin is adhered to the plate (the aquatint). Next the artist draws his design with a sugar solution. The plate is then covered with acid-resistant varnish. Upon drying, the plate is washed in water which swells the sugar-drawn passages removing the varnish. When the plate is placed in an acid bath, those parts no longer covered by varnish are bitten. The result is a drawing, just as painted by the artist, in the granular texture typical of aquatint. By contrast, the open-bite method avoids the hard edges of the varnish since the artist draws directly with acid on the aquatint ground.

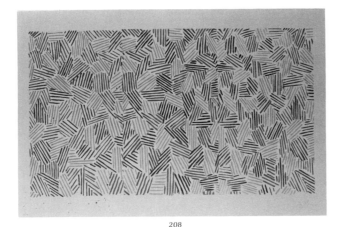

208

208. Scent 1975-76

Lithograph from four plates, printed on a hand-fed, offset proofing press; linocut from four blocks; wood-cut from four blocks

 (1) white plate ("negative" – printed around and under the color hatchings)
 (2) orange plate (tusche and crayon)
 (3) green plate (tusche and crayon)
 (4) purple plate (tusche and crayon)
 (5) white linoleum block ("negative" – hatchings cut away)
 (6) orange linoleum block
 (7) green linoleum block
 (8) purple linoleum block
 (9) white wood block ("negative" – with hatchings routed out)
 (10) orange wood block (veneer strips adhered to block)
 (11) green wood block (veneer strips adhered to block)
 (12) purple wood block (veneer strips adhered to block)

31¼ x 47 (794 x 1194) Twinrocker handmade paper watermarked "scent" and stamped with the paper-maker's seal in black on verso
Edition 42 plus 7 artist's proofs
Published by U.L.A.E.; printed by Bill Goldston and James V. Smith (offset), and Juda Rosenberg (letterpress)

Rather carefully derived from Scent, 1974 (oil and encaustic on canvas, 72 x 126 in., coll. Dr. Peter Ludwig, Aachen). Pains were taken to provide each section of hatching with its own character: thin and opaque tusche for each stroke of the offset third, careful overlapping of the white in the linoleum third, and a deliberate variation of grain-orientation in the woodcut third.

209. Corpse and Mirror (Aquatint) 1975-76

Lift-ground aquatint and drypoint.

 (1) black
 (2) white ("negative" plate)
 (3) pink, yellow and blue
 (4) black 'x' and other minor touches

Plate 10⅜ x 14 (264 x 356) printed on 25¾ x 19¾ (654 x 502) Rives BFK paper
Edition 50 plus 10 artist's proofs
Printed by Aldo Crommelynck, Paris
Published by Petersburg Press, London and New York

Loosely derived from Corpse and Mirror (first version) of 1974 (oil and encaustic on canvas, 50 x 68⅛ in., coll. Dr. and Mrs. Jack M. Farris). The strokes were varied through careful control of the surrounding whites and by frequent addition of dry point black spines.

210. Corpse and Mirror (Lithograph) 1976

Lithograph from twelve plates, printed on a hand-fed, offset proofing press

 (1) Left – white ("negative" – prints around hatching, producing black strokes)
 (2) Right – white ("negative" – less brilliant)
 (3) Right – white ("negative" – some overlapping)
 (4) Left – white with some yellow ("negative" – mostly upper left; some hatching added elsewhere)
 (5) Bottom left – white with some violet
 (6) Middle left – white
 (7) Left – black wash (quite transparent)
 (8) Right – white
 (9) Right – semi-transparent black (hatchings and grid marks)
 (10) Right – darker black
 (11) Upper right – light pink (wash)
 (12) Upper right – silver black plus blue (X)

30¾ x 39¾ (781 x 1010) black German etching paper
Edition 58 plus 11 artist's proofs
Published by U.L.A.E.; printed by Bill Goldston and James V. Smith

Also loosely derived from Corpse and Mirror (first version) of 1974, this is a far more ambitious work. Its technique can be traced back to that of Two Maps I of 1965-66 (F.51) which was also printed in white on black paper. The present work, by contrast, is more complex – the artist going back into the many white printings with three varied black plates.

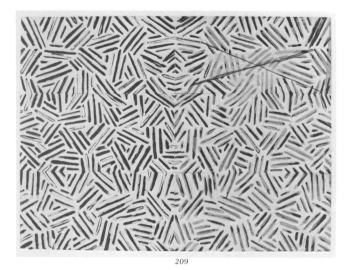

209

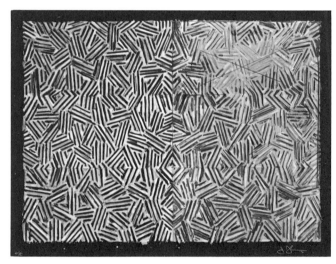

210

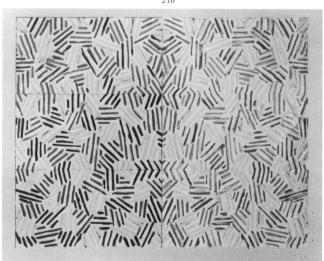

211

211. Corpse and Mirror (Screenprint) 1976

Screenprint from thirty-six screens

 (1) Left—orange
 (2) Left—green
 (3) Left—violet
 (4) Left—gray (grid)
 (5) Upper left—white
 (6) Right—orange
 (7) Right—gray (grid)
 (8) Right—green
 (9) Right—violet
 (10) Upper left—red
 (11) Upper left—blue
 (12) Upper left—yellow
 (13) Upper left—gloss (same as screen 12)
 (14) Upper left—gloss (same as screen 12)
 (15) Right—white
 (16) Bottom left—white
 (17) Bottom left—gloss (same screen as 16)
 (18) Right—red
 (19) Right—blue
 (20) Right—yellow
 (21) Bottom left—red
 (22) Bottom left—gloss (same screen as 21)
 (23) Bottom left—blue
 (24) Bottom left—gloss (same screen as 23)
 (25) Bottom left—yellow
 (26) Bottom left—gloss (same screen as 25)
 (27) Middle left—white
 (28) Middle left—red
 (29) Middle left—blue
 (30) Middle left—yellow
 (31) Right—red
 (32) Right—blue
 (33) Right—yellow
 (34) Right—white
 (35) Right—white
 (36) Right—orange (circle)

42¼ x 53 (1073 x 1346) ivory Nishinouchi Kizuki
Kozo paper watermarked "Corpse and Mirror"
Edition 65 plus 6 artist's proofs
Printed by Takeshi Shimada, Kenjiro Nonaka, and
Hiroshi Kawanishi, New York City
Published by the artist and Simca Print Artists, Tokyo

This version follows its prototype (*Corpse and Mirror II,*
1974-75) more closely than had the preceding prints. To ef-
fect this, Johns placed a properly scaled photograph of the
painting underneath each screen as a guide. It should be
remembered, especially with the hatched images, that the
order in which the elements were printed does not reflect

the sequence of their execution. Most often the principle colors were drawn and proofed first. Although the marks deposited by each screen are concentrated in the areas designated, most of the screens covered the entire surface of the print and added occasional hatchings to each of the six sections. With this in mind, the printing of the sections might be summarized as follows:

Upper left: orange, green, violet, gray, white, red, blue, yellow, gloss, gloss

Middle left: orange, green, violet, gray, white, red, blue, yellow

Bottom left: orange, green, violet, gray, white, gloss, red, gloss, blue, gloss, yellow, gloss

Upper right: orange, gray, green, violet, white, red, blue, yellow, red, blue, yellow, white, white

Middle right: orange, gray, green, violet, white, red, blue, yellow, red, blue, yellow, white, white, orange

Lower right: orange, gray, green, violet, white, red, blue, yellow, red, blue, yellow, white, white.

The inks themselves were varied. Those employed for the left half ranged from matte to medium to high gloss; those on the right were uniformly matte, and were compounded of encaustic, dammar, linseed oil, and pigment. While the left hand sections vary in degrees of depth and reflectivity, those at the right are uniformly dull, denser, and whiter.

212

212. Light Bulb 1976

Lithograph from three plates, printed on a hand-fed, offset proofing press

 (1) warm gray (wash, quarter strength)
 (2) warm gray (wash, half strength)
 (3) black (crayon)

17 x 14 (432 x 356) J. Whatman 1956 handmade paper
Edition 48 plus 5 artist's proofs
Published by U.L.A.E.; printed by Bill Goldston and James V. Smith

This image used the same piece of sculpture as that depicted in the etchings of 1967-69 (F.72, 79, & 86): *Light Bulb I*, 1958 (sculpmetal, 4½ x 6¾ x 4½ in., coll. Mr. and Mrs. Robert Rowan, Pasadena).

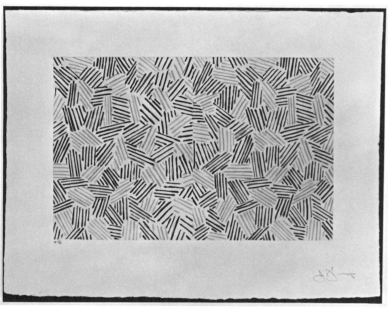

213

214

213. Untitled I (Hatching) 1976

Etching and aquatint from four plates
- (1) yellow
- (2) red
- (3) blue
- (4) white (printed around and over the color
 hatchings)

Plate 13 x 19¼ (330 x 490 printed on 20½ x 26 (520 x
660) Richard de Bas Auvergne à la main paper
Edition 55 plus 10 artist's proofs
Printed by Aldo Crommelynck, Paris
Published by Petersburg Press, London and New York

Originally intended as the front endpaper for *Fizzles* but
rejected because the artist disliked the appearance of a bled
etched image, i.e. of an etching deprived of its platemark.
After the present edition was pulled in primary colors, the
plates were cut down (to 293 x 465) and printed in second-
ary colors for *Fizzles*.

214. Untitled II (Flagstones) 1976

Aquatint from three plates
- (1) white
- (2) red
- (3) black

Plate 13 x 19¼ (330 x 490) printed on 20½ x 26 (520 x
660) Richard de Bas Auvergne à la main paper
Edition 55 plus 10 artist's proofs
Printed by Aldo Crommelynck, Paris
Published by Petersburg Press, London and New York

The subtle tones within the black shapes were obtained by
controlling the interaction of acid and ground – not by over-
printing with transparent white.

215.-248. Fizzles (Foirades) 1975-76

Book with five texts by Samuel Beckett, thirty-three etchings and one lithograph by Jasper Johns

13⅛ x 9⅞ (333 x 251) page size; Richard de Bas handmade paper watermarked with the initials of the author and the signature of the artist
Edition 250 (numbered 1-250) plus 30 artist's proofs (numbered I-XXX) and 20 copies hors-de-commerce
Type set and hand-printed by Fequet & Boudier, Paris
Etchings printed by Aldo Crommelynck, Paris
Published by Petersburg Press, London and New York

The enormous concentration and expenditure of time that went into these etchings can only be glimpsed through the trial proofs. These exist in unique impressions (coll. the artist) and vary in number from none to seventeen for any given plate. Although Johns claims that they reveal numerous cul-de-sacs he would rather have avoided, they are the most astonishingly intimate glimpse of the artist at work—and at work at his best, it should be added. The trial proofs are not all to be considered as "states" since some carry work added by hand rather than printed from an altered plate. Together with the 28 trial proofs of *D/D Casts (Colors)*, F.197, these will someday make a most fascinating exhibition.

Although these trial proofs provide some insight into the variety of techniques and the nuances of marks Johns (and Crommelynck) achieved, a verbal description of the finished works would be too dry and abstract. We have tried and have pretty much failed to indicate the varied and subtle means by which Johns controlled the bite of the acid (most remarkably seen in the soft edges of trial proofs one and two of *Casts*, no. 243, and in *Buttocks and Knee*, no. 244). Some plates have been burnished to weaken parts of the drawing and thus to enhance the chiaroscuro of the entire design; now and then, however, the burnisher was used as an unorthodox means to draw in white line. In other plates, passages of white line were achieved by drawing with a stop-out crayon (e.g. *Numeral 4*). But the majority of the fluid and painterly effects were obtained through the lift-ground and open-bite aquatint methods described briefly in entry 206. An unexpected device was the artist's habit of cutting down his plates (e.g. nos. 215, 217, 218, 234, 242, and 246), not only to accommodate his change of plans (originally he had thought to include Beckett's texts within the space of his own images) but to effect artistic transformations.

On the early history of the project, see Roberta Bernstein's excellent article (B-3); on the relationship between the words and the images, and for further technical notes, see Judith Goldman's fine catalogue (B-14).

FIZZLES

SAMUEL BECKETT

ETCHINGS

JASPER JOHNS

1976

FOIRADES

SAMUEL BECKETT

GRAVURES

JASPER JOHNS

1976

215. Hatching (Endpaper, front)

Lift-ground aquatint and drypoint from four plates
printed in orange, green, purple, and white

11⁹⁄₁₆ x 18⁵⁄₁₆ (293 x 465)
From the same plates (cut-down) as those used for
Untitled I (Hatching) 1976, F.213.

216. Numeral 1

Etching, soft-ground, and drypoint

9³⁄₁₆ x 6¹⁵⁄₁₆ (234 x 176)
Two trial proofs

217. Face

Lift-ground aquatint, scraper, and abrasive powder

10⁷⁄₈ x 8³⁄₈ (276 x 212)
Twelve trial proofs

218. Words (Buttock Knee Sock…)

Etching and lift-ground aquatint

10⁹⁄₁₆ x 17¹⁄₂ (268 x 445)
Ten trial proofs

215

216

217

218

219. Four Panels (ABCD)

Etching, soft-ground, lift-ground aquatint, and burnishing
2¹³/₁₆ x 7³/₈ (72 x 188)
One trial proof

219

220. Four Panels (BCDA)

Etching, soft-ground, and lift-ground aquatint
2¹³/₁₆ x 7³/₈ (72 x 188)
One trial proof

220

221. Four Panels (CDAB)

Etching, soft-ground, and lift-ground aquatint
2¹³/₁₆ x 7³/₈ (72 x 188)
Two trial proofs

221

222. Four Panels (DABC)

Etching, soft-ground, lift-ground aquatint, and stop-out
2¹³/₁₆ x 7³/₈ (72 x 188)
Four trial proofs

222

223. Numeral 2

Etching, lift-ground aquatint, crayon stop-out, and open-bite

9⁵/₁₆ x 6¹⁵/₁₆ (237 x 177)

Four trial proofs

Most of the work on this plate was accomplished by repeated, precise applications of acid over various aquatint grounds. By painting in acid, Johns was able to achieve a control and a fluidity of tone not even available to the user of lift-ground aquatint.

224. Leg (a)

Etching, drypoint, and open-bite

6¹/₁₆ x 3⁷/₈ (153 x 98)

Five trial proofs

225. Leg (b)

Etching and lift-ground aquatint

10⁵/₁₆ x 5³/₈ (262 x 137)

226. Leg (c)

Etching

10⁵/₁₆ x 5¹/₂ (262 x 139)

227. Casts and Hatching

Etching, lift-ground aquatint, and open-bite

10¹¹/₁₆ x 14³/₁₆ (272 x 360)

Four trial proofs

224

225

226

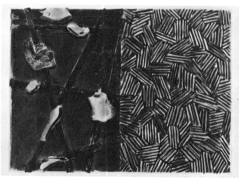

227

223

228. Hatching

Etching and lift-ground aquatint

10¹/₂ x 7¹/₁₆ (267 x 178)
Four trial proofs

The tonal variation over this plate resulted from the application of acid by cotton swab rather than by means of the normal bath.

229. Leg (d)

Etching and open-bite

2¹/₂ x 5³/₈ (63 x 137)

230. Flagstones (a)

Etching and lift-ground aquatint

10¹/₂ x 7¹/₁₆ (267 x 179)
Seven trial proofs

231. Flagstones (b)

Etching, lift-ground aquatint, burnishing, and stop-out

10¹/₂ x 7¹/₁₆ (267 x 178)
Six trial proofs

Johns occasionally used stop-out over or around a given area in order to create a slightly lowered edge. This edge would inevitably retain some ink and print as a margin of subtly varied tone.

232. Numeral 3

Stop-out varnishes over aquatint ground

9³/₈ x 7¹/₁₆ (238 x 178)

Liquid and paste-like stop-outs were applied over an aquatint ground for the two basic textures of this work.

230

231

232

228 229

233. Torse

Photo-screen squeegeed onto plate, lift-ground aquatint, and open-bite

9⅜ x 7 (238 x 179)
Two trial proofs

The white contours resulted from the fine control exercised by the artist during successive applications of sugar-lift solution, first for the letters and then for their surrounds.

234. Hatching and Flagstones

Soft-ground etching, open-bite, and burnishing

10¾ x 14¼ (273 x 362)
Six trial proofs

All of the brushmarks were made by direct application of acid to an aquatint ground (open-bite).

235. Torso

Lift-ground aquatint

9⁵/₁₆ x 7¹/₁₆ (236 x 178)
One trial proof

236. Numeral 4

Lift-ground aquatint, stop-out crayon, and burnishing

9⁵/₁₆ x 6¹⁵/₁₆ (237 x 177)
Nine trial proofs

237. Casts

Etching and lift-ground aquatint

10½ x 7¹/₁₆ (267 x 179)
Two trial proofs

234

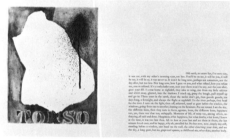

235

236

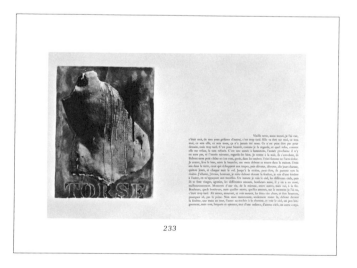

233

237

238. Flagstones and Flagstones

Etching, lift-ground aquatint, and open-bite
$10^{13}/_{16}$ x $14^{1}/_{4}$ (275 x 362)
Five trial proofs

239. Buttocks – Knees – FootHandSockFloor – Face – Torso

Etching and open-bite
11 x $2^{13}/_{16}$ (280 x 71)
Two trial proofs

240. Feet (a)

Etching and lift-ground aquatint
$2^{3}/_{8}$ x $3^{3}/_{4}$ (61 x 96)
Two trial proofs

238

Closed place.

All needed to be known for say is known. There is nothing but what is said. Beyond what is said there is nothing. What goes on in the arena is not said. Did it need to be known it would be. No interest. Not for imagining. Place consisting of an arena and a ditch. Between the two skirting the latter a track. Closed place. Beyond the ditch there is nothing. This is known because it needs to be said. Arena black vast. Room for millions. Wandering and still. Never seeing never hearing one another. Never touching. No more is known. Depth of ditch. See from the edge all the bodies on its bed. The millions still there. They appear six times smaller than life. Bed divided into lots. Dark and bright. They take up all its width. The lots still bright are square. Appear square. Just room for the average sized body. Stretched out diagonally. Bigger it has to curl up. Thus the width of the ditch is known. It would have been in any case. Sum the bright lots. The dark. Outnumbered the former by far. The place is already old. The ditch is old. In the beginning it was all bright. All bright lots. Almost touching. Faintly edged with shadow. The ditch seems straight. Then reappears a body seen before. A closed curve therefore. Brilliance of the bright lots. It does not encroach on the dark. Adamantine blackness of these. As dense at the edge as at the centre. But vertically it diffuses unimpeded. High above the level of the arena. As high above as the ditch is deep. In the black air towers of pale light. So many bright lots so many towers. So many bodies visible on the bed. The track follows the ditch all the way along. All the way round. It is on a higher level than the arena. A step higher. It is made of dead leaves. A reminder of beldam nature. They are dry. The heat and the dry air. Dead but not rotting. Crumbling into dust rather. Just wide enough for one. On it no two ever meet.

239 240

241. Numeral 5

Etching, lift-ground aquatint, burnishing with sandpaper

9⁵/₁₆ x 6¹⁵/₁₆ (237 x 177)
Eleven trial proofs

242. Feet (b)

Etching, photo-engraving, lift-ground aquatint, and open-bite

10¹⁵/₁₆ x 8³/₈ (278 x 212)
Nine trial proofs

243. Casts (Words)

Etching, lift-ground aquatint, stop-out, and burnishing

10⁷/₈ x 7³/₄ (276 x 197)
Five trial proofs

244. Buttocks and Knee

Etching and lift-ground aquatint; acid applied through cloth

6⁷/₁₆ x 8¹/₂ (163 x 216)
Three trial proofs

245. Flagstones and Casts

Etching, lift-ground aquatint, and open-bite

10¹³/₁₆ x 14¹/₄ (274 x 362)
Five trial proofs

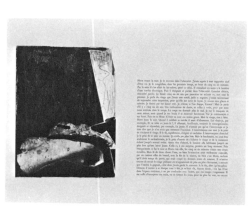

242

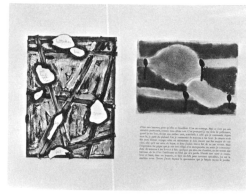

243 244

245

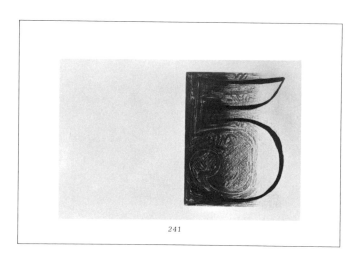

241

246. HandFootSockFloor

Etching, lift-ground aquatint (includes hand print), scraper, and burnishing

$9^{5}/_{8}$ x $7^{1}/_{2}$ (244 x 190)
Seventeen trial proofs

247. Flagstones (Endpaper—back)

Lift-ground aquatint and open-bite from three plates printed in red, black, and white

$11^{9}/_{16}$ x $18^{5}/_{16}$ (294 x 465)
Two trial proofs

The outlines or edges of the black and red flagstones were drawn in sugar-lift solution; subsequently the interiors were modulated by direct brushing of acid onto the (aquatint-grounded) plate.

248. Hatching (Box Liner)

Lithograph printed from four plates in orange, green, purple, and white

$13^{1}/_{8}$ x $10^{1}/_{16}$ (333 x 255)

The measurements are for each "half"; the entire print lacks a central section which was excised along the spine of the box. Printed in New York, not Paris, the lithograph represents a later addition that repeats the image of the front, etched, endpaper.

246

247

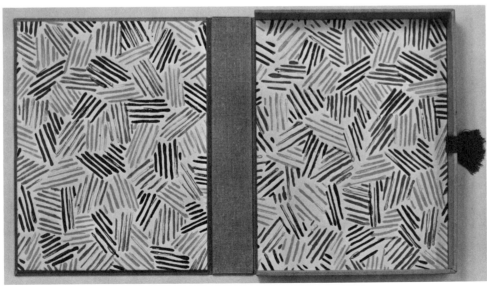

248

249.-254. 6 Lithographs (after 'Untitled 1975') 1976

249. #1

Lithograph from eleven plates
 (1) gray (grid)
 (2) yellow
 (3) red
 (4) blue
 (5) transparent yellow
 (6) transparent red
 (7) transparent blue
 (8) orange
 (9) green
 (10) violet
 (11) white

30⅛ x 29⅞ (765 x 759) Rives gray Newsprint paper
Edition 60 plus 13 artist's proofs
Published by Gemini G.E.L.; printed by Jim Webb,
Ron McPherson, and Anthony Zepeda

Derived from *Untitled*, 1975 (oil and encaustic on canvas,
50⅛ x 50⅛ in., private collection).

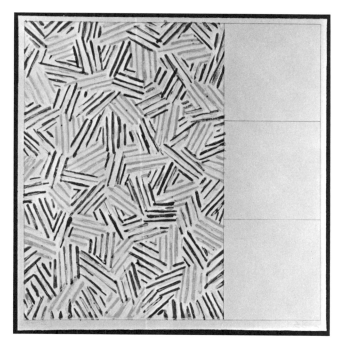

249

250. #2

Lithograph from twelve plates
 (1) gray (grid)
 (2) yellow
 (3) red
 (4) blue
 (5) transparent yellow
 (6) transparent red
 (7) transparent blue
 (8) varnish (top and bottom right)
 (9) varnish (bottom right)
 (10) varnish (bottom right)
 (11) white
 (12) varnish (top and bottom right)

30⅛ x 29¾ (765 x 756) Rives gray Newsprint paper
Edition 60 plus 15 artist's proofs
Published by Gemini G.E.L.; printed by Edward Henderson and Mark Stock

Plates 2-7: the center squares are transfers from the corresponding plates (2-7) of lithograph #1; some new work has been added. The right-hand squares are completely new drawings, based on the adjacent images. Unfortunately, the Gemini documentation implies that the plates of #1 were literally cut-up at this juncture; that was not the case. Parts of these plates were *transferred* to new plates. Only these new plates were cut-up — and that only for the printing of the final image, #6.

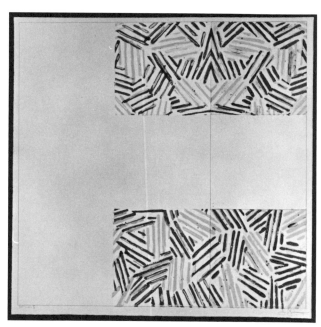

250

251. #3

Lithograph from eleven plates
 (1) gray (grid)
 (2) yellow
 (3) red
 (4) blue
 (5) transparent yellow
 (6) transparent red
 (7) transparent blue
 (8) varnish (right square)
 (9) varnish (right square)
 (10) white
 (11) varnish (right square)

30⅛ x 29¾ (765 x 756) Rives gray Newsprint paper
Edition 60 plus 11 artist's proofs
Published by Gemini G.E.L.; printed by Anthony
Zepeda, Edward Henderson, Jim Webb, and Serge
Lozingot

Plates 2-7: the center square is a transfer from the corresponding plates (2-7) of lithograph #1; some new work has been added. The right-hand square is a completely new drawing, based on the earlier, adjacent image.

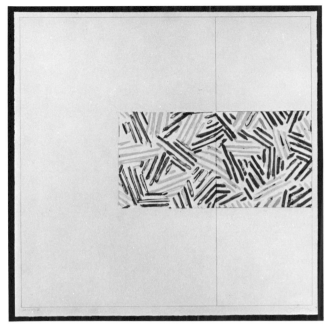

251

252. #4

Lithograph from twelve plates
 (1) gray (grid)
 (2) yellow
 (3) red
 (4) blue
 (5) transparent yellow
 (6) transparent red
 (7) transparent blue
 (8) varnish (middle and bottom right)
 (9) varnish (middle and bottom right)
 (10) varnish (bottom right)
 (11) white
 (12) varnish (middle and bottom right)

30⅛ x 29⅞ (765 x 759) Rives gray Newsprint paper
Edition 60 plus 13 artist's proofs
Published by Gemini G.E.L.; printed by Edward Henderson and Mark Stock

Plates 2-7: both squares are transfers, the bottom from lithograph #2 (plates 2-7), and the center from lithograph #3 (plates 2-7). These transfers then received additional work.

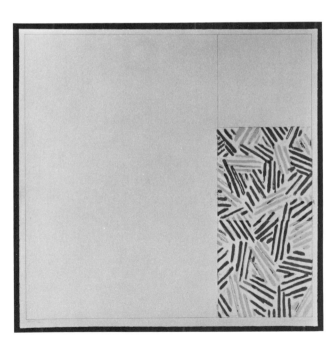

252

118

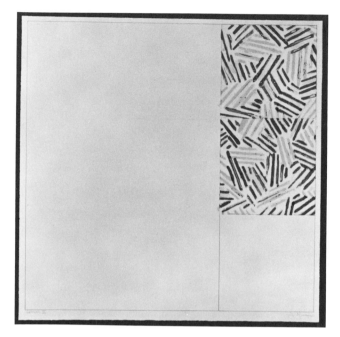

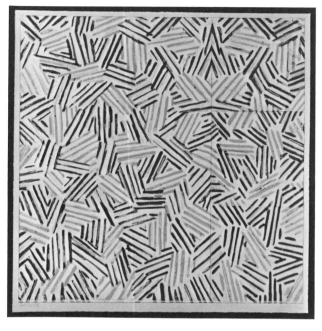

253

254

253. #5

Lithograph from eleven plates
 (1) gray (grid)
 (2) yellow
 (3) red
 (4) blue
 (5) transparent yellow
 (6) transparent red
 (7) transparent blue
 (8) varnish (top and middle right)
 (9) varnish (middle right)
 (10) white
 (11) varnish (top and middle right)

30⅛ x 29¾ (765 x 756) Rives gray Newsprint paper
Edition 60 plus 13 artist's proofs
Published by Gemini G.E.L.; printed by Mark Stock
and Edward Henderson

Plates 2-7: both squares are transfers, the top from lithograph #2 (plates 2-7), and the center from lithograph #3 (plates 2-7). These transfers then received additional work.

254. #6

Lithograph from sixteen plates
 (1) gray (grid)
 (2) orange
 (3) green
 (4) violet
 (5) yellow
 (6) red
 (7) blue
 (8) varnish (three squares at right; varnish ends
 about ⅓rd inch from bottom of image)
 (9) transparent yellow
 (10) transparent red
 (11) transparent blue
 (12) white
 (13) white (newly drawn plate)
 (14) varnish (three squares at right)
 (15) varnish (middle and bottom right)
 (16) varnish (bottom right)

30⅛ x 29¾ (765 x 756) Rives gray Newsprint paper
Edition 60 plus 20 artist's proofs
Published by Gemini G.E.L.; printed by Serge Lozingot and Mark Stock

Plates 2-4 are identical with plates 7-9 of lithograph #1 except that a few additions were made for the squares added on the right.

Plates 5-7 and 9-12, on the other hand, are combinations. The left and center squares are physically identical with lithograph #1 plates 2-7 & 11, but the right-hand squares were printed from plates assembled from cut-out portions of other plates: the top right square from lithograph #5 (2-7 & 10), the middle and bottom right squares from lithograph #4 (2-7 & 11).

255. 0 through 9 (Bookplate for the Friends of the Sarah Lawrence College Library) 1976

Lithograph in black from one plate

11½ x 10¾ (292 x 273) Japanese Mulberry paper
Edition 10 (all hors commerce)
Published by Gemini G.E.L.; printed by Anthony Zepeda and Victor Schiro
Offset edition unknown; printed by Blair Litho, Los Angeles

255

256. Untitled (Bookplate for David Grainger Whitney) 1976-77

Lithograph from two plates
 (1) black (crayon and tusche image)
 (2) black (photoplate for letters)

9¼ x 7¼ (235 x 184) Rives lightweight paper
Edition 50 plus 4 artist's proofs; 10 further proofs (hors commerce) of the first plate were printed on Ron McPherson handmade paper
Published by Gemini G.E.L. and the artist; printed by Anthony Zepeda and Mark Stock
Offset edition of 1000 printed by Blair Litho, Los Angeles

256

257

257. **0 through 9** (for the Skowhegan School of Painting and Sculpture) 1976-77

Lithograph printed from two plates
 (1) black – photoplate (after drawing)
 (2) transparent black (crayon hatching)

10 x 7½ (254 x 190) Torinoko Japan paper
Edition 63 plus 12 artist's proofs
Published by Gemini G.E.L.; printed by Anthony Zepeda and Jim Webb

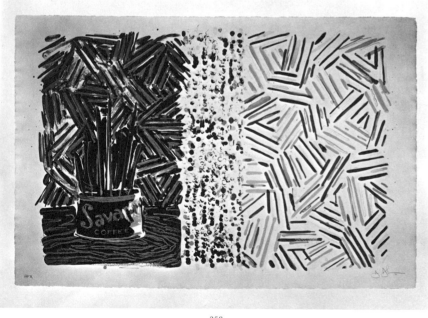

258

258. **Untitled** 1977

Lithograph from twelve plates, printed on a hand-fed, offset proofing press
 (1) black (tusche and washes)
 (2) orange
 (3) green
 (4) violet
 (5) light orange (printed over first orange)
 (6) light green (printed over first green)
 (7) light violet (printed over first violet)
 (8) yellow
 (9) blue
 (10) red (prints brown over Savarin can)
 (11) brown
 (12) white

27½ x 39¾ (699 x 1010) J.B. Green paper
Edition 53 plus 9 artist's proofs
Published by U.L.A.E.; printed by James V. Smith

259. Savarin 1977

Lithograph from seventeen plates printed on a hand-fed, offset proofing press
 (1) gray (top of image)
 (2) gray (bottom)
 (3) blue (center)
 (4) blue (top)
 (5) blue (center)
 (6) red (top)
 (7) yellow (bottom)
 (8) yellow (top)
 (9) tan
 (10) tan
 (11) red (savarin can)
 (12) red (top of can, brushes)
 (13) silver gray
 (14) white (top)
 (15) white (bottom)
 (16) black (bottom)
 (17) black (top)

45 x 35 (1143 x 889) handmade Twinrocker paper, watermarked ULAE
Edition 50 plus 10 artist's proofs
Published by U.L.A.E.; printed by Bill Goldston and James V. Smith

Poster edition: "Jasper Johns / 18 October 1977 • 22 January 1978 / Whitney Museum of American Art"
Lithograph from the same seventeen stones as above plus five for the lettered addition at the bottom; printed on a hand-fed, offset proofing press
Edition A/B: 14 on J. Whatman paper, 54 x 32 (1372 x 813)
Edition B/B: 8 on Arches paper, 48 x 32 (1319 x 813)
Published by U.L.A.E.; printed by Bill Goldston and James V. Smith
Commercial edition: unlimited quantity, printed by conventional, four-color process, offset lithography
Published by the Whitney Museum of American Art; printed under the supervision of Telamon Editions, West Islip, New York

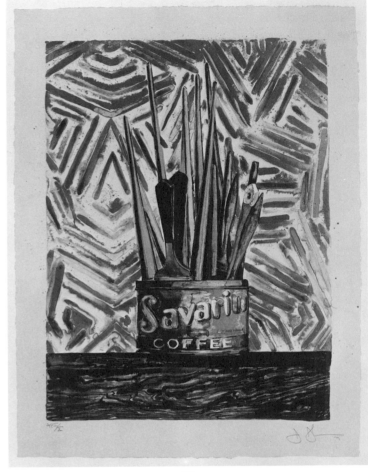

259

260. Untitled 1977

Screenprint from nine screens
 (1) ivory (for paper tone – printed twice)
 (2) letters (photoplate of original collage)
 (3) red
 (4) blue
 (5) yellow
 (6) green
 (7) orange
 (8) violet
 (9) white

24 x 19 (610 x 483) Rives Moulin du Gué paper
Edition 130 plus 13 artist's proofs
Printed by Takeshi Shimada, Kenjiro Nonaka, and
Hiroshi Kawanishi, New York
Published by the artist and Simca Print Artists, Tokyo

Catalogue cover edition for Brooke Alexander, Inc.,
New York
Printed from the same nine screens but in comple-
mentary colors:
 (1) ivory (for paper tone – printed twice)
 (2) black (letters; photoplate of original collage)
 (3) yellow (original element 8)
 (4) blue (original element 7)
 (5) red (original element 6)
 (6) violet (original element 5)
 (7) orange (original element 4)
 (8) green (original element 3)
 (9) white

10 x 10 (254 x 254) Patapar printing parchment
Edition 3000
Printed by Takeshi Shimada, Kenjiro Nonaka, and
Hiroshi Kawanishi, New York
Published by Brooke Alexander, Inc., New York

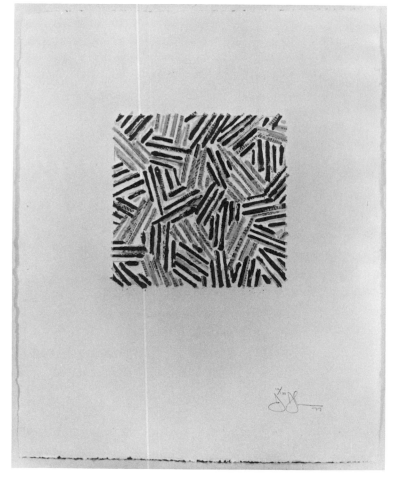

260

Corrections to Jasper Johns: Prints 1960-1970, Philadelphia Museum of Art and Praeger Publishers, New York, 1970

1 & 17. *Target* and *"O"* Although the *0-9* series (17-46) were published in 1963, the first stone was executed at the same moment as *Target*, 1960.

3. *Coat Hanger II* was definitely printed from the same stone as *Coat Hanger I*, 1960.

9. *Painting with Two Balls II* was published in an edition of 13.

48. *Skin with O'Hara Poem* It was the artist who suggested adding the poem.

49. *Pinion* The printer, Ben Berns, worked out the method for applying the blended colors; the edition was printed by Zigmunds Priede.

53. *Light Bulb* The dark gray was printed first, the black second.

59. *Voice* The large areas of wash were carried by the aluminum plate, while the crayon drawing was printed from the stone.

60. *Watchman* Through some mix-up I thought I had been told that the cast (in the painting) had been taken from a Japanese acquaintance of the artist; in fact, an American friend was used.

61, 63, 69, 70 & 91. The printer was Fred Genis. Apologies.

65. *Target II* Only aquatint was added.

77 a & b. *Ale Can* was executed in etching and open-bite.

84. The correct title is *Ale Can* (singular); it was executed in etching and open-bite.

87 & 88. In the colophon of *1st Etchings, 2nd State*, these are referred to as *Ale Cans (small)* and *Paintbrushes (small)*.

91. *White Target* The seventh stone printed white line throughout the image, not just around the edges.

120. *Flag* measures 17 x 23 in.

128. *Light Bulb* derives from a sculpture of ca. 1970, English Light Bulb, now in the collection of Mark Lancaster, New York. The paper was made by Fred Siegenthaler, of Basel.

*to be used in conjunction with that in Vol. I (B-11)

1. Alloway, Lawrence. *American Pop Art*, New York, 1974.

2. _____ . "Jasper Johns' Map," *The Nation*, November 22, 1971, pp.541-542; reprinted in *Topics in American Art Since 1945*, New York, 1975, pp.136-139.

3. Bernstein, Roberta. "Johns & Beckett: Foirades/ Fizzles," *Print Collector's Newsletter*, vol.7, no.5 (November-December 1976), pp.141-145.

4. _____ . "Jasper Johns and the Figure: Part One: Body Imprints," *Arts Magazine*, vol.52, no.2 (October 1977), pp.142-144.

5. Bourdon, David. "The Lines Lead to Johns," *The Village Voice*, February 9, 1976, pp.91-92.

6. Bowling, Frank. "Another Map Problem," *Arts Magazine*, vol.45, no.3 (December 1970-January 1971), p.27.

7. Carpenter, Joan. "The Infra-Iconography of Jasper Johns," *Art Journal*, vol.36, no.3 (Spring 1977), pp.221-227.

8. Coplans, John. "Fragments According to Johns, An Interview with Jasper Johns," *Print Collector's Newsletter*, vol.3, no.2 (May-June 1972), pp.29-32.

9. Crichton, Michael. *Jasper Johns*, New York, 1977. Catalogue of the 1977 Johns retrospective at the Whitney Museum of American Art.

10. Dreiss, Joseph. "Jasper Johns," *Arts Magazine*, vol.49, no.1 (September 1974), p.59.

11. Field, Richard S. *Jasper Johns: Prints 1960-1970*, Philadelphia and New York, 1970. Catalogue of the 1970 exhibition at the Philadelphia Museum of Art.

12. _____ . "Jasper Johns' Flags," *Print Collector's Newsletter*, vol.7, no.3 (July-August 1976), pp.69-77.

13. _____ . "A Tribute to Jasper Johns," in *Skowhegan School of Painting and Sculpture, Thirty-First Anniversary Awards Dinner Program*, New York, 1977, pp.11 & 24.

14. *Foirades/Fizzles*, The Whitney Museum of American Art, New York, 1977. Catalogue prepared by Judith Goldman.

15. Frankenstein, Alfred. "Fooling the Eye," *Artforum*, vol.12, no.9 (May 1974), pp.32-35.

16. D.G. "Jasper Johns at MOMA," *Arts Magazine*, vol.45, no.5 (March 1971), p.51.

17. Gidal, Peter. "Beckett & Others & Art: A System," *Studio International*, vol.188, no.971 (November 1974), pp.183-187.

18. Goldman, Judith. "Print Criteria," *Art News*, vol.70, no.9 (January 1972), pp.48-51, 65.

19. Herrera, Hayden. "Drawings by Gallery Artists," *Art News*, vol.73, no.4 (April 1974), p.98.

20. Herrmann, Rolf-Dieter. "Johns the Pessimist," *Artforum*, vol.16, no.2 (October 1977), pp.26-33.

21. Hess, Thomas B. "Polypolyptychality," *New York Magazine*, vol.6, no.8 (February 19, 1973), p.73.

22. _____ . "On the Scent of Jasper Johns," *New York Magazine*, vol.9, no.6 (February 9, 1976), pp.65-67.

23. _____. "Jasper Johns, Tell a Vision," *New York Magazine*, vol.10, no.45 (November 7, 1977), pp.109-111.

24. Higginson, Peter. "Jasper's Non-Dilemma: a Wittgensteinian Approach," *The New Lugano Review*, vol.8/9 (Fall 1976), pp.53-60.

25. *Jasper Johns Decoy: The Print and the Painting*, The Emily Lowe Gallery, Hofstra University, Hempstead, Long Island, 1972. Catalogue with Introduction by Roberta Bernstein and Notes by Robert R. Littman.

26. *Jasper Johns Drawings*, The Arts Council of Great Britain, 1974-75. Exhibition catalogue with an homage "For Jasper Johns" by Ellen H. Johnson, and excerpts from an interview with David Sylvester, Edisto Beach, South Carolina, Spring, 1965.

27. *Jasper Johns: Fragments—According to What, Six Lithographs*, brochure published by Gemini G.E.L., Los Angeles, 1971. With a commentary by Walter Hopps.

28. *Jasper Johns Graphik*, ed. Carlo Huber, Bern, 1971. The catalogue section by Richard S. Field was virtually unacknowledged. Also included "Jasper Johns" by Alan Solomon; "Jasper Johns, Stories and Ideas" by John Cage; "Sketchbook Notes" by Jasper Johns; "Marcel Duchamp" by Jasper Johns, all translated into German; and "Jasper Johns: Die Graphik," by Carlo Huber.

29. *Jasper Johns: 6 Lithographs (after 'Untitled 1975')*, *1976*, brochure published by Gemini G.E.L., Los Angeles, 1977. With text by Barbara Rose.

30. *Jasper Johns Lithographs*, The Museum of Modern Art, New York, 1971. Catalogue and essay by Riva Castleman.

31. *Jasper Johns: Matrix 20*, Wadsworth Atheneum, Hartford, Connecticut, 1976. Catalogue prepared by Richard S. Field.

32. *Johns, Stella, Warhol: Works in Series*, Art Museum of South Texas, Corpus Christi, 1972. Catalogue with an Introduction by David Whitney.

33. Jasper Johns/Screenprints, Brooke Alexander, Inc., New York, 1977. Catalogue with an essay by Richard S. Field.

34. Kaplan, Patricia. "On Jasper Johns' According to What," *Art Journal*, vol.35, no.3 (Spring 1976), pp.247-250.

35. Kelder, Diane. "Tradition and Craftsmanship in Modern Prints," *Art News*, vol.70, no.9 (January 1972), pp.56-59, 69-73.

36. _____. "Prints: Jasper Johns at Hofstra," *Art in America*, vol.61, no.1 (January-February 1973), pp.109-110.

37. Kozloff, Max. *Jasper Johns*, New York, 1974.

38. _____. "Traversing the Field…'Eight Contemporary Artists' at MOMA," *Artforum*, vol.13, no.4 (December 1974), pp.44-49.

39. Krauss, Rosalind. "Jasper Johns: The Functions of Irony," *October*, vol.2 (Summer 1976), pp.91-99.

40. Leventhal, A.J. "Letter to the Editor," *Print Collector's Newsletter*, vol.8, no.3 (July-August 1977), p.77.

41. Marandel, J. Patrice. "Lettre de New York," *Art International*, vol.15, no.2 (February 1971), pp.74-77.

42. Masheck, Joseph. "Sit-in on Johns," *Studio International*, vol.178, no.916 (November 1969), pp.193-195.

43. _____. "Jasper Johns Returns," *Art in America*, vol.64, no.2 (March-April 1976), pp.65-67.

44. Mikotajuk, Andrea. "Jasper Johns at Castelli," *Arts Magazine*, vol.49, no.3 (November 1974), p.17.

45. *Offset Lithography*, Davison Art Center, Wesleyan University, Middletown, Connecticut, 1973. Catalogue prepared by Louise Sperling and Richard S. Field.

46. Olson, Roberta J.M. "Jasper Johns—Getting Rid of Ideas," *The Soho Weekly News*, vol.5, no.5 (November 3, 1977), pp.24-25.

47. Perrone, Jeff. "Jasper Johns's New Paintings," *Artforum*, vol.14, no.8 (April 1976), pp.48-51.

48. Prints by Four New York Painters, *The Metropolitan Museum of Art*, New York, 1969-1970.

49. Raynor, Vivien. "Jasper Johns," *Art News*, vol.72, no.3 (March 1973), pp.20-22.

50. *Recent American Etching*, Davison Art Center, Wesleyan University, Middletown, Connecticut and the National Collection of Fine Arts, Washington, D.C., 1975-1977. Catalogue prepared by Richard S. Field.

51. Rees, R.J. "Jasper Johns Drawings at the Museum of Modern Art, Oxford," *Art International*, vol.188, no.972 (December 1974), p.261.

52. Reichardt, J. "The Rendering is the Content," *Architectural Digest*, vol.44, no.12 (1974), p.801.

53. Rose, Barbara. "The Graphic Work of Jasper Johns," (2 parts) *Artforum*, vol.8, no.7 (March 1970), pp.39-45; and *Artforum*, vol.9, no.1 (September 1970), pp.65-74.

54. _____. "Decoys and Doubles: Jasper Johns and the Modernist Mind," *Arts Magazine*, vol.50, no.9 (May 1976), pp.68-73.

55. Rose, Bernice. *Drawing Now*, Museum of Modern Art, New York, 1976.

55A. Roth, Moira. "The Aesthetic of Indifference," *Artforum*, vol.16, no.3 (November 1977), pp. 46-53.

56. Russell, John. "Jasper Johns and the Readymade Image," in *The Meanings of Modern Art*, vol.11, New York, 1975, pp.15-23.

57. _____. "Jasper Johns Sketches Himself—and Us," *The New York Times*, Sunday, February 1, 1976, Art Section, p.1.

58. Shapiro, David. "Imago Mundi," *Art News*, vol.70, no.6 (October 1971), pp.40-41, 66-68.

59. Stuckey, Charles F. "Johns: Yet Waving?" *Art in America*, vol.64, no.3 (May-June 1976), p.5.

60. Tomkins, Calvin. "Profile: Tatyana Grosman," *The New Yorker*, vol.52 (June 7, 1976), pp.42ff.

61. Young, Joseph E. Review of R.S. Field, Jasper Johns: Prints 1960-1970, in *Print Collector's Newsletter*, vol.2, no.2 (May-June 1971), pp.37-39.

62. _____. "Jasper Johns Lead Relief Prints," *Artist's Proof*, vol.10 (1971), pp.36-38.